DATE DUE	RETURNED

Stores
of the Year

No. 16

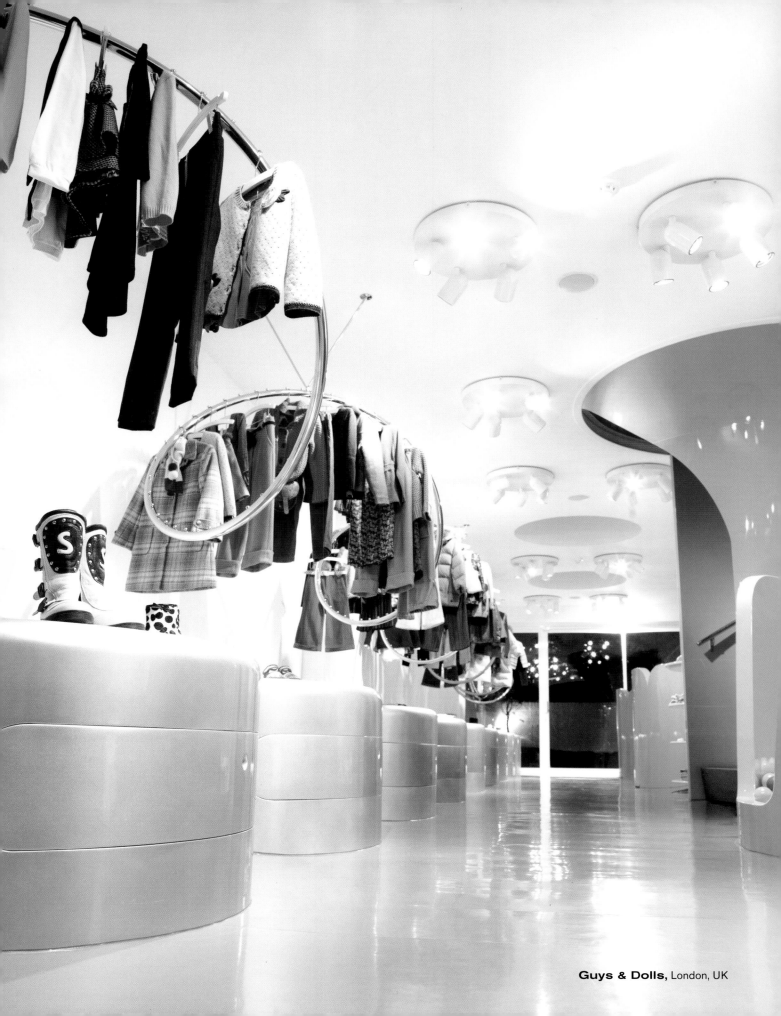

Guys & Dolls, London, UK

Stores
of the Year

No. 16

Martin M. Pegler

VISUAL REFERENCE PUBLICATIONS, INC., New York, NY

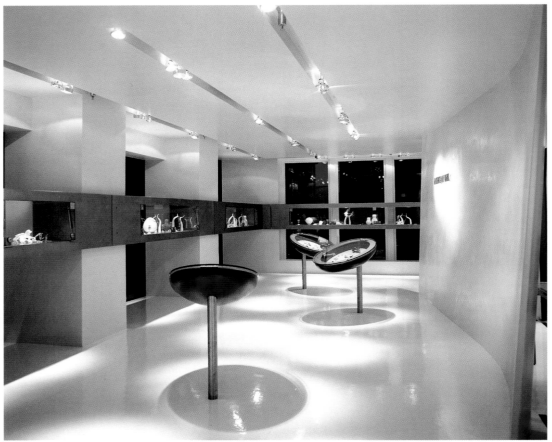

Anthony Nak, Austin, TX

Visual Reference Publications, Inc.
302 Fifth Avenue
New York, NY 10001

Distributors to the trade in the United States and Canada
Watson-Guptill
770 Broadway
New York, NY 10003

Distributors outside the United States and Canada
HarperCollins International
10 E. 53rd Street
New York, NY 10022

Library of Congress Cataloging in Publication Data:
Stores of the Year, No. 16

Printed in China
ISBN: 1-58471-113-2
 978-1-58471-113-1

Book Design: Judy Shepard

TABLE OF CONTENTS

The amazing world of EuroShop:

diverse, inspiring, unique.

Ideas for shopfitting, architecture & store design. Current issues for POP marketing & visual merchandising. Fascinating lighting technology. Innovations for IT and security technology. All **at EuroShop 2008, the largest trade fair worldwide for the retail industry and its partners.**

EuroShop ✳

The Global **Retail Trade Fair**

February 23–27, 2008 Düsseldorf, Germany

www.euroshop.de

INTRODUCTION

This *Stores of the Year* edition showcases how far we have come in the last several decades since the first book in this series was produced. Actually, it was the fourth edition—published two decades ago—that set the format that we still follow: a presentation of retail stores—large and small—minimal or opulent—designer or funky—that expertly merchandise the retailer's wares.

Looking back at *Stores of the Year No. 4,* and re-reading the introduction that I wrote for that book, I realized that things haven't really changed that much. So—with your indulgence I am restating what I stated back then.

"Success stories—that's what these stores are! These are not necessarily the 'best' stores of the year and then one would have to question by whose standards and what standards they were declared to be 'the best.' They are, however, successful stores. They have succeeded in satisfying the needs of the retailers and the shopping needs and experiences of their shoppers. These are stores with a focus; they have been designed and targeted at a particular shopper or product or look—a fashion attitude—a way of life or a lifestyle. The stores you are about to visit were selected for this book because they were doing something right; they were and are reaching out to their selected customers—bringing them in—and then giving them what they want in an ambiance that says and does all the right things—for those customers. They are not necessarily the most prestigious stores or most notorious or ballyhooed ones though quite a few have garnered design awards in various challenges. They are, however, all bright and original—different—and have managed to solve problems of space and form—they have managed to say something that is new in an industry of 'sameness' and 'knock-offs.' They have reached out—extended themselves—tried new approaches and come up with solutions that are working—and are often economical. Some of our selections are or have become prototypes for stores that are already or will soon be seen—sometimes with alterations or adaptations—in new spaces in new areas. The concepts, the approaches, the design theory and fixturing and store fitting ideas work. Some of our stores are new and are making bold steps into uninvestigated areas with fairly unknown product lines while others are "rehabs" that have discovered the fascinating potentials of older architecture combined with fresh, new retailing techniques. Some of our shops are designed by world renowned architectural concerns or store designers while others have been created and nurtured by young and emerging talents that we are pleased to introduce in this book.

Over the past two years (actually 20 years) there have been decided changes in retailing. There have been changes in merchandising concepts, and changes in how merchandise is presented—and sold. Just as times change—customers change; becoming more educated—more affluent—more sophisticated—more aware of fashion looks and trends. The changing retail scene and the changing customer and customer demands are affecting the store's design and the store furnishings."

So, 30 years ago—when I wrote the above quote—we already were talking about customer's up-scaling and lifestyle and though not mentioned by the current buzz-word—retailers creating branded images for their wares. Add to that all the technology and new materials that have developed over these years and apply them to the new designs and what you have is the *Stores of the Year No.16.*

This is truly an INTERNATIONAL selection of stores and designers with 12 countries providing more than half the projects balanced by some of the finest retail stores in the U.S. This is what the Internationalization of design is all about.

Examine—Enjoy—and maybe get some new ideas to expand upon.

Martin M. Pegler

LOTTE DEPARTMENT STORE

Sang-In, Korea

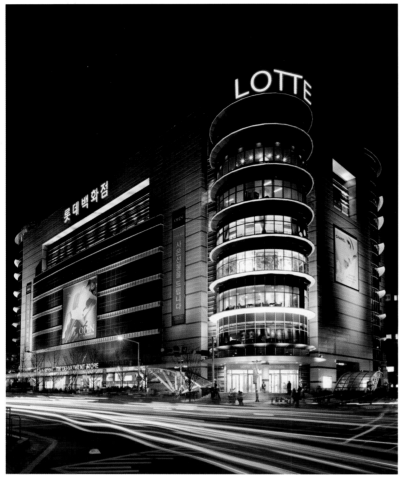

Lotte, in Saang-in, Korea, was awarded first place in the "full line department category of the *ISP/VMSD* annual international challenge. The 500,000 sq. ft. store offers natives of that city eight levels of fashion and personal products along with a giant supermarket and food court on the below ground levels.

The challenge for FRCH Design Worldwide of Cincinnati, OH was "to individualize each floor to appease specific shoppers." To accomplish this, the design team used different colors to express various categories of fashions and services. With the addition of natural woods and clear site lines on each floor, they were able "to establish a comfortable environment and apparel showcase." To create a sense of theater and "bring emotion intro the space," bold lighting, innovative fixturing and a strong graphics program were implemented as well.

The corner of the building features a rounded glass and steel tower that reaches up from over the corner entrance to the roof line where the

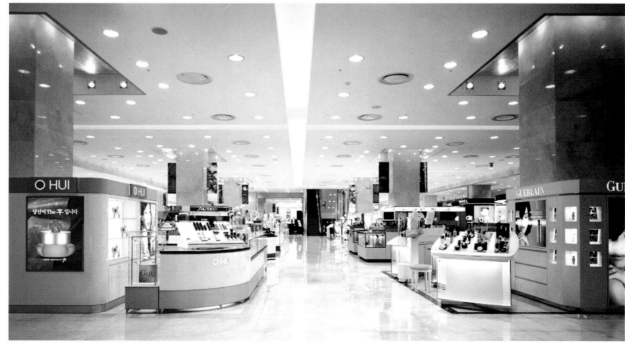

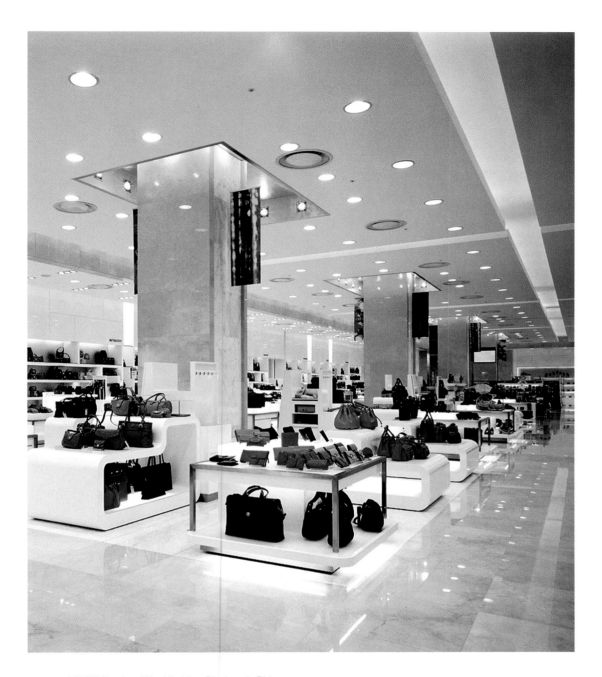

DESIGN: **FRCH Design Worldwide,** Cincinnati, OH

PRINCIPAL IN CHARGE: **Jim Lazzari**

VP/DESIGN: **Andrew Mc Quilken**

DESIGN DIRECTOR: **Jeanine Storn**

RESOURCE DESIGN: **Sonja Davis**

PROJECT MANAGER: **Denette Callahan**

PROFESSIONAL: **Tim Goyette**

For LOTTE

CHAIRMAN: **Kyuk-Ho Shin**

PRESIDENT: **In-Won Lee**

GENERAL MANAGER/MERCHANDISE STRATEGY: **Hee-Tae Kang**

SR. PROJECT DESIGNER: **Hyeong-Se Soe**

PHOTOGRAPHY: **Courtesy of FRCH Design Worldwide**

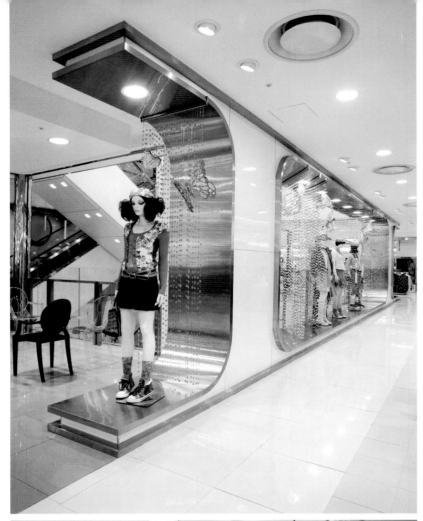

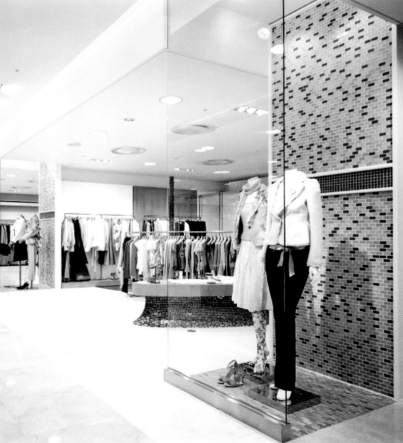

store's logo name crowns the construction. Through this see-through curved element, shoppers on the street can visually sample some of Lotte's merchandise. The mainly white ground level with its polished off-white marble-like floors and massive gold-leafed supporting columns that pierce the light filled ceiling is filled with a gallery of perfume and cosmetic "boutiques"—"balanced in harmony" with the rest of the store. Set out on the creamy marfil floors are white laminate covered fixtures with curved or rounded profiles combined with simple metal fixtures.

Throughout, the softening ends appear as in the interior display windows that surround the escalator well that connects the floors. Here the white is complemented by the bold sweeps of polished metal. In the "young Zone," accented in aqua, young male and female shoppers can roam amid the offerings—"modern and retro at the same time." For this floor the designers created focused environments for fashion coordinated apparel presentations. A dramatic wall merchandising system makes for exciting focal points that draw shoppers from other areas in the store. Rich and unexpected materials and finishes are combined in the store's design like the mosaic tile T-walls and curved bases of feature tables that invite shoppers to enter and sample over 30 designer brands in the women's department.

In the lower levels Lotte wanted a perfect setting for its supermarket and the adjacent food court. FRCH used overhead graphics, focused lighting and a flexible natural wood fixture system to provide "an outdoor mood." It is now the ideal setting in which to showcase the abundant produce, fresh-caught seafood and meats.

In addition to the welcoming café on the second level of the curved glass tower, there is a cultural center. FRCH's marriage of man-made and natural materials creates the new Lotte modernism concept that is present throughout the department store.

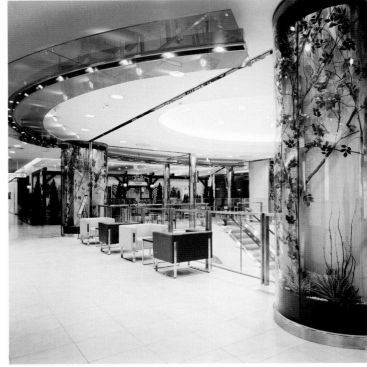

GLOBUS

Zurich, Switzerland

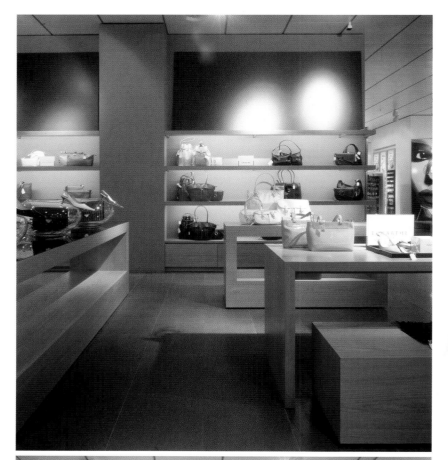

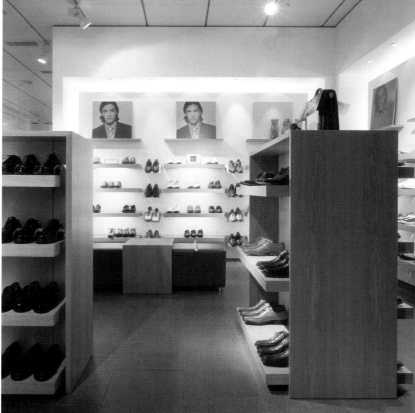

The huge ground floor of the well-known Globus Department Store, in Zurich Switzerland, has recently been "newly conceptualized" and re-arranged into several mini-departments. The 2800 sq. meter (approx. 30,000 sq. ft.) space has been divided into specific zones for perfumes and toiletries, jewelry, accessories including shoes and hosiery, eyewear and stationery.

Although each area has its own custom designed furniture and fixtures as well as specific colors and materials, the space is unified by the use of Basaltina natural stone tile flooring throughout. As now arranged, the traffic pattern connects the heavy pedestrian movement on the Rue du Marche to the Rue du Rhone. A side axis leads through the new food hall (reviewed in the May 2005 issue of *Retail Design*) to the Place du Molard. The large "Grande Passager" runs through the main axis of the floor.

As designed by Stefan Zwicky and Muller+Fleischli of Zurich, the palette is mostly neutral in color and the floor fixtures and wall systems are predominantly constructed of a rich, natural wood in the fashion accessories areas such as shoes and handbags. Simple and contemporary, cube-like in design, the fixtures not only hold shoes and bags, but they serve as low partitions or dividers creating specialty zones within the designated departments. Whether the wall shelves are recessed or built-in between the piers or are cantilevered off the walls—as in the men's shoes area—the shelves are thick slabs of the same wood that is used for the floor fixtures set out on the tiled floors.

In the eyewear shop, the illuminated white translucent plastic walls carry clear glass shelves upon which the frames are displayed. The glowing light shows off the frames to their full advantage. Around the perimeter of this department the glasses are presented by "designer" or "brand name." The names

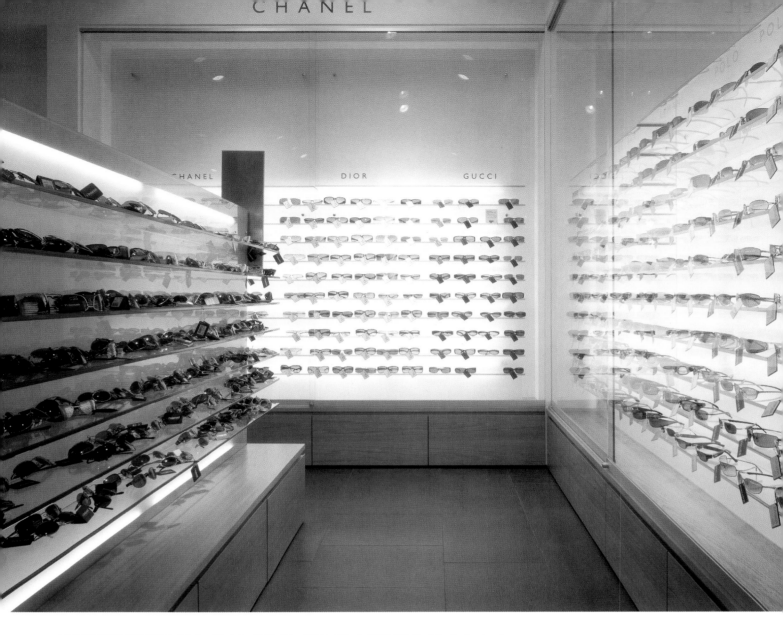

ARCHITECTS/DESIGNERS: **Stefan Zwicky & Muller+Fleischli, Architects,** Zurich, Switzerland
DESIGN TEAM: **Samuel Eberli, Veronique Locher, Bertrand Senwald, Nadja Keller**
PHOTOGRAPHY: **Courtesy of the Architects**

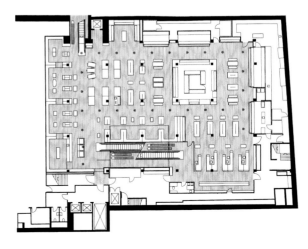

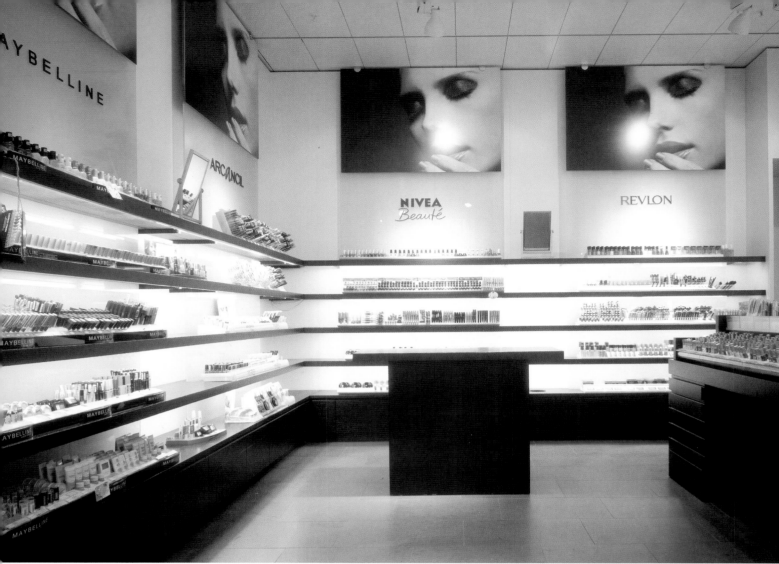

discretely but legibly appear over the lined-up product display.

The perfumes, cosmetics and toiletries area takes on a more sophisticated and darker tone with the cabinetry, shelving and fixtures finished in black to contrast more sharply with the warm, white ambience that, in turn, is flushed with a flattering pink light. Individual "brands" are also acknowledged here and the logos appear in the illuminated squares set above the packaged products arranged on the ebony colored wood shelves. The on-the-floor cases combine the black wood bases with frosted acrylic and stainless steel to make the squared off units.

Graphics are used as signage throughout to identify the various departments and the repetitive use of the same face or figure adds a decorative pattern to the overall design of the new main level of Globus.

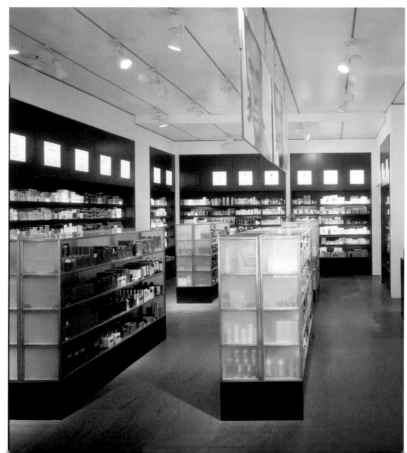

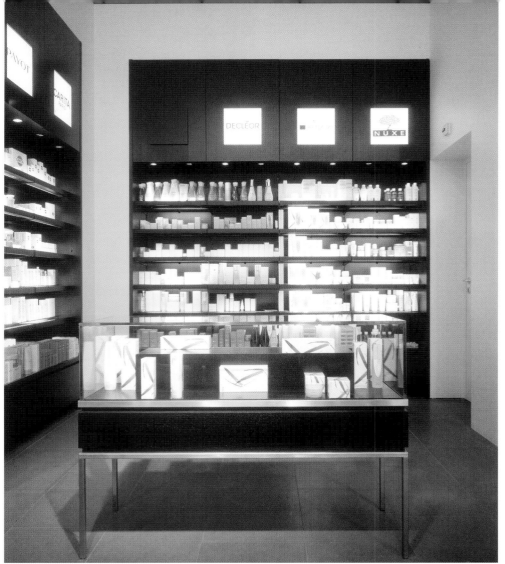

HOUSE OF FRASER

Dundrum, Dublin, Ireland

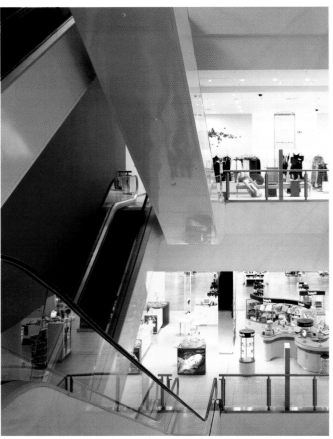

Following is a design statement by the designers of the new store that is shown here:

"House of Fraser is the leading retailer of designer brands in the UK. Kinnersley Kent design aims to create an aspirational, exciting and accessible environment to showcase these brands, and to give House of Fraser itself a recognisable identity as a fashionable, sophisticated shopping destination. This is achieved by applying a sleek, contemporary architectural language to each store, with elements of colour, texture and interest helping to define a specific mood.

"There are some very fundamental philosophies which remain constant. Service areas such as Personal Shoppers, and architectural elements such as column claddings, cash till features, and visual display points have a defined language which is applied to all new schemes.

There is also a materials palette for each department, which creates a sense of continuity between stores, and help to break the space down into recognisable zones for the customer.

"These core architectural elements remain consistent through all schemes, providing a backbone. Individual site solutions are tailored to specific contexts and markets by incorporating some signature statements, whether they be the bold red escalator feature wall used in Dublin, or the more classic timber and stone elements used in stores like Guildford. In each case, the site-specific elements reflect an understanding of the local customer profile and aspirations. Subtle adjustments to the materials palette, and an evolving approach to merchandising and display, help to keep each store fresh and up-to-date.

"Kinnersley Kent design and

DESIGN: **Kinnersley Kent Design (KKD),** London, UK
PHOTOGRAPHY: **Peter Cook**

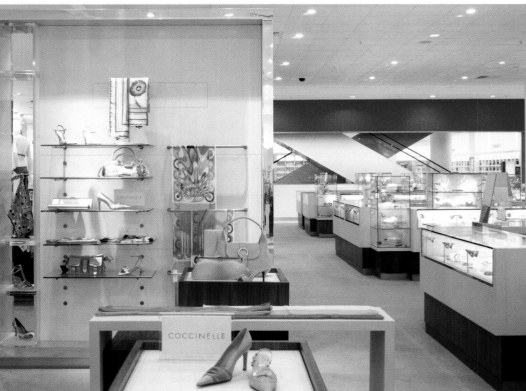

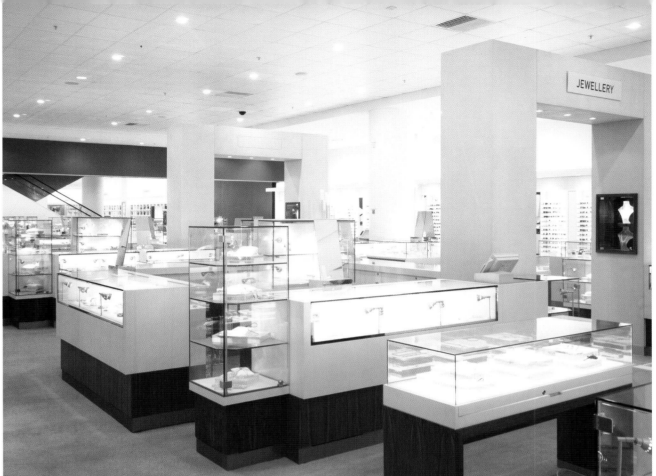

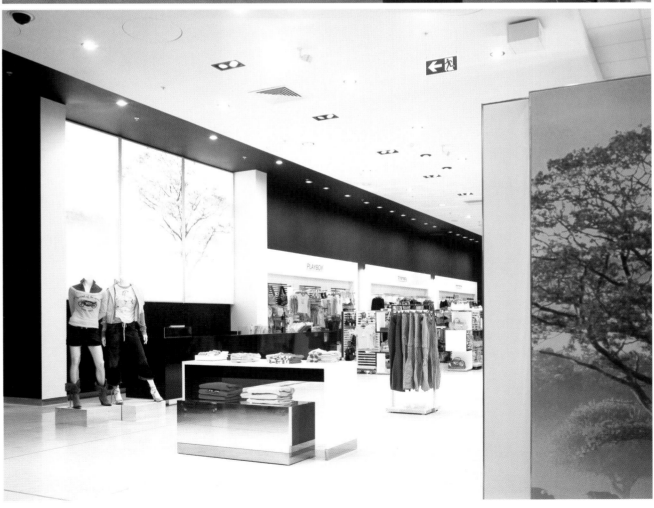

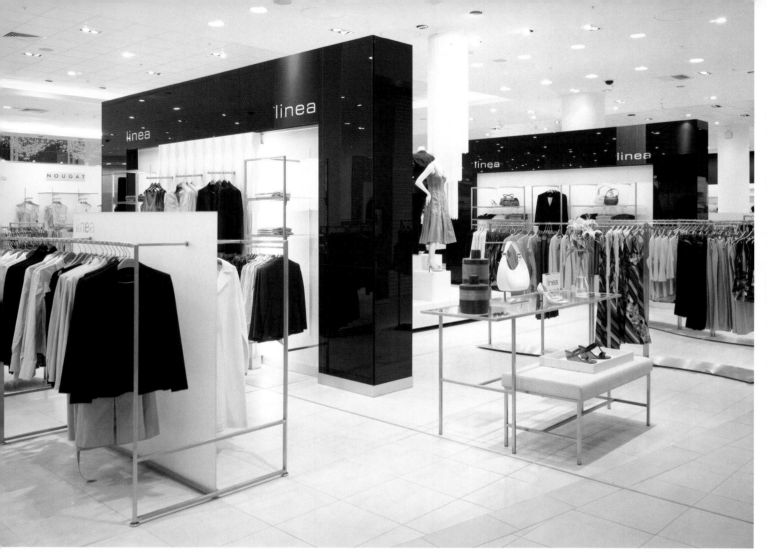

House of Fraser work together closely throughout the lifespan of each project to ensure that the finished result reflects the retailer's image. Each project is reviewed as it opens to highlight areas to be developed, and both the designers and the retailers keep a close eye on market trends to ensure the brand image remains fresh and exciting."

The overall aim of the scheme was to create a landmark store for House of Fraser in one of the largest and most significant retail developments in Ireland to date. The store is, as destination and an anchor site, attracting customers from a broad catchment. This new 140,000 sq. ft., four-level store is located in the Dundrum Shopping Center which is located just outside of Dublin City center and the store is distinguished by a triple height glazed facade with a seven meter (22 ft.) long fiber optic light installation by Sharon Marsden. The all-glass façade affords views into the wom-

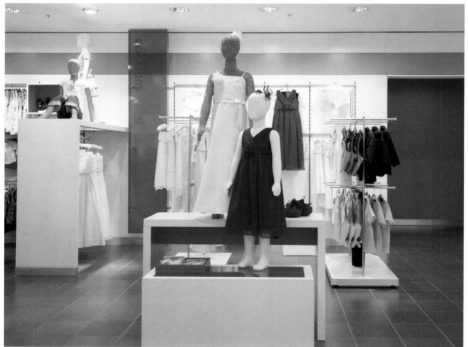

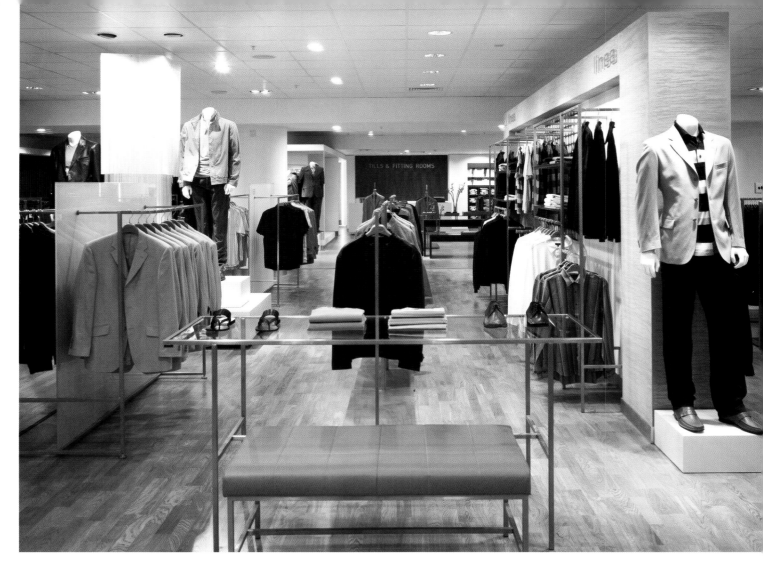

enswear and home fashions floors.

Inside, the key architectural feature is a dramatic red wall that runs down the center of the building—over 100 ft. from the atrium roof to the car park five stories below. "This unifying feature functions both as a central point for navigation and also as a draw to customers to circulate the space vertically and horizontally." Slots in this feature wall serve as display and promotional zones as well as provide views across and between retail floors. The atrium is flooded with light from the glazed roof, and the well "steps in and out on different levels to open up views between the floors."

The mall level is where shoppers will find beauty and accessories. The heart of the Beauty area is a central, backlit promotional tower which provides both drama and focus. Angled, mid-floor walls break up the space and create backdrops against which

brands are merchandised. Core brands are located around the perimeter where a curved illuminated acrylic bulkhead creates "a glowing framework for the brands in the categories of fragrance, skin care and cosmetics." Rich, sophisticated finishes such as champagne metalwork, walnut and bone white surfaces as well as back illuminated mirrors create a stylish setting for the fashion accessories: jewelry, watches, sunglasses, shoes, hats, handbags and luggage.

Menswear is located on the lower ground level and here metal fins divide up the brands architecturally. These are evident upon arrival at this level and they are accented with splashes of red and backlit Profalit glass—"creating an exciting, buzzy feel." The materials and colors here shift from walnut fixtures and gray stone floors to special shop areas where textured gray Armourcoat goalposts frame the brand

locations and the "strong visual treatments help to define sporty, denim and golf zones." Concessions such as Aquascutum and Chelsea Cobbler bring their own corporate brand look to this floor as well.

Womenswear, on the first floor, is presented as a "dynamic fashion zone" filled with young fashion, contemporary, and designer womenswear as well as evening wear and lingerie. The overall look "breathes confidence and theater into the space." The color and materials palette includes gloss blacks and reds, glass, slate and walnut. Adding to the drama and impact of this 50,000 sq. ft. space is the ceiling height of almost 15 ft. This large area is divided into more intimate zones with subtle changes in the colors and the materials. A matte black backdrop for the gloss-white wall system creates a dramatic contrast for the brands displayed in young fashions. Mirror pol-

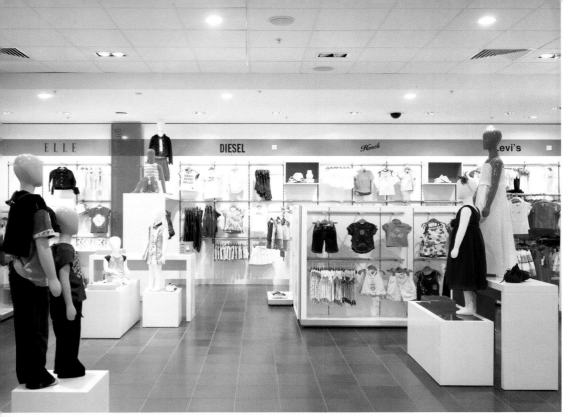

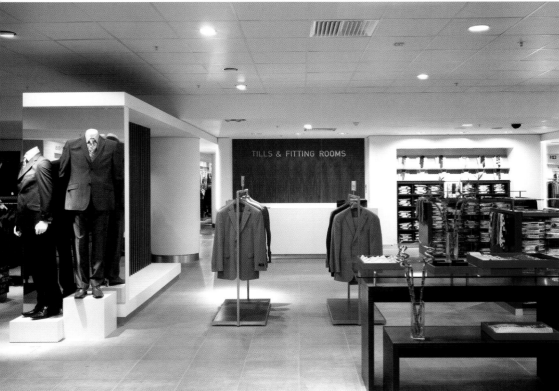

ished dark gray floor tiles, chrome metalwork and large scale light boxes create "an up-tempo, glamorous feel." Architectural totems are dressed seasonally and they affect "a rhythm of activity and change along the walkways."

More glossy and reflective—in red and black—is the contemporary womenswear area. This zone is in the center of the floor and creates opportunities for special promotions and fashion shows. The materials used here are more timeless and elegant thus allowing this area to blend seamlessly with the adjacent classic brands area where the materials shift towards frosted glass and white. Along with the Burlington slate they add to that area's sense of sophistication. The free-standing fixtures are simple, refined and light with subtle material and color shifts to define the various classifications. Evening wear

and the bridal suite are located at the rear of this level and have an ambiance all of their own: "long, delicate light features hover over a dramatic central mannequin catwalk of high gloss black lacquer. "Warm beige tones give the space a softer, more luxurious individuality which continues into the adjacent lingerie area."

The lingerie concept—"a private boudoir zone with a stylish attitude"—maintains a discreet, relaxed mood in an area with a dropped ceiling and daylight diffused through translucent acrylic panels around the perimeter. Ivory goalposts, fabric shades, textured lilac wallpaper and pale pink glass panels all help to affect the desired feminine ambiance.

The top level of this House of Fraser is shared by the children's world, homewares and the Café Memo. While vibrant blues, greens, pinks and yellows and a 3D effect Amtico flooring create a "funky, playful environment" for children's wear, homewares is set out in clean, simple, architectural room-like settings.

"The application of striking colors and rich materials create strong visual statements throughout the store, and adds a feeling of quality and drama to the scheme. The overall look is light, airy and contemporary, while strong visual destinations make the space easy to navigate."

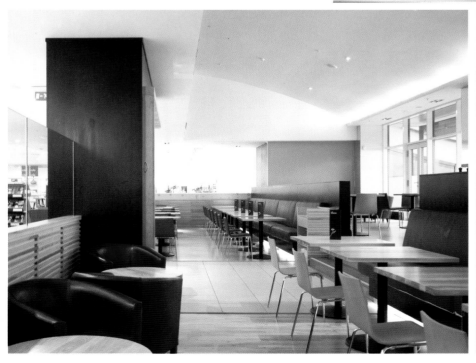

BLOOMINGDALE'S

Lexington Ave., New York, NY

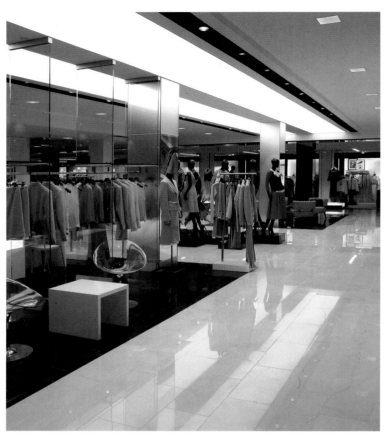
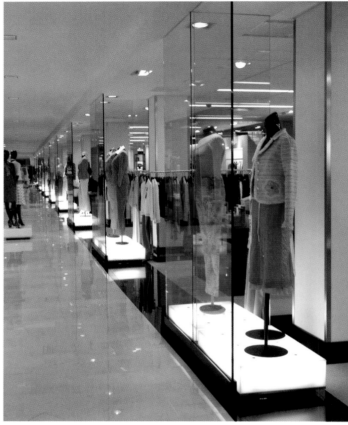

The popular "bridge floor" in the Bloomingdale's flagship store on Lexington Avenue and East 59th Street has been completely redesigned and refocused. The store wanted a more sophisticated and updated look for its new, more sophisticated merchandising concept and they called upon the New York City architectural design firm of Mancini-Duffy to create the "New View" in this 65,000 sq. ft. space. Twenty three vendors are now featured on this floor which is like an upscale mini-mall dedicated to trendsetting fashions.

To make this massive alteration work, the design firm—working closely with Jack Hruska, Federated's Divisional VP of Planning & Design, a new, clearer and more open traffic pattern was instituted. To help accomplish this the ceiling was raised from 9 ft. to 11 ft. and "a strong architectural frame" was devised. Ed Calabrese, Creative Director at Mancini-Duffy explained, "We created a brand image for a category while the design complements and cohabits with the variations of the vendors. This gives the department texture and interest. We emphasized the circulation via a graphic aisle system punctuated with black granite. The ceiling plane follows the circulation and allows for dramatic lighting effects."

Throughout, the designers specified a warm, light neutral palette of rich and elegant materials accented with black granite and mirrored "frames" around each vendor's area. Though each vendor was given the opportunity for self expression and for creating their own signature looks, they all worked within the general color, texture and material scheme.

Some of the designers represented on the designer's floor (on four), such as Burberry, Moschino and Ralph Lauren also appeared on this new third floor. Sal Lenzo, the VP for Visual Merchandising for Burberry, USA designed the Burberry shop—"a little more slick—a little more modern than we normally do." He used light colored lacquered tables combined with oak.

Ralph Lauren's Black Label shop is elegant and luxurious with crystal chandeliers topped with black silk lampshades, black chairs, stainless steel and thick slabs of Lucite for the floating shelves. Black accents and black feature walls add to the smart styling of that shop.

Also represented here is an Ellen Tracy shop complete with contemporary black sofas on a gently muted Tibetan carpet that sets the look for the area.

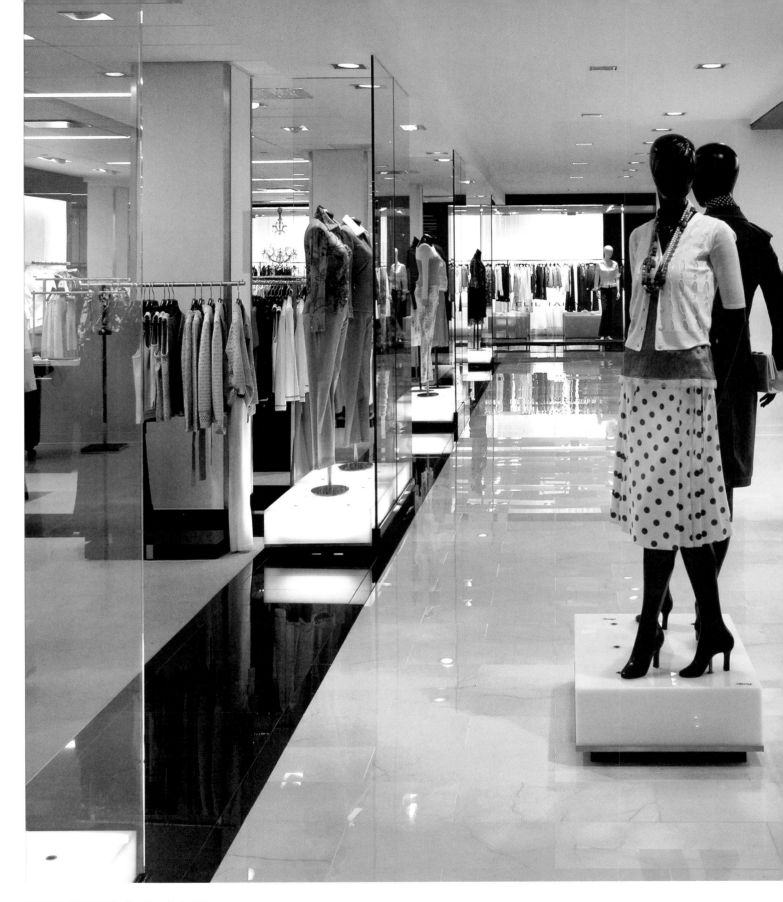

DESIGN: **Mancini-Duffy,** New York, NY
PHOTOGRAPHY: **Brent K. Smith of Mancini- Duffy**

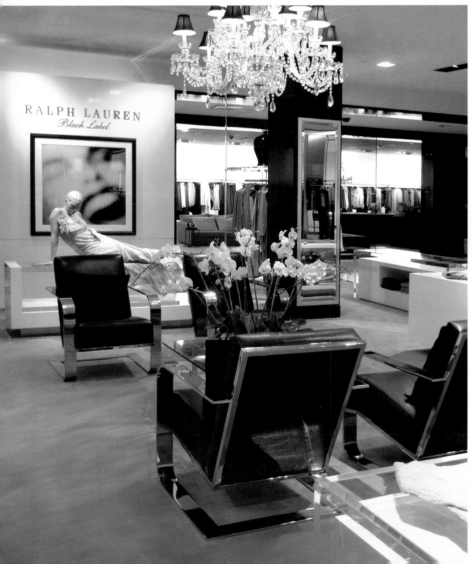

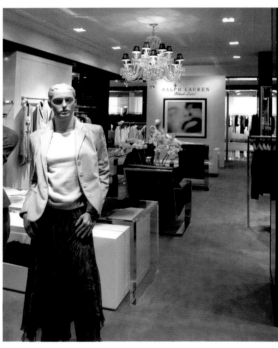

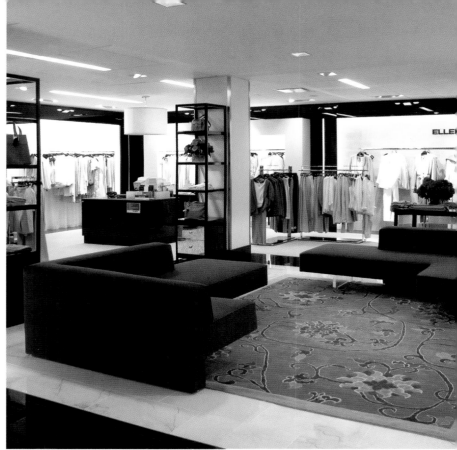

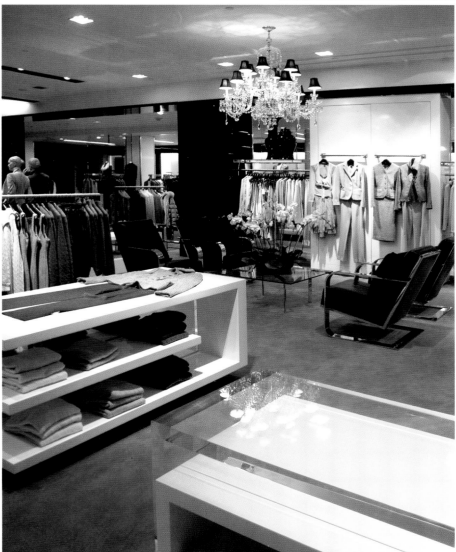

The Lilly Pulitzer shop, according to Michael Newman—the architects, recalls the "romantic Palm Beach life-style" and yet sits comfortably amidst the other vendor shops.

Piero Lissoni designed the Elie Tahari shop which takes up a long narrow space on that floor. The space is defined by the long, long table that dominates the shop.

Rootstein and Goldsmith mannequins appear throughout the floor. They are finished in the same warm beige color that is used throughout. They can be found standing on the floor—mingling with the shoppers in the shops-within-the-shop—and on the low platforms that line the long walkways as well as in front of some of the shops. Luxurious dressing rooms are located all over the floor but there is a major changing area with eleven fitting rooms located near the Ellen Tracy shop. Three way mirrors and soft but effective lighting enhance these fitting rooms.

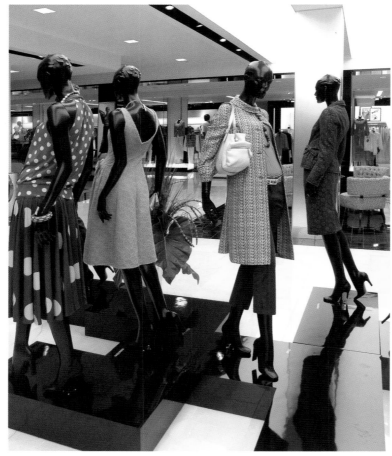

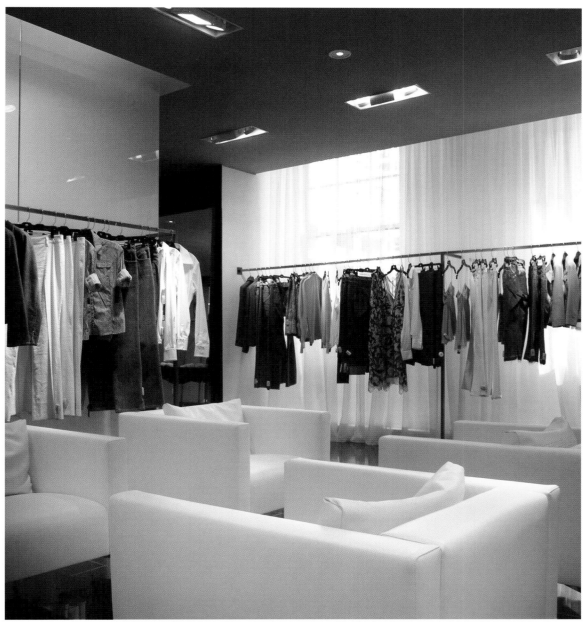

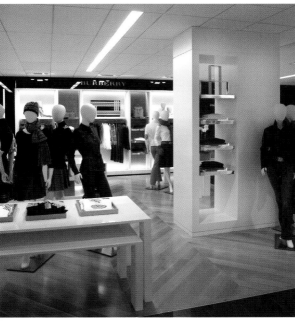

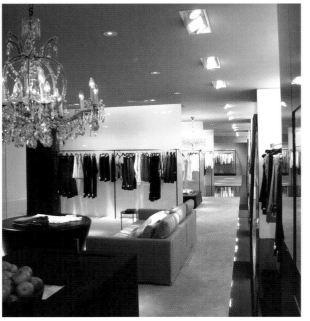

LANE CRAWFORD

Pacific Place, Hong Kong

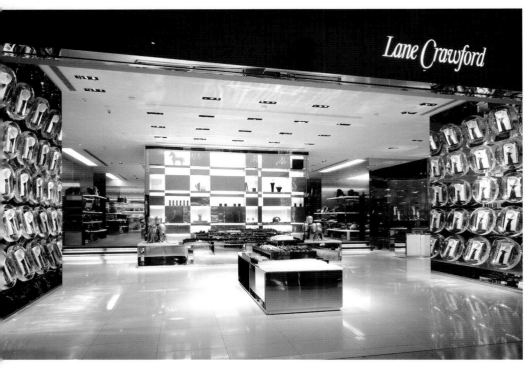

DESIGN: **Yabu Pushelberg,** Toronto, ON, Canada
George Yabu, Glen Pushelberg
PHOTOGRAPHY: **Nacasa & Partners**

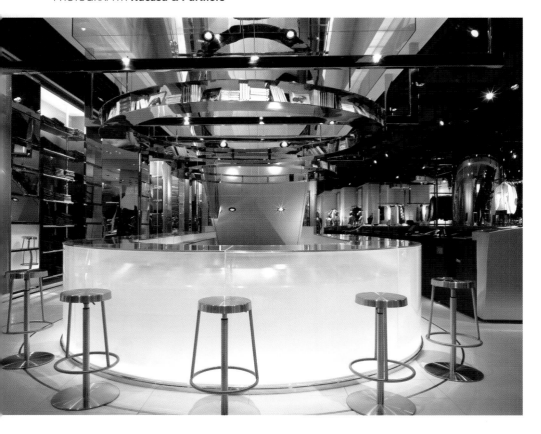

"While our IFC (International Finance Center) store is a luxury destination, the vision for Lane Crawford Pacific Place was to have a high-tech, interactive, modern, casual and democratic store with a greater emphasis on contemporary and casual wear, and premium denim," said David Riddiford, President of Lane Crawford. The design firm that turned this vision into an award-winning reality is the Yabu Pushelberg design firm based in Toronto, Ontario, in Canada.

Lane Crawford, a 155 year old brand, in its newly refurbished 50,000 sq. ft. store "is engaging and interactive," and it is Yabu Pushelberg's "incorporation of art, ingenious use of technology, and overall flare for chic contemporary design that separates the Pacific Place location from retail establishments across the globe." According to Glen Pushelberg, founder of the design firm, the space has been transformed into a dynamic showcase for fashion, beauty, lifestyle, design and art. "The IFC store is timeless, tailored, new and contemporary. The design is much more spirited, younger and more edgy. It is graphically much stronger with hard edges and a lot more energy."

The "i-Bar"—a long, sculptured counter—is the "hub" of the store. This is where customers gather for information, to browse current magazines and to check their email. The "CD-Bar" features i-Pod sound stations and a Bose sound system with 12 individual music zones and a live DJ takes over here on weekends. "With an exposed high ceiling and hard reflective polished stainless steel, the CD-Bar's custom sliding panel surrounds an internally lit frosted curved counter. This area celebrates the youth and energy that encompasses the design of the store."

The high-tech conveyor belt rests

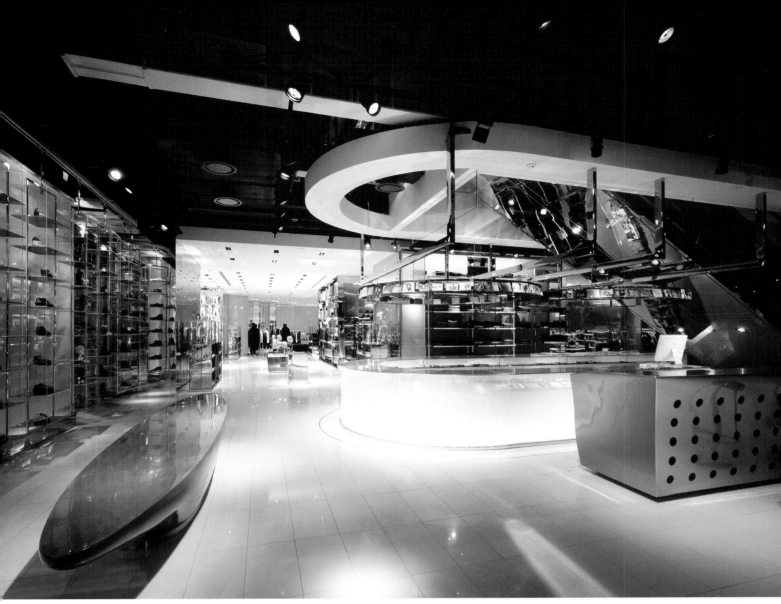

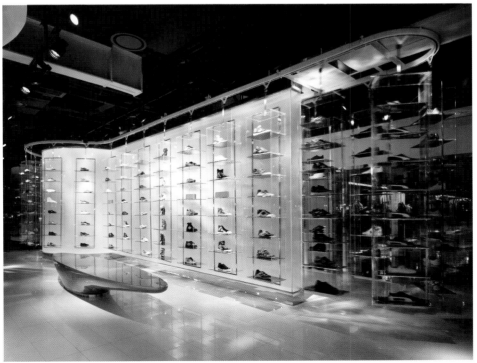

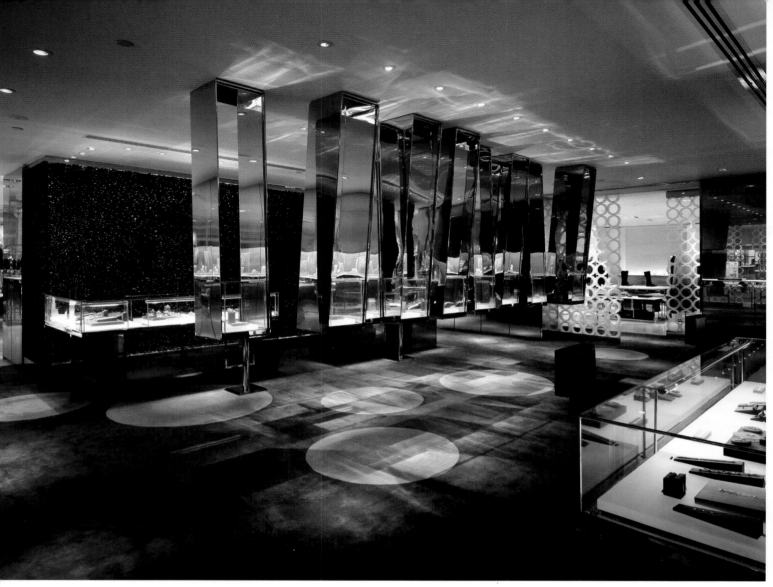

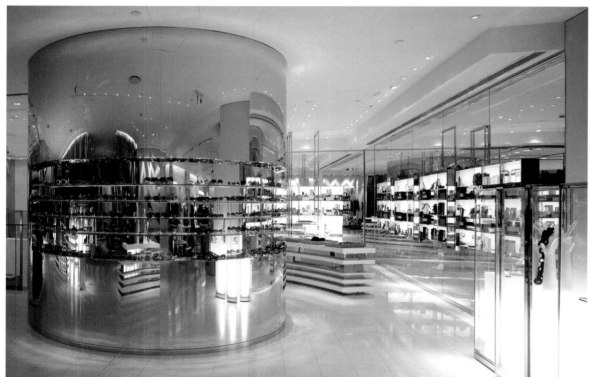

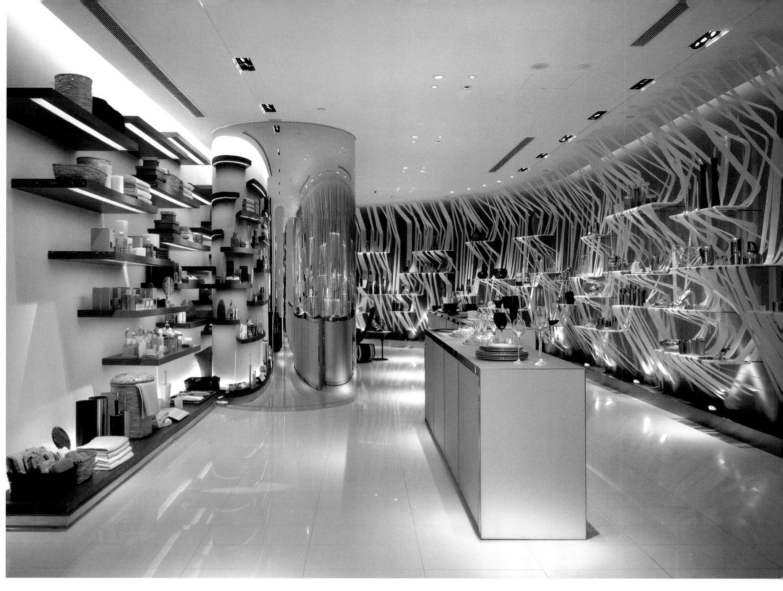

on a track made of steel with a modified hanger that rotates to bring constant "newness." Customers get their viewing experience while watching the moving garments floating by. "This serves as a unique storage system that is able to display more stock merchandise, allowing for less 'back-of-the-house-storage.'" Motion graphics are used to create interactive spaces between the public and their "retail experiences." Behavioral technology (designed by the Korean company, FLUR) responds to the movement of passing shoppers by projecting images on glass panel screens that morph and change. Within the contemporary section, the projections occur on a glass surface with a grid pattern of white dots. Sculptural point of sales counters, treated with heat sensitive paint, respond to the shopper's touch.

Throughout, design features combine light movement and illusion to create an atmosphere charged with energy and theater. By using assorted materials on the walls, "the ordinary is transformed into art." In some instances graphics are projected onto the walls and in other areas they are decorated with charcoal, or there are blocks of resin that are painted vibrant pink, yellow, orange and green. Mirror finished stainless steel contrasts with the matte plaster or hand-painted surfaces. "With every turn there is something different and unique, yet it all works well together."

Very original is the award winning (International Houseware Association's gia 2006) Home Department which is gallery-like in ambiance. A striking feature is the "artistic synthetic strips that peel away from

the wall to create a 3 dimensional display for merchandise." This wall is complemented by the opposite wall of floating shelves followed by ceramic discs." As you turn the corner, the home section is transformed once again with the use of strong color, which changes with every season." A glass staircase, located in the middle of the cosmetics area, serves as a focal point for this area.

On the second level in the women's designer collection, there are branch-like metal screens, designed by Japanese artist Hirotoshi Sawada. These are set into tracks and the panels can be moved to create a variety of different spaces. The jewelry area is centered on this level and the backlit walls are made of fiberglass and treated to resemble charred wood. The display cases are suspended from the

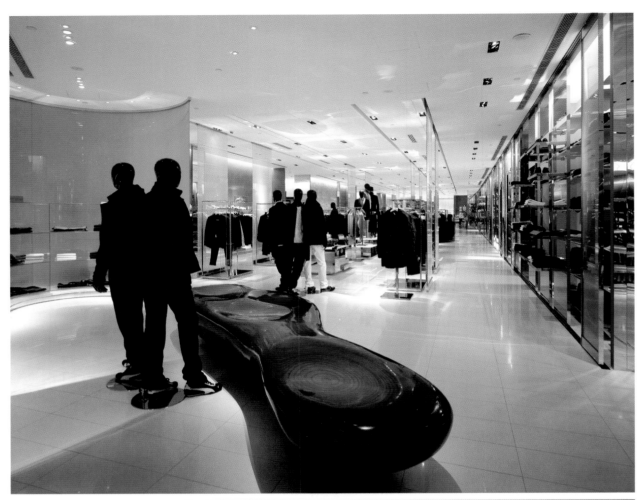

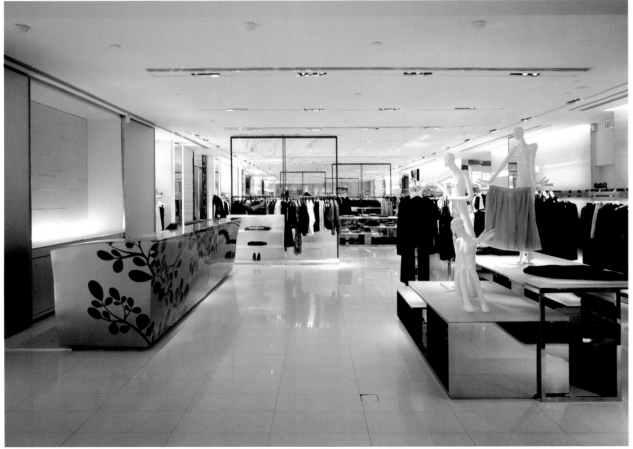

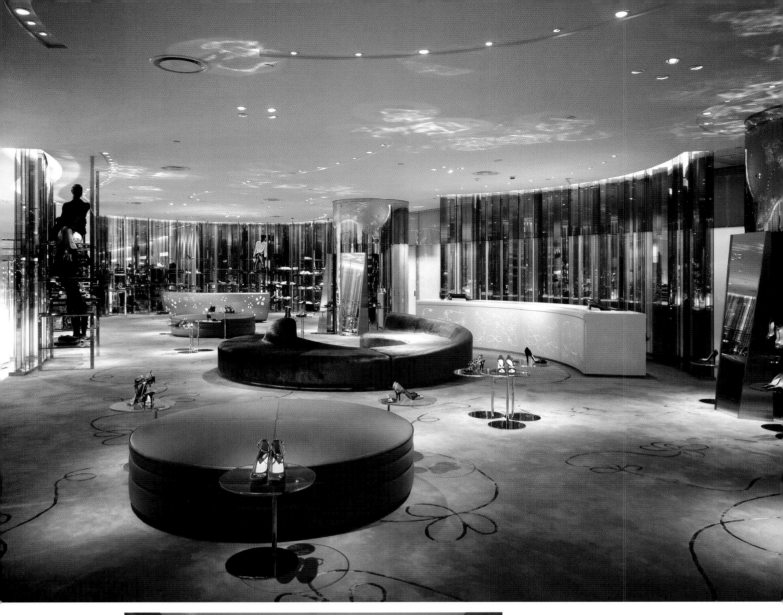

ceiling. This department is identified by custom acrylic patterned screens with cut, cylindrical tubes.

George Yabu said, "This was a truly exciting project. It took only nine months from start to finish: such a project would have taken two years elsewhere in the world. The management team showed tremendous passion throughout this project and were open to our innovative conceptual ideas. But most importantly, the team was aware of the power of store design when it comes to creating an exciting retail environment."

Turn to page 40 to see some on the image-making displays being produced in Lane Crawford's windows and interiors.

SAKS FIFTH AVENUE

Phipps Plaza, Atlanta, GA

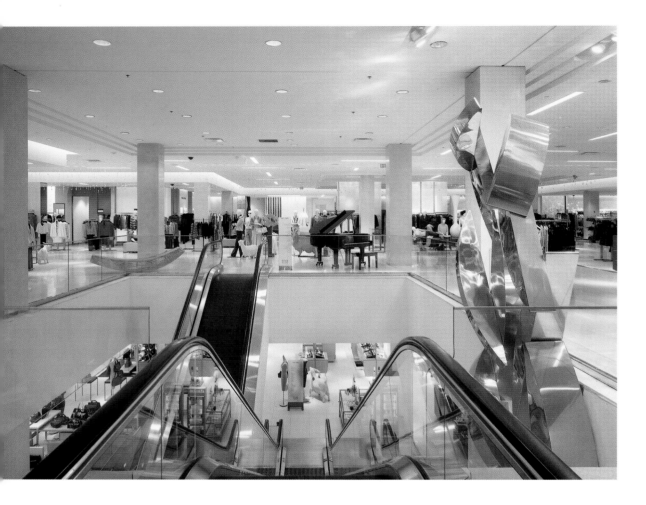

There is a totally new look and attitude at the Saks Fifth Avenue store in Phipps Plaza in Atlanta, GA. Three architectural firms were called upon to renovate and reinvigorate the three story, 150,000 sq. ft. store; Gabellini Associates of New York created the store's new exterior and Callison Architects of Seattle were entrusted with the cosmetics area. The balance of the store's retail departments were designed by Hambrecht Oleson of New York and they are illustrated here.

What the designers accomplished was to create "a very open, harmonious store" through the use of a cohesive neutral palette. "It's whiter and brighter; all color inspiration starts with nature." The neutral palette was highlighted by the use of unique and "surprising" materials and textures such as gold leaf mosaics, a hand painted birch tree mural, and etched glass screens. "Accent colors," according to William Herbst, VP for Visual Merchandising at Saks Fifth Avenue, "created a point of reference by department and the color creates energy." There are "no fussy store details" in this design. The interior finishes often run floor-to-ceiling for "a clean monolithic backdrop to the merchandise."

In describing their design, the design team at Hambrecht Oleson often uses the word "minimalist." Traditional department store fixtures

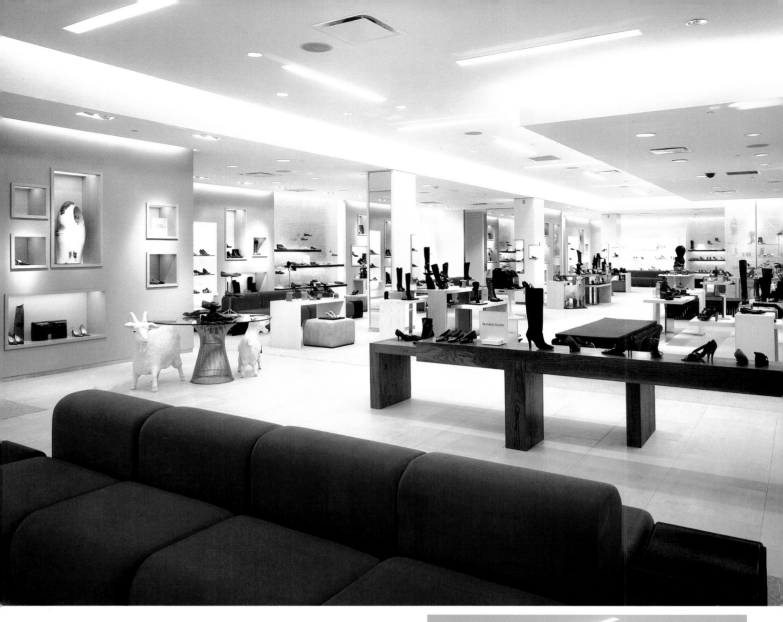

DESIGN: **Hambrect Oleson,** New York, NY
CREATIVE PRINCIPAL: **Karen Oleson**
PROJECT ARCHITECT: **Stephen Hambrecht**
PROJECT DIRECTOR: **Argelio Diaz**
SR. DESIGNER: **Susan Menk**
DESIGNER: **Mee Eun Jung**
PROJECT MANAGER: **John Herrera**

For Saks Fifth Avenue
PROJECT MANAGER: **Randy Panell**
VP STORE DESIGN & PLANNING: **Bob Tank**
STORE PLANNING: **Errol Pierre, Mary Montifar**
VP OF VISUAL MERCHANDISING: **Bill Herbst**
VISUALS: **Steve Wilburn**
STORE DESIGN: **Karen Kornbau**

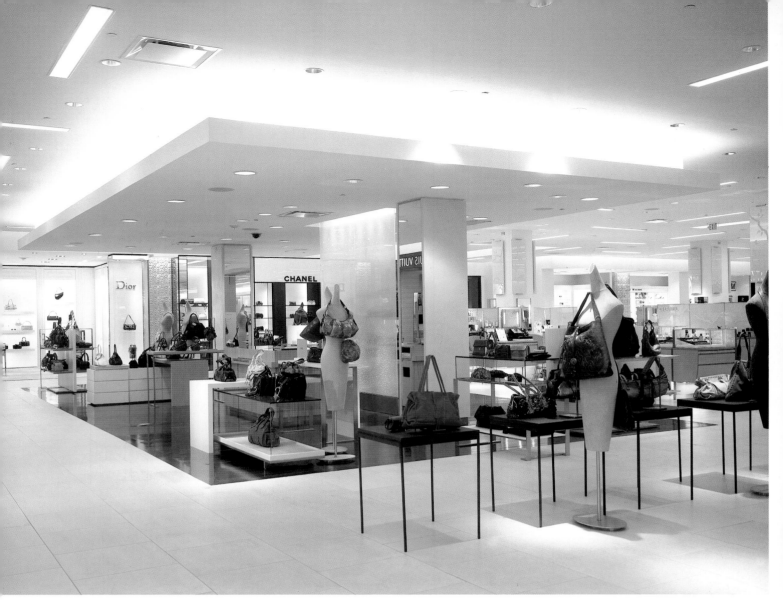

and concepts of fixturing have been avoided "to better represent and reflect Saks Fifth Avenue's image." The shoe department, on ground level, runs from door to door with interesting and beautifully illuminated perimeter articulation. Instead of the usual residential-style seating, the designers took a very contemporary sculptural approach by using long lines of classic Knoll pieces and benches that have been stained black. The off-whites and pale grays are accented by the bright, deep pink upholstery and the wall bays lined with gold leaf mosaic tiles that "glisten and attract the eye from across the floor."

A serene environment was created for the jewelry area and one

wall is enhanced with the previously mentioned birch tree mural executed in grays and charcoal. The natural elements of twigs and branches are repeated in the vitrines and the furnishings of this area. The two-tier glass cases display fashion jewelry at a customer-friendly height and affect "a dramatic vertical element" in the composition. Deep, cool blue chairs, cubes of branches bound together and softly patterned area rugs add warmth and comfort.

The wood enclosure that had originally encased the escalator well was removed and thus opened up sight lines. Here, the "minimalist open well" is highlighted with a three story metal sculpture created by a local artist. It "becomes the orientation point

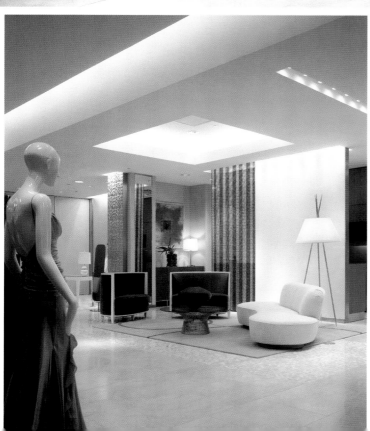

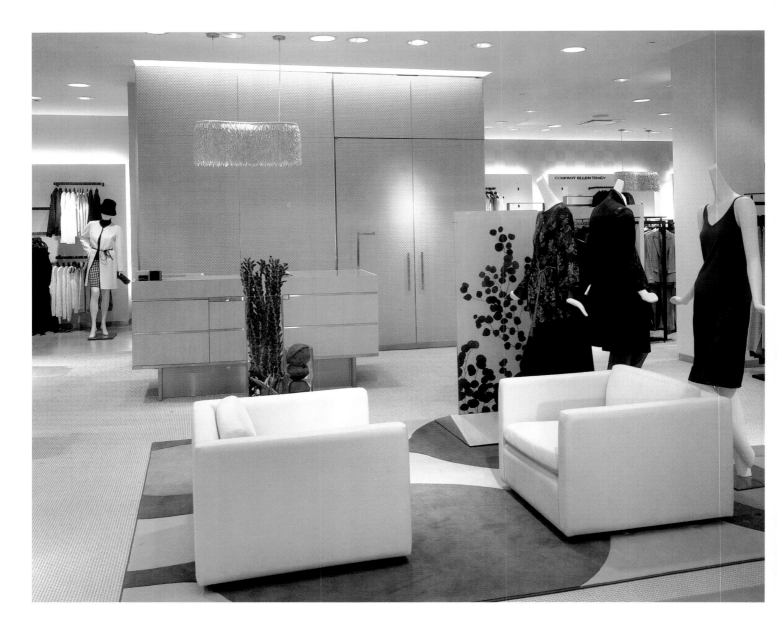

and signature element of the new Atlanta store."

A broad aisle runs through the designer area on the second level and it is delineated by a unique crystal ceiling element—like a gentle rainfall of crystals—that is reflected on the floor that is set with an alabaster mosaic. Changing colors illuminate the walls and the handcrafted white circles-in-the-square-tiles. Warm "gouged" wood panels, natural fibers in neutral colors and custom designed rugs produce "an harmonious environment for the Women's Collection."

The contemporary department is bright and sparkles with color. The combination of gray concrete flooring accented with red porcelain tiled areas creates "a fresh and loft-like setting" for the clothes. An illuminated "runway" runs down the center of the department upon which featured outfits are laid. Surrounding the runway and sharing the selling floor with the shoppers are numerous red semi-abstract mannequins wearing the most desired outfits.

For this store the furniture selected was all design classics or special art pieces. "Visual elements are all nature inspired, warm and substantial to add texture and substance to a subdued 'museum quality' environment."

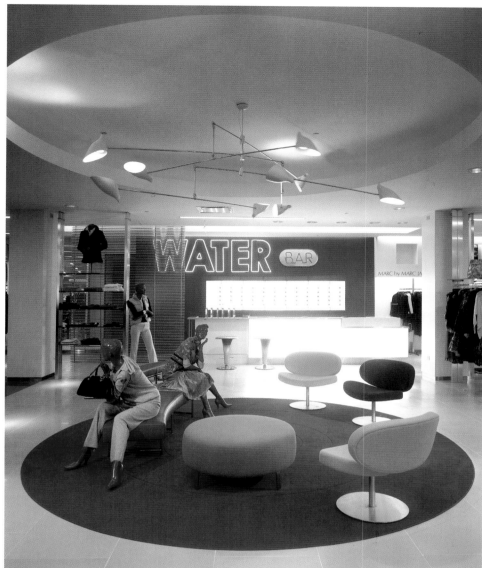

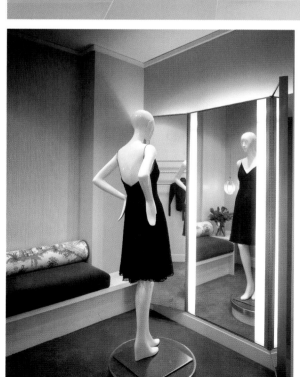

SFA ATLANTA LOWER LEVEL FALL 2004

SFA ATLANTA MAIN LEVEL FALL 2004

SFA ATLANTA UPPER LEVEL FALL 2004

FORNARINA

Via Dei Condotti, Rome, Italy

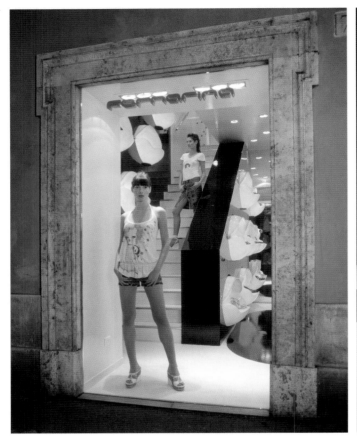 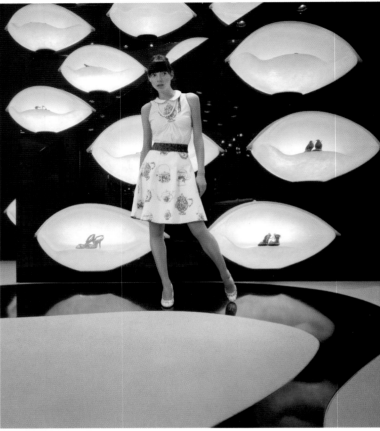

Giorgio Borruso, the multi-award winning designer and recipient of the Designer of the Year title, has created many noteworthy projects—many of which we have been pleased to bring to you in our magazine and our books. As a follow-up to his head-turning, gasp-worthy, super, super spectacular Fornarina shop in Las Vegas that picked up almost every design award available, he now has completed a Fornarina shop in Rome. For what he did and why and how—we turn this page over to him.

"This project for Fornarina, the Italian retailer of fashionable women's apparel, shoes and accessories, takes place inside a 16th century building in Rome in a location that is considered one of the most prestigious in the world—Via Dei Condotti near the Spanish Steps.

"In this three level site of 1500 sq. ft. of retail space with 500 sq. ft. storage/office below, we needed to create breathing room, and a connection between floors. We sliced an oval-shaped opening through the ground floor ceiling, perceptually expanding volume. A dramatic scene is visible from outside, three pearlescent white 21 ft. lacquer panels, perforated by chrome rings, are suspended and run the vertical height between the two floors. To support this 772 pound structure, we had to create a steel bracing system with ribs extending from the ceiling vault down the walls of the upper level. Capping the ribs, which are covered in drywall, is a stainless steel channel into which the panels are inserted.

DESIGN: **Giorgio Borruso & Associates,** Marina Del Rey, CA
Giorgio Borruso
GENERAL COORDINATOR: **Buzzoni,** Rovigo, Italy
PHOTOGRAPHER: **Benny Chan/Fotoworks,** Los Angeles, CA

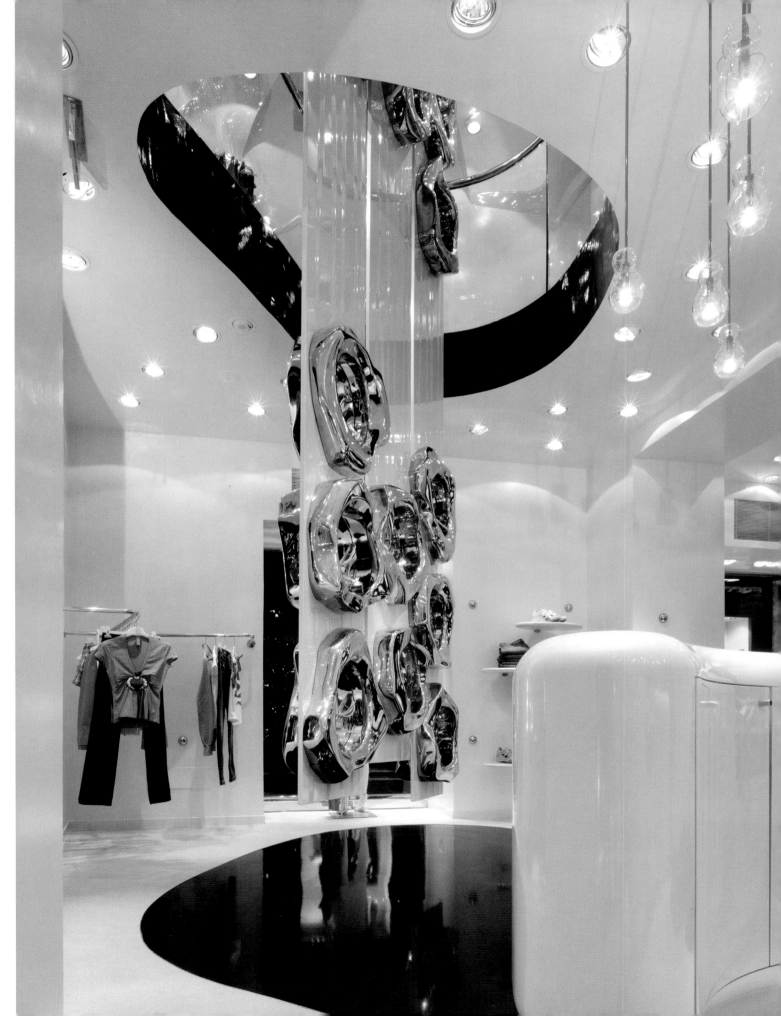

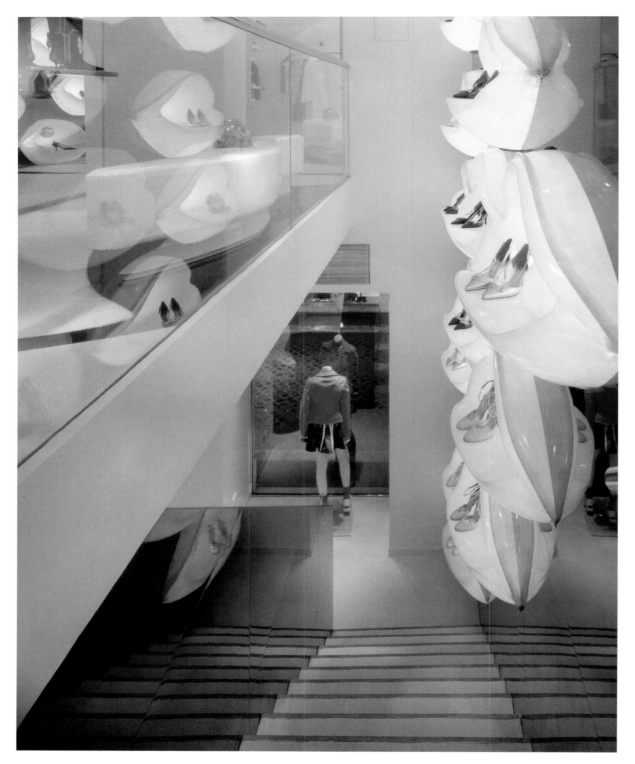

"From the entrance, is visible a back wall composed of a grid of black lacquer panels with groups of 'eyes' embedded. The 'eyes' flirtatiously hinge open and shut to display shoes and accessories. They also change color, alternating between white and rhodamine red, Fornarina's signature color. As you approach, this voyeuristic wall opens to become a staircase.

"In this project, there are two levels to read. On one level, you can read the composition of the architecture of the building, one element after another, arch, column, vault, etc. On another level, there are all the elements that define the language of Fornarina. But, it's like the two systems are not overlapping precisely. There is a disturbance. You have a

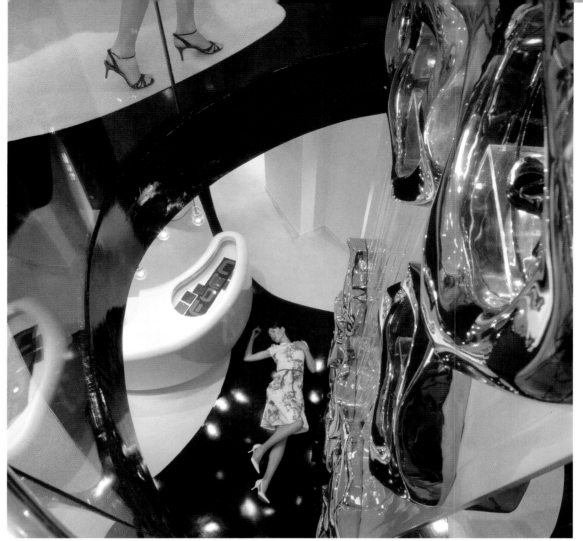

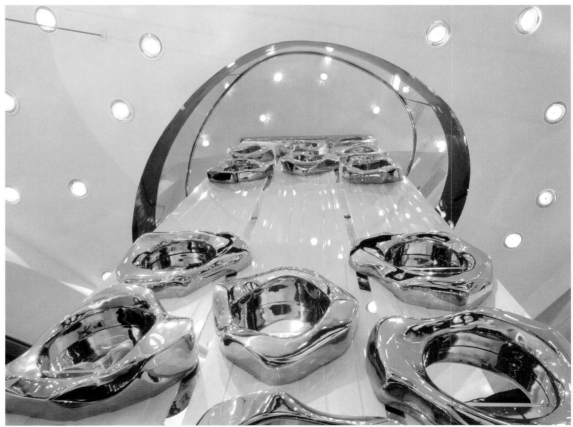

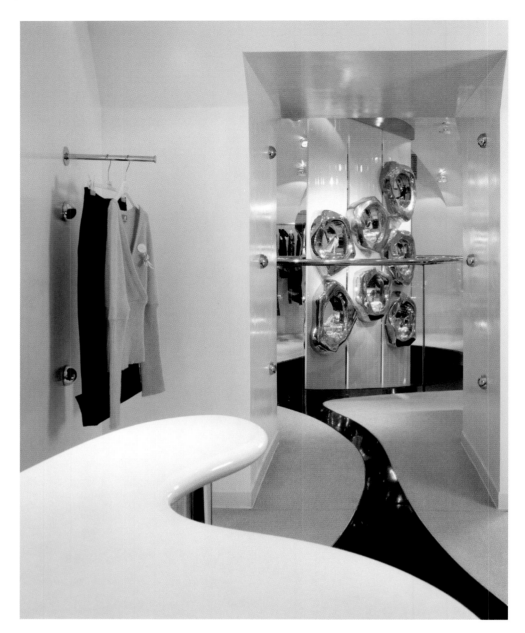

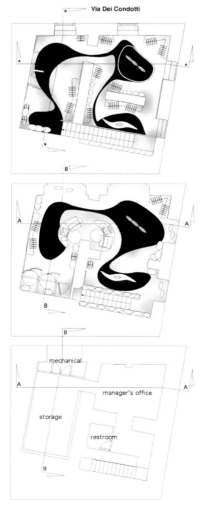

perception that each element of the Fornarina language is in the wrong place. Two mirrored cash registers are under an arch, in a passageway, a table in front of a mirror, etc. But this shifting between the two systems becomes a tool that allows us a sort of simultaneous vision. You can feel yourself immersed in the Fornarina world, but at the same time you are able to read the pre-existent architecture of the building.

"In an apparently random pattern, stainless steel knobs are embedded into the white-painted walls. These knobs pull out to reveal built-in receptacles for hang bars or rods that support organic shaped lacquer shelves.

"On the floor, curves of white vinyl and black resin flow through the space like a fluid—encouraging shoppers to move throughout the two levels. Around the opening on the second level, black resin pools as if to flow to the floor below. Illusion and surprise are pushing the visitors to move from one room to another, one floor to another—exploring—continuing the journey."

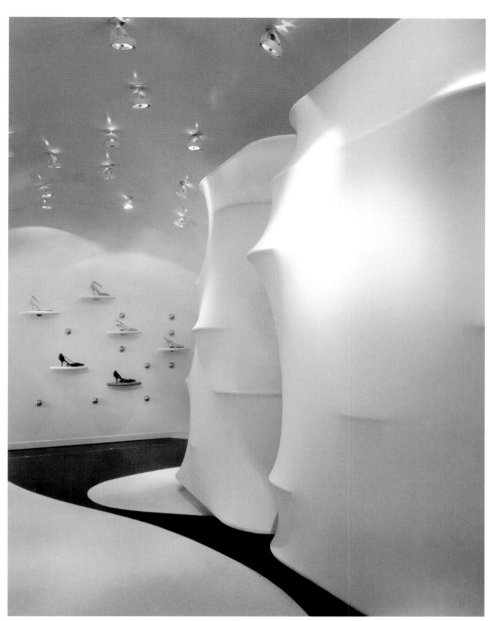

ALESSANDRO DELL'ACQUA

Madison Ave., New York, NY

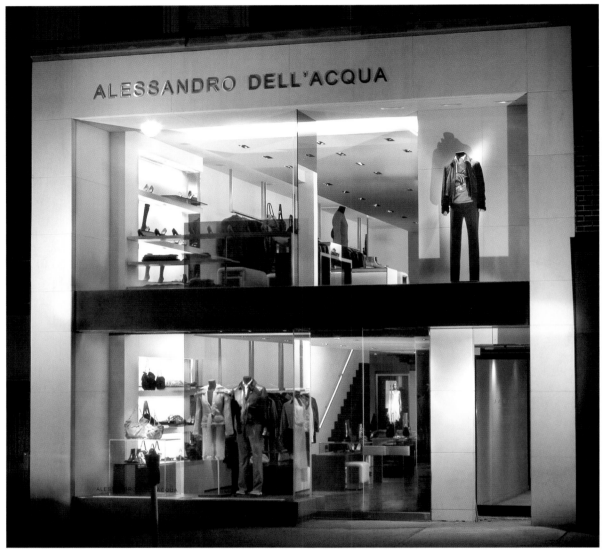

DESIGN: **TPG Architecture, LLP,** New York, NY
PHOTOGRAPHY: **Mike Butler**

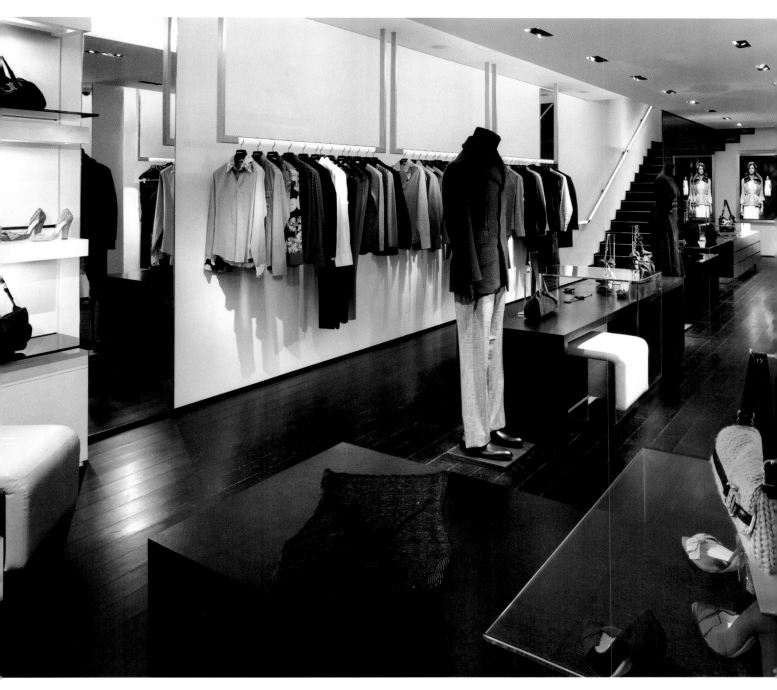

The 2600 sq. ft., two level Alessandro Dell'Acqua boutique is located on Madison Avenue and as designed by TPG Architecture of New York—the space was inspired by the black and white cinema of the forties. The shop was to be "simple, austere and clean-lined—but with a twist." The façade with its two story high glass windows puts the entire shop on display on Madsion Avenue and the store interior is seen through a framework of white stone accentuated by a black band that separates the two levels. Custom designed clear resin manne-

quins "seem to be suspended in mid air" and they feature the latest in the men's and women's wear.

Inside, the space is all white and black. The floor is African Wenge wood that has been stained black—"sophisticated yet surprisingly warm." The walls and ceiling are warm white with the black repeated on some of the low profile wood cases and on the steps of the cantilevered staircase that are also the stained Wenge wood. The wood stairway is balanced on the opposite side by a translucent, tinted glass balustrade. "Clear resin hang-

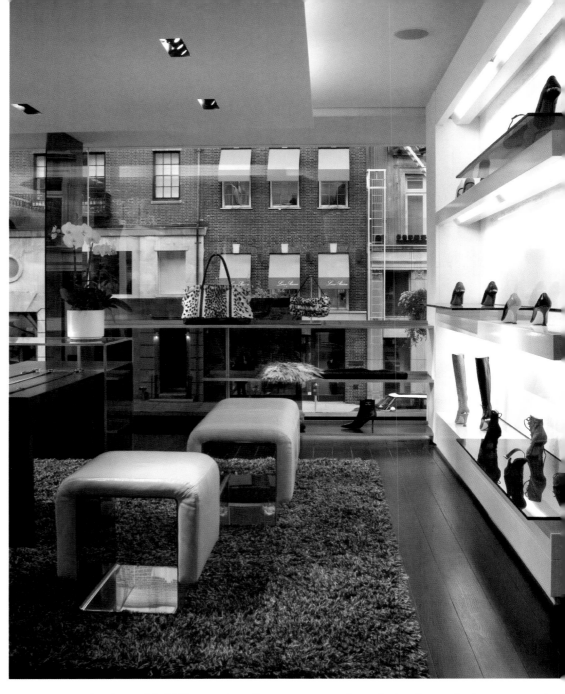

ing bars with LED crystals radiate white light during the day and glow colorfully at night—complementing the collection and providing a playful source of illumination." Focusable recessed ceiling lamps not only highlight the displayed garments but also add to the romantic yet dramatic ambiance.

Throughout both levels of the shop there are elegant benches and stools covered in natural leather and highlighted with stainless steel. These are provided for the shoppers' comfort and to personalize the visit to the space. The fitting rooms seem to carry through the cinematic theme as they welcome the shoppers to "the breezy opulence of a Mediterranean villa or the urban chic of an upscale Roman apartment."

HERMÈS

LIAT Tower, Singapore

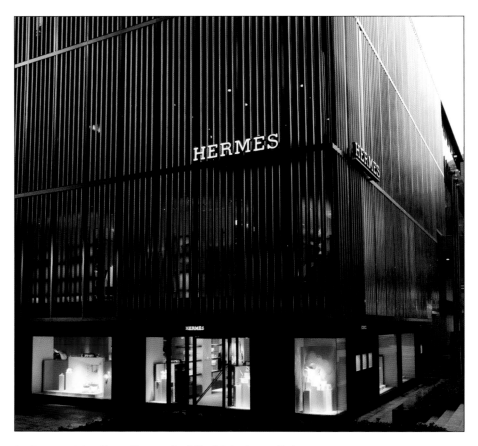

ORIGINAL DESIGN: **Rena Dumas Architect Interieure,** Paris
EXECUTION: **Atelier Pacific,** Hong Kong
PHOTOGRAPHY: **Courtesy Hermes South East Asia PTE.**

At 485 sq. meters, or approximately 5,000 sq. ft., this Hermès boutique, located in the LIAT Tower on Orchard Road in Singapore, is one of the largest in this region. The space includes two levels of retail as well as a VIP/exhibition area. The original design is by Rena Dumas of Paris, the original Hermes design firm. Atelier Pacific was called upon "to arrange for site surveys, collating background site information, sourcing and coordinating local consultants, and product managing the tender award and construction process through to a successful completion and store opening." Since so many fixtures and fittings were produced overseas "our coordination role was of the utmost importance to ensure the smooth realization of the store."

The exterior facade is "the most visible and unique aspect of the store." It consists of numerous strips of aerodynamic aluminum fins that can be adjusted, per floor, to suit the user's requirements." This multi-faceted façade conveys the idea of protecting the inner private space while—at the same time—providing an openness to the outside also allowing light to flood into the store as required. The shop's interior is warm, rich and quietly elegant. It follows other Rena Dumas designed shops in the use of fine cherry wood fixtures, fittings and cabinetry accented with nickeled brass hardware. These are set off by the light colored Armourcoat polished plaster walls.

A sweeping staircase leads shoppers from the ground level up to the first

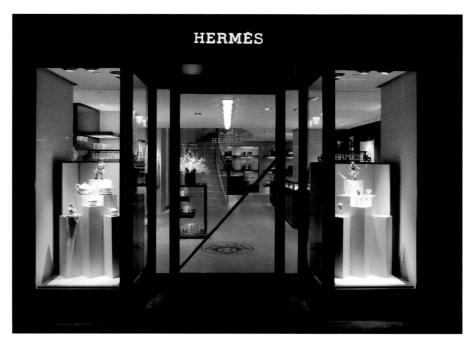

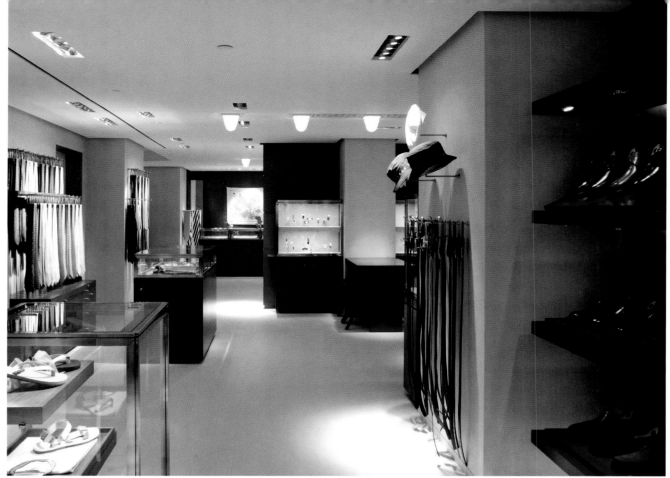

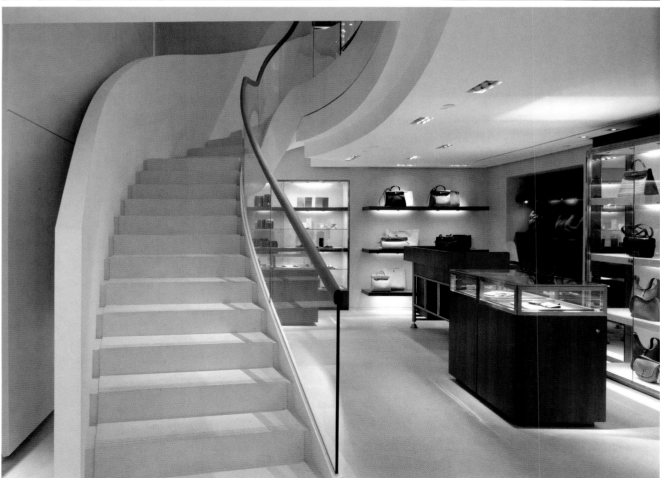

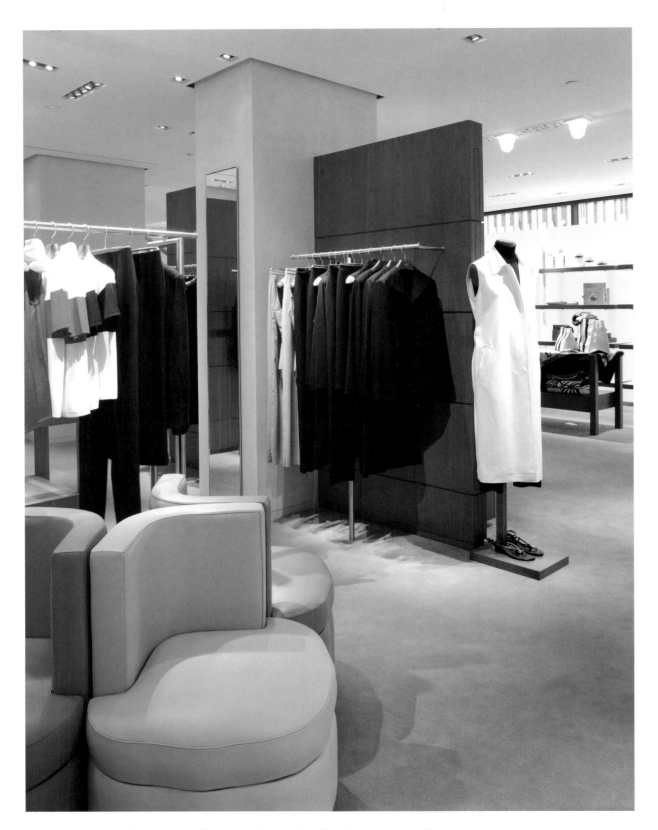

level where the ready-to-wear fashions are on view. Though the ceilings are low, the off-white floor, walls and ceiling enhance the feeling of spaciousness. Leather chairs and stools in deep, burnished red-brown are scattered throughout the men's area while white and red leather seating in the women's sector creates friendly groupings. Throughout, the colors and materials "enhance the luxury of the space within the shop and the merchandise on display."

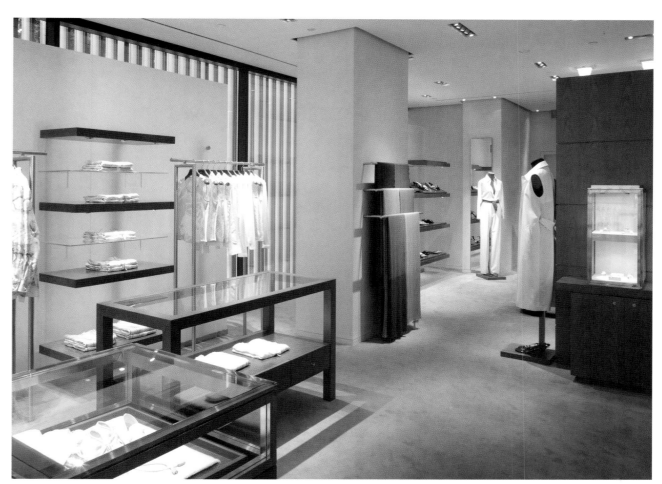

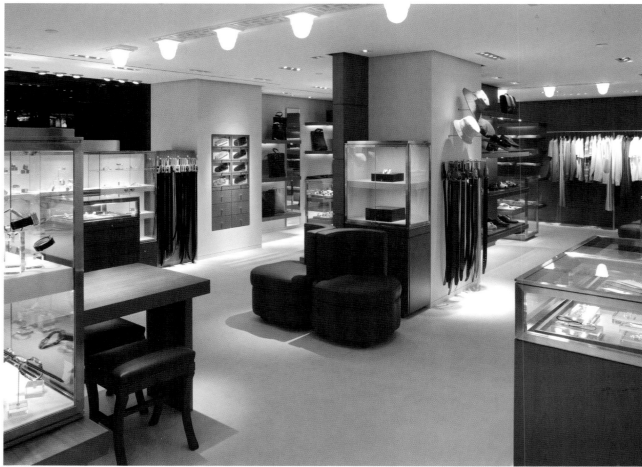

SPAZIO A

Florence, Italy

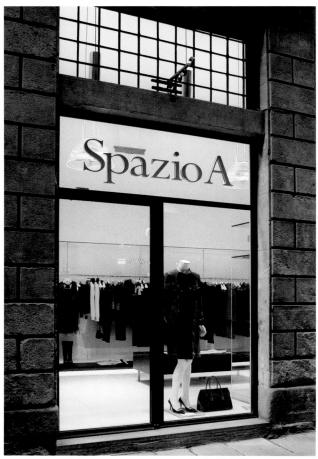

Spazio A is a boutique, in Florence, Italy, that caters to the "high-end, women's designer clothing shopper." Housed in an arcade of a 16th century palazzo—off the Piazza S. Trinita and across from the Ferragamo Palazzo—the shop was designed by David Ling Architect of New York. In it are products designed by such notables as Moschino, Alberta Ferretti and Narciso Rodriguez.

According to David Ling, "It was conceived as a series of glass boxes inserted into the Palazzo arcades." Through the two story high arched window openings, shoppers on the street have a semi-hidden view of the high ceiling interior. "Within each arched opening a waterfall—sandwiched between scrim—veils the view inside as runway shows are projected on the rear surfaces." Near the entry is a glass stairway that leads up to the partial mezzanine where the fitting rooms and offices are located. The staircase is set between supporting glass

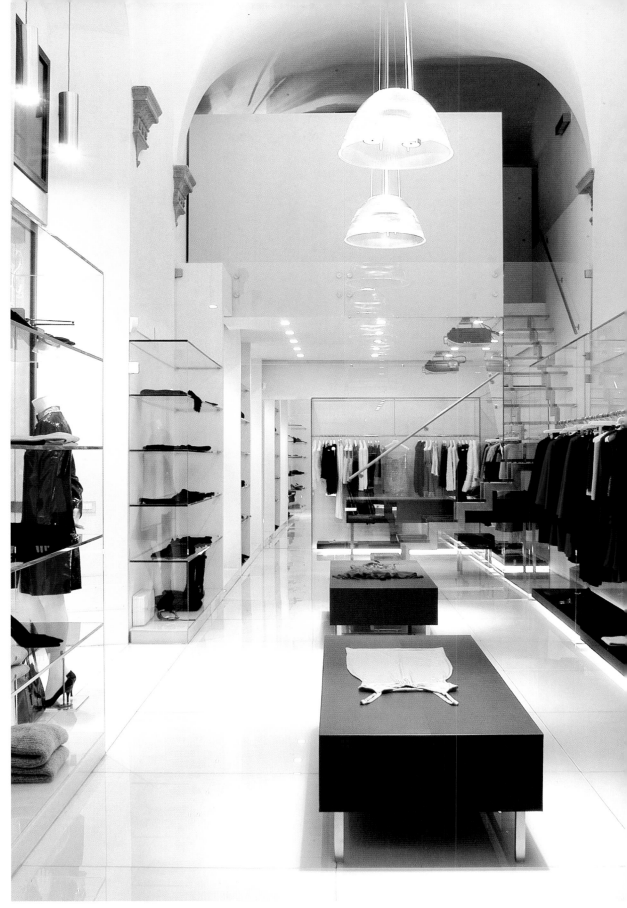

DESIGN: **David Ling Architect,** New York, NY

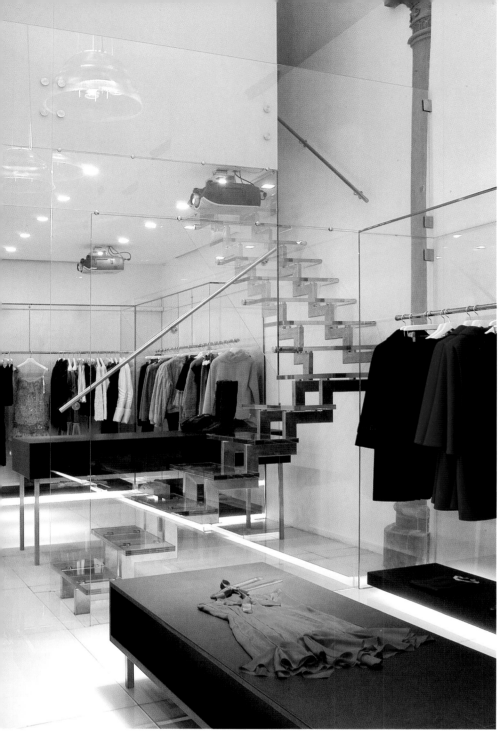

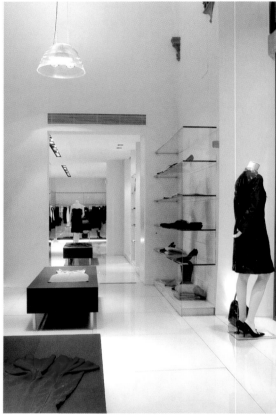

planes in the vaulted space. The ceiling is painted plaster over the original stone vaulting and the glass floor is painted to match the cream-colored wall surfaces. It continues the designer's "all glass theme" that is introduced in the individual "glass boxes" that create the mini-boutiques within the boutique. They house the garments by the designer/brands: Gaultier, Moschino, Rodgriguez and Ferretti. David Ling says, "To further

the client's 'brand image'—since there are multiple brands—my concept was to both delicately define and separate individual collections while unifying the space—as well as lighten the already narrow space—with glass fixturing."

Contrasting with the cream colors and the glass are the ebonized walnut fixtures and the cash/wrap. The fixtures and the furniture were all custom designed by Ling. He specified

clear tempered glass, nickel hanging rods and leather display bases for the fixtures. Padded leather and nickel were used for the cash/wrap and the furniture.

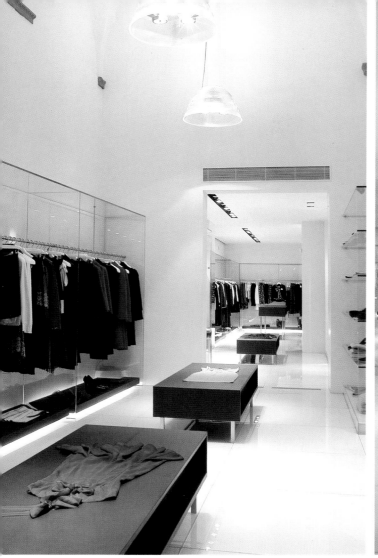

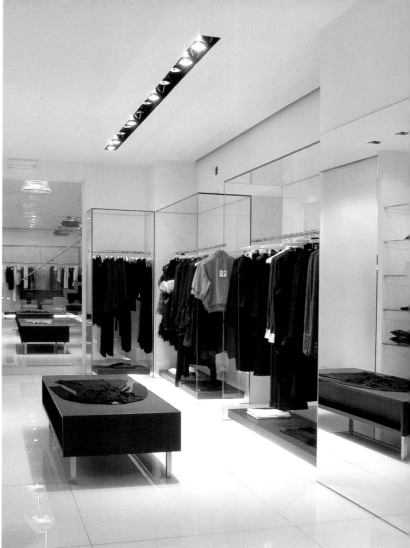

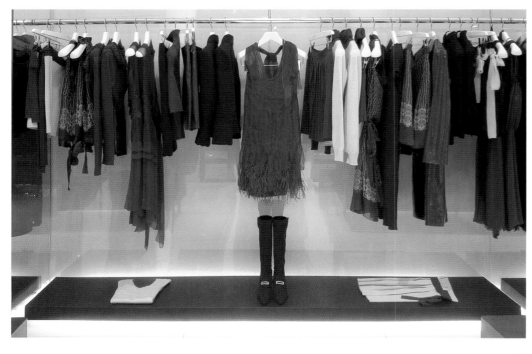

HARVEY NICHOLS: MEN'S DEPARTMENT

Knightsbridge, London, UK

The task of refitting the 1200 sq. meter (12,700 sq. ft.) space in Harvey Nichol's Flagship store in Knightsbridge fell to Dula. The noted fixture/fitting designer and manufacturer worked closely with the client and HMKM of London who provided the interior design for the layout of the basement level.

This area houses HN's Menswear and it is broken up into several smaller spaces with low ceilings. The challenge was to refurbish this area in phases so that business could go on during the renovation and to assure that the department would have a better and more upscale ambience as well as customer flow pattern. The merchandise here is targeted at the more "up market" shopper and it is stocked with high-end brands and designer names as the attraction. Throughout, the design-

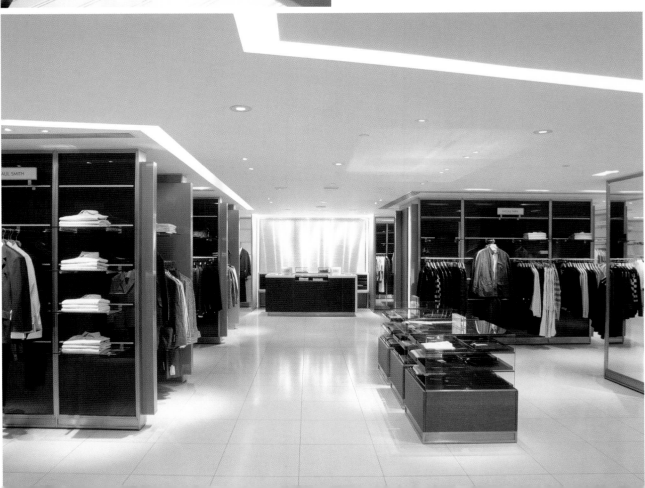

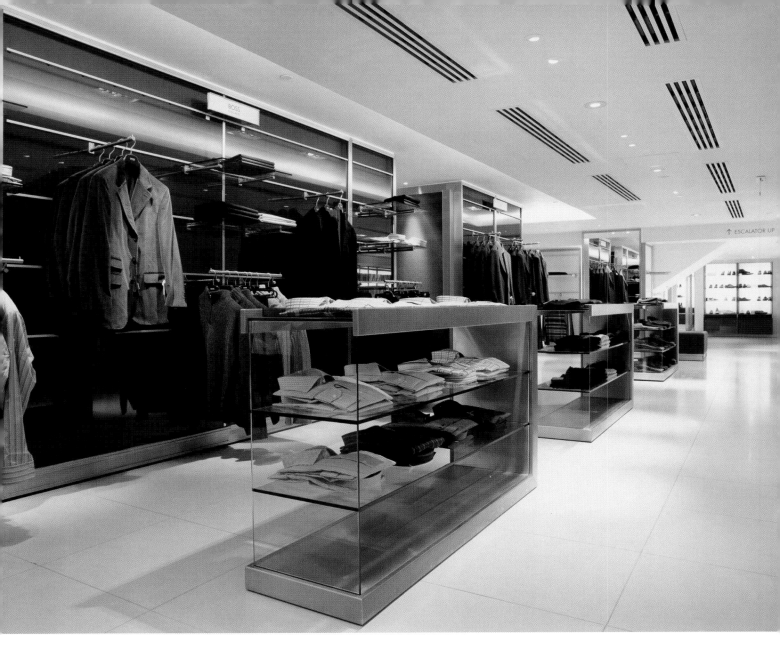

DESIGN: **Hosker Moore Kent Melia (HMKM),** London, UK
PROJECT MANAGER: **Keith Ivemy**
FIXTURES & FITTINGS: **Dula,** Dortmund, Germany
PHOTOGRAPHY: **Courtesy of Dula**

ers specified polished plaster and rout-ed timber for the walls, high gloss lac-quer finishes and polished Wilsonart laminates for the floor fixtures.

The descent to the lower level of the store is enhanced by the see-through acrylic walls of the stairwell that makes the space below seem more open and inviting. The light-colored stone floors, the white ceil-ings and the wide open, uncluttered and un-merchandised areas all further the "open and inviting feeling." The recurring vertical lines, emphasized in the wall systems, seems to "raise" the ceiling to a more comfortable height. Framed mirrors, freely interspersed amid the wall fittings, add to the sense of spaciousness and they help to

disperse the light to enhance the open feeling. Ceiling washers and warm, flattering downlights also enhance the ambience as do the back-lit, glowing walls in the shoe and sunglasses areas.

The free-standing fixtures are low and the headless mannequins stand on the floor and are used to "introduce" the various merchandise categories in the department. They also add to the illusion of a higher ceiling. Through-out, there is a feeling of elegance, refinement and sophistication due largely to the overall design of the set-ting, the light and neutral palette, the effective lighting plan—and the open-ness of the layout.

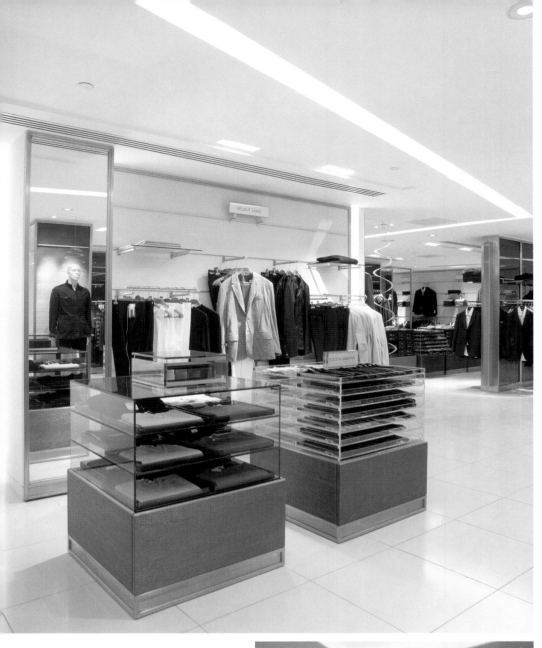

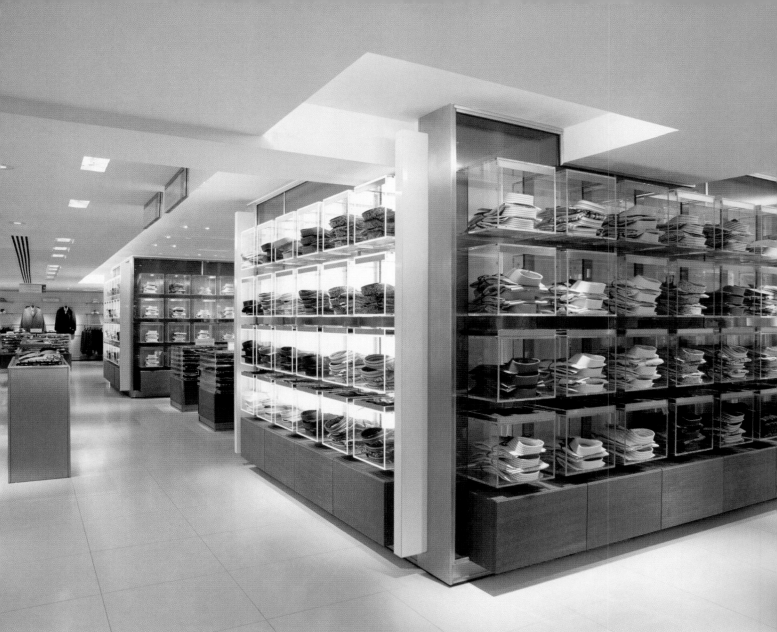

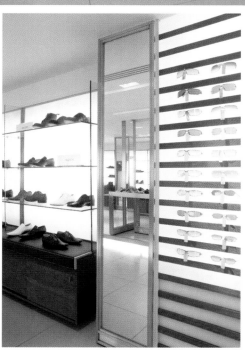

OZWALD BOATENG BOUTIQUE

Selfridges, Oxford St., London, UK

Ozwald Boateng is a "bespoke (custom) couture" manufacturer of men's wear and for their concession—or vendor's shop—in Selfridge's men's wear department in the London flagship store on Oxford St., they commissioned Checkland Kindleysides to design the space. "Our design brief was to design an environment which would develop the Ozwald Boateng brand as the authority in style and Saville Row tailoring; presenting the brand's ready-to-wear alongside their made-to-measure service."

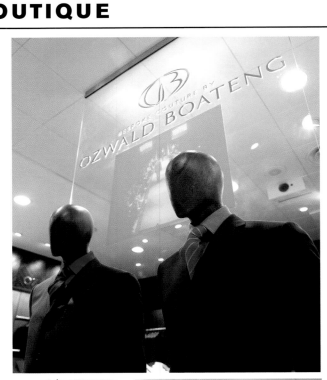

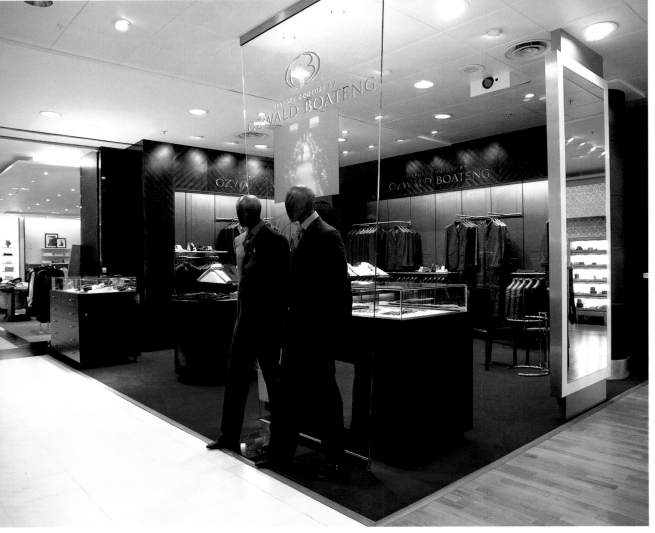

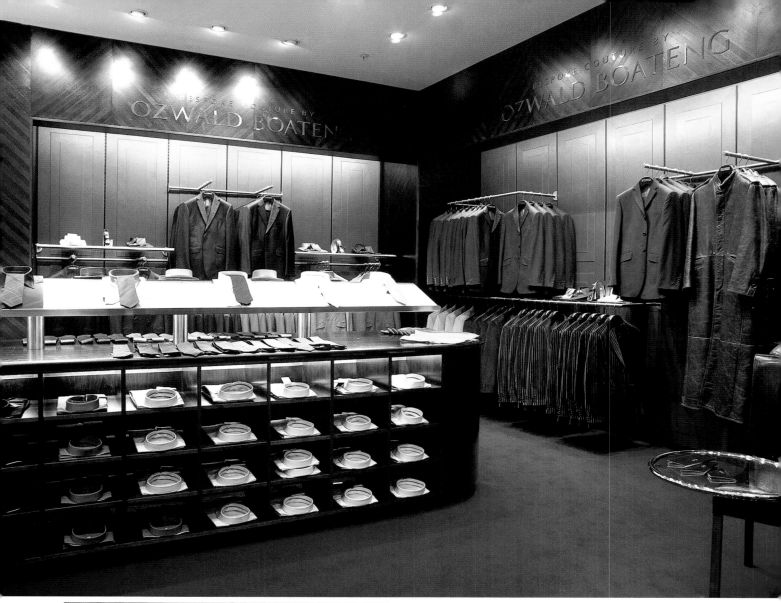

DESIGN: **Checkland Kindleysides,** London, UK

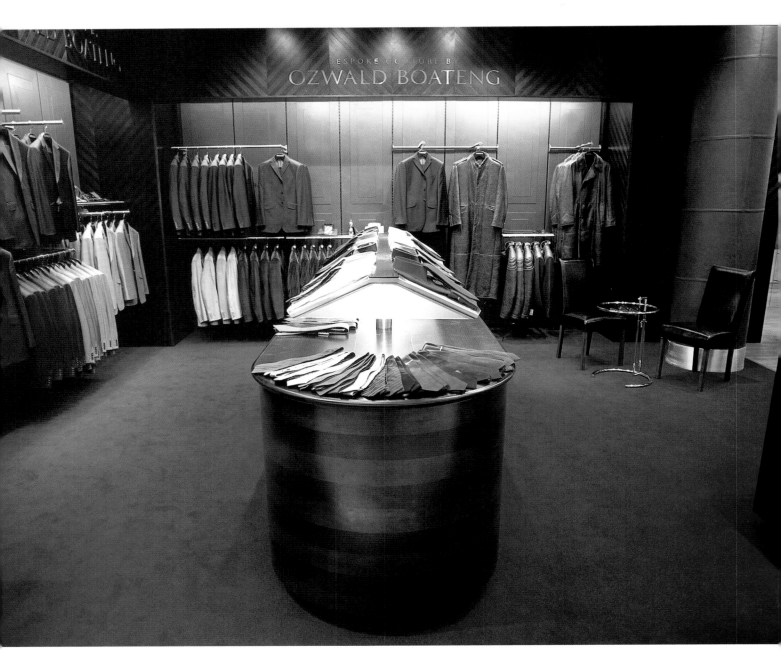

It became the task for the design firm, in the open on three sides, 420 sq. ft. space, to express the client's "passion for color, heritage, modernity and Saville Row etiquette"—in an environment that would suggest a modern gentleman's club where quality and luxury are felt in the design details and the materials used.

This new shop-within-the-shop is targeted at young, discerning men "with a distinct sense of style and color." Injecting movement and vibrancy—and sort of defining the open space—there is a clear glass panel on one side, off the aisle, that carries the Ozwald Boateng logo. On a panel beneath it is projected film footage of the designer's fashion shows. Ozwald Boateng's signature herringbone detail appears on the wood enclosures that frame the garments along two walls. The backs of the walls are covered with rich, ocher leather panels and they are stitched in red to "suggest traditional English style." The jewel toned, ruby red flooring gives "a distinct Ozwald Boateng twist" to the shop.

Centered in the space is a display table with rounded ends. It is horizontally banded in two tones of dark wood and topped with an angled displayer unit upon which shirts and ties are presented at eye level. The angled unit serves as a "lamp shade" and the light source hidden by it seeps out to illuminate the ties fanned out around the tabletop surface. It makes "the perfect backdrop for the vibrant and colorful shirts, ties and accessories from the ready-to-wear collection."

Black leather chairs and chrome glass cocktail tables furnish the space, and in the consultation area shoppers may browse fabric books before being measured for their custom-made outfits.

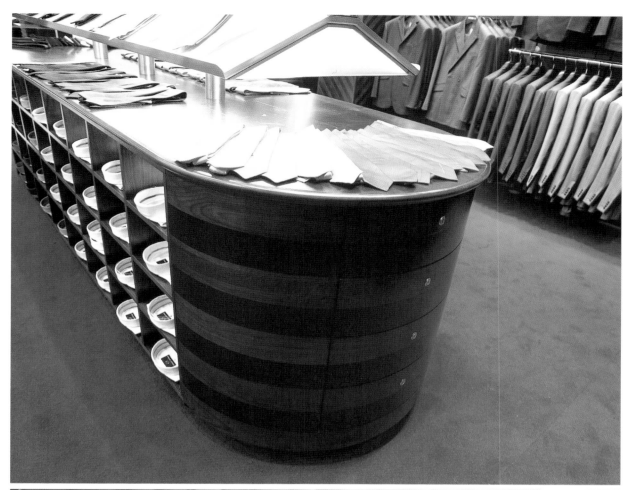

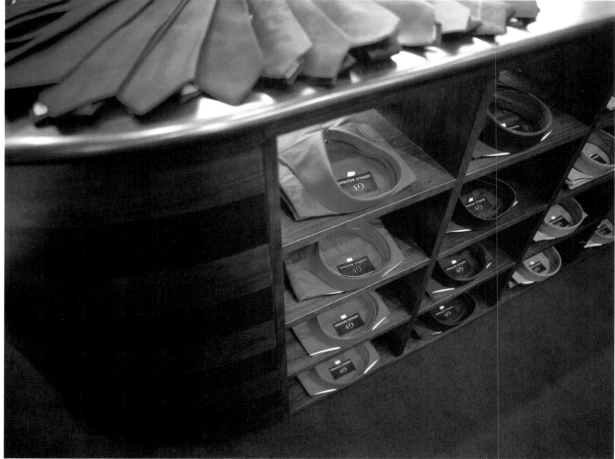

SMOO'TH

Turin, Italy

DESIGN: **Creapolis**, Milan, Italy
STRATEGY: **Massimo Fabbro**
DESIGN CONCEPT: **Mauritzo Favetta**
PROJECT LEADER: **Camilla Croce**
DESIGNERS: **Katerina Kaza & Valentina Bertolini**
DEVELOPMENT COORDINATOR: **Arch. Nicola Golfari**
LIGHTING: **Pollice Illuminazione**
PHOTOGRAPHER: **Ilvio Gallo & Barbara Bozzi**

Creapolis is "a multi-discipline creative company that carries out architectural space projects by complementing the visual and styling works with accurate strategic and research activities." This relatively young, Milan-based company turns their projects into "sense-making experiences" by combining design, architecture, consumer strategy, environmental graphics, in-store communication and multi-sensory and interactive techniques. All of this brings about "Physical Brand Delivery" which, they say, is "the ability to represent the world of a brand in all the physical locations where the company and outside world meet." This is what they did for Smoo'th.

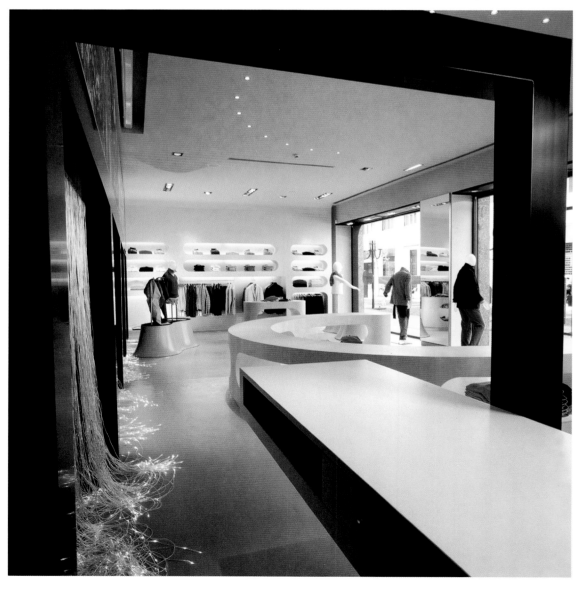

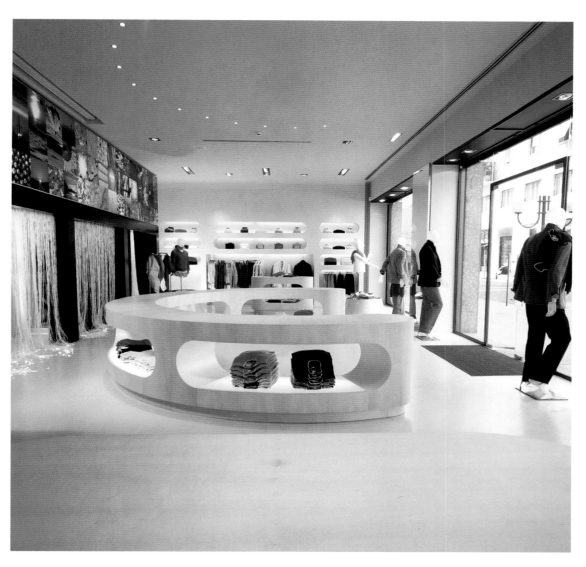

"Smoo'th is soft, cozy and enveloping!" This new brand of menswear "runs against established trends challenging the conventional image of basic rigor that characterizes casual fashion for men." With this, Smoo'th's first showroom, the designers of Creapolis presented the new brand as "soft, non-aggressive" and with an almost sensual approach to the traditional market—"the women who often act as the efficient and qualified shopping consultants."

Specially designed mannequins, reminiscent of the Bauhaus and the Transavangarde, are made of reinforced polystyrene and wear the clothing in a rather "bizarre" way in the windows that rise from the floor. The interior of this over 2000 sq. ft. space on a busy pedestrian street off the Via Roma in Turin, is a perfect rectangle: "the ideal to focus all the environment at a single glance." Upon entering the shop there is a wide, circular piece of furniture " that embraces the central area and provides the first impact presentation of the collection." It is the main square—the meeting place: it is the "key reference" to the entire space. The

maple wood of the unit blends with the other surfaces that are finished in ocher resins.

The merchandise is arranged in the walls of the shop rather than on them. According to the designers, "The display walls run seamlessly from floor to ceiling, holding the items in shaped niches with suitable back lighting." Everything is made of medium density fiberboard, finished with resin materials of the same color as the floor. The products stand out in their shadow boxes as well as integrate with the architecture. The upper part of the almost 50 ft. rear wall is an "image poster": a backlit screen upon which is projected "snapshots" of everyday life shown in a gradual transition from violet through blue, green, red, orange and yellow —and then back towards the same chromatic shades. A dropped ceiling, just in front, hides a screen that is sometimes used for video art productions specifically created for the brand. The black openings below, covered with "cascades of optical fibers," serve as the entries to the dressing rooms. These areas are enhanced with wall paintings—to keep the shopper interested as he tries on garments.

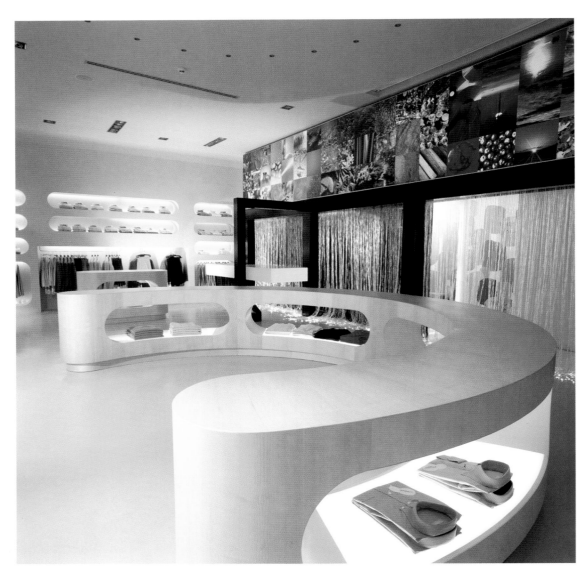

Massimo Fabbro, who created the "strategy" for this shop explains, "Adapting the sales point as an integrated design and communication project, with an intent of protagonism, the shop identity emerges as 'Communication Strategy'—as an authentic project for the creation of the 'Brand Concept.' The space and functional concept goes beyond all aesthetic considerations, establishing itself as a Brand. The store is the brand itself—its image—its world of reference. Clothing, atmosphere, materials and architecture meet into a unique surprising project of design and communication. The visual and sensorial experience of the environment is perceived by the customer as one single reference image—complete and exciting. Each element is part of the Smoo'th world—which is the showroom—which is the Brand materializing in space."

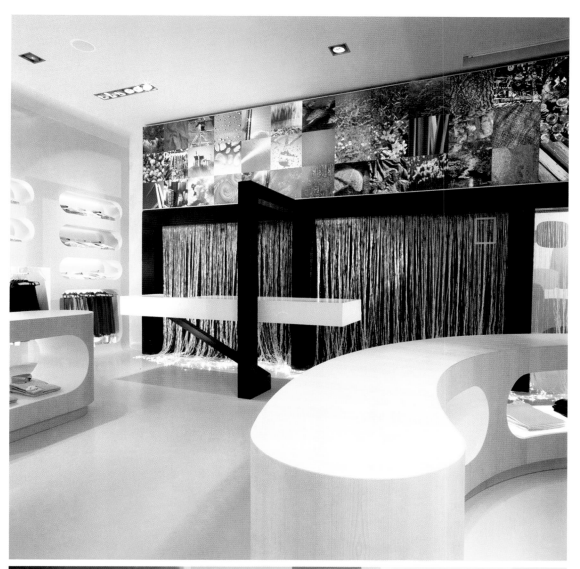

PAMELA SCOTT

Dundrum Shopping Centre, Dublin, Ireland

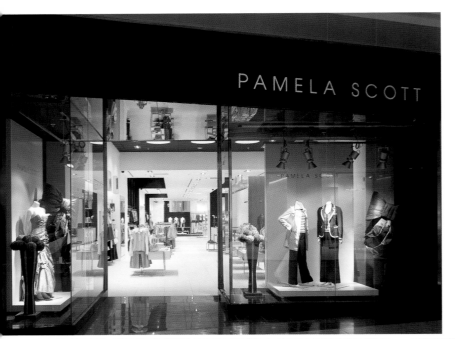

This privately owned women's fashions business, which has been operating throughout Ireland for over 20 years, wanted to create a new concept for their retail identity, to promote their new flagship store at Dundrum Shopping Centre, Dublin.

Aware of the very strong fashion mix proposed for Dundrum, Pamela Scott wanted to re-position their offer, with more authority and sophistication, to attract younger customers to their Hilfiger and Esprit offer, while retaining and enhancing their core product ranges of Bianca, Gerry Weber, Betty Barclay and own brand eveningwear and occasion wear. Aware that Hilfiger and Esprit would be opening stand-alone stores at

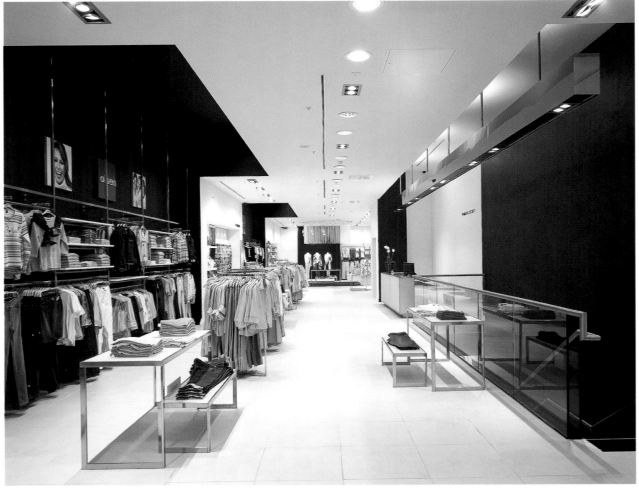

DESIGN: **Dalziel + Pow,** London, UK
DIRECTOR: **Keith Ware**
INTERIOR DESIGNER: **Paula Ives**
INTERIOR DESIGNER: **Andy Piepenstock**
GRAPHIC DESIGNER: **Akiko Shishido**
PHOTOGRAPHY: **Peter Cook**

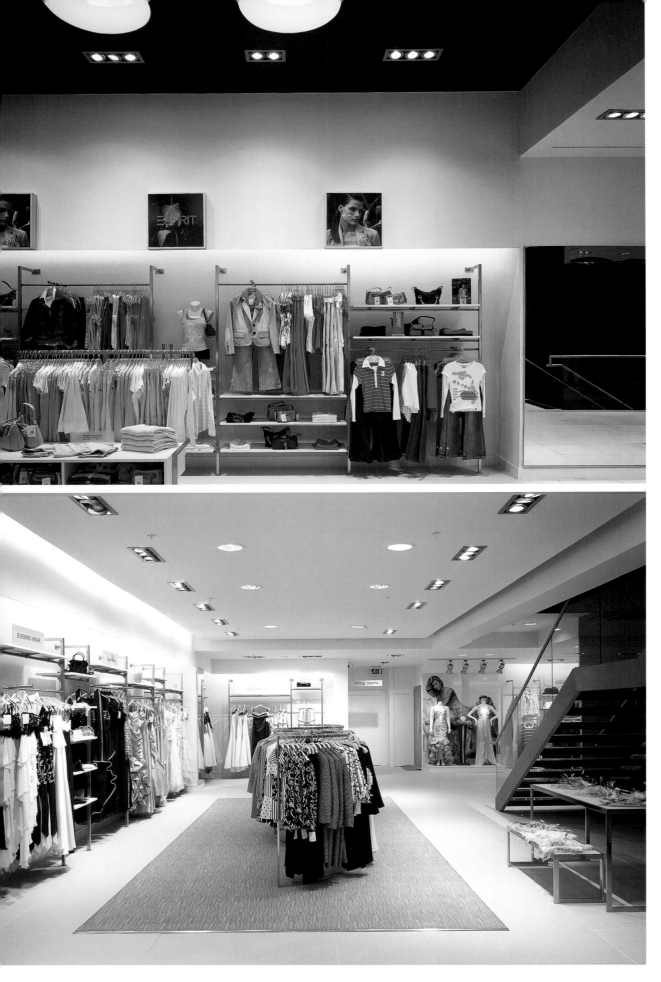

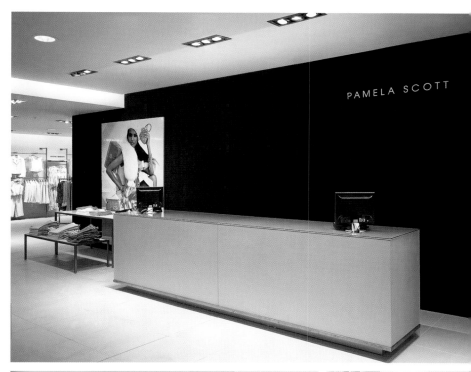

Dumdum, the challenge was to create an environment that would promote the existing brands alongside the new brand product ranges of Sophie B and PS, enhancing the overall offer for existing and new customers alike.

Dalziel & Pow created a dramatic, theatrical shopfront and window display, to differentiate Pamela Scott from its competitors within the mall. To achieve this, a back painted glass fascia and lobby soffit were combined with polished black granite floor tiles, contrasting against white high gloss display plinths within the windows. Narrow beam suspended spotlights provide a very dramatic lighting solution which plays up the rich fabrics and colors of the product offer.

The new store operates over 7200 sq. ft. on two floors. The ground floor appeals to a younger customer and provides branded room sets, which break down the offer and adds pace to the long and narrow layout. The room-sets are designed to showcase each of the brands alongside Pamela Scott's own label product and accessories. A bespoke feature chandelier was created as a focal point within the Betty Barclay room, to draw customers through the length of the store.

Dalziel & Pow introduced a new dark aubergine signature colour which is used throughout the interior finishes and links to the new logo, bags and swing tickets designed as part of the overall retail identity. Torn aubergine coloured wallpaper is used as a feature finish on the staircase wall, leading down to the basement, which houses a more formal offer of occasion and eveningwear.

The basement, which features a

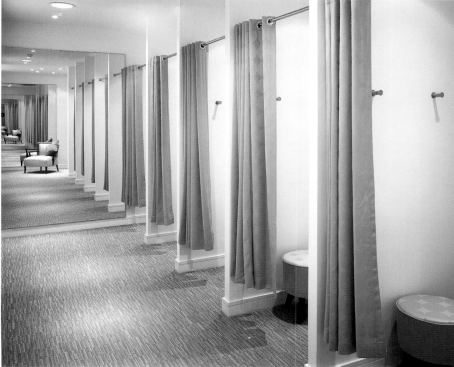

subtle pistachio colored carpet and a frosted glass cash desk together with a lowered ceiling, helps to create a more intimate and calmer atmosphere, supporting the more considered purchase.

Parts of the new identity are already rolling out to other new Pamela Scott stores throughout Ireland, including Mahon Point and Cork.

FOREVER 21

Powell St., San Francisco, CA

DESIGNER/ARCHITECT: **Gensler**, San Francisco, CA
Client's Design Team:
CONSTRUCTION: **Brian Chung**
INTERIOR DESIGN/STORE PLANNING: **Amir Taj**
VISUALS: **Vicki Eshelman**
STORE DESIGN: **Sayuri Takeda**
INTERIOR DESIGN: **Monique Lee Kim**
PHOTOGRAPHY: **Sherman Takata**, Gensler, San Francisco, CA

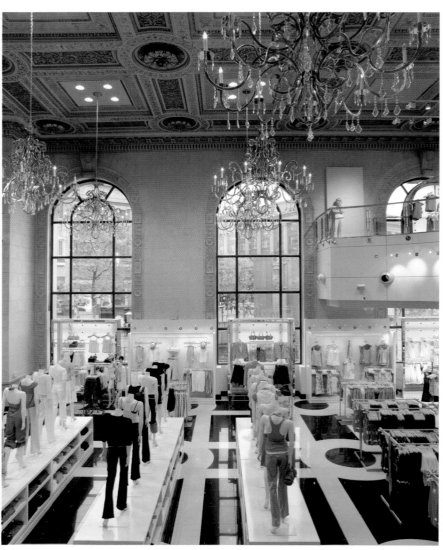

The 1921 building located at One Powell St., in San Francisco, is alive and well and now the thriving flagship store for Forever 21—a retailer for "savvy trendy shoppers." Gensler Architecture, Design & Planning Worldwide, has restored and converted the cavernous 100,000 sq. ft. space into an eight story building that includes three floors of Forever 21 and five floors of condominium residences above. "The renovation of One Powell is a strategic component in San Francisco's civic improvement plan. Restoring the historic elegance of One Powell has enhanced this important pedestrian corner." Scott Dunlap, Managing Director of Gensler's San Francisco office adds, "The retail presence in combination with the apartments adds a fresh new dynamic to the area for tourists and residents alike."

The landmark bank building maintains its original American Renaissance facade as well as many of the note-

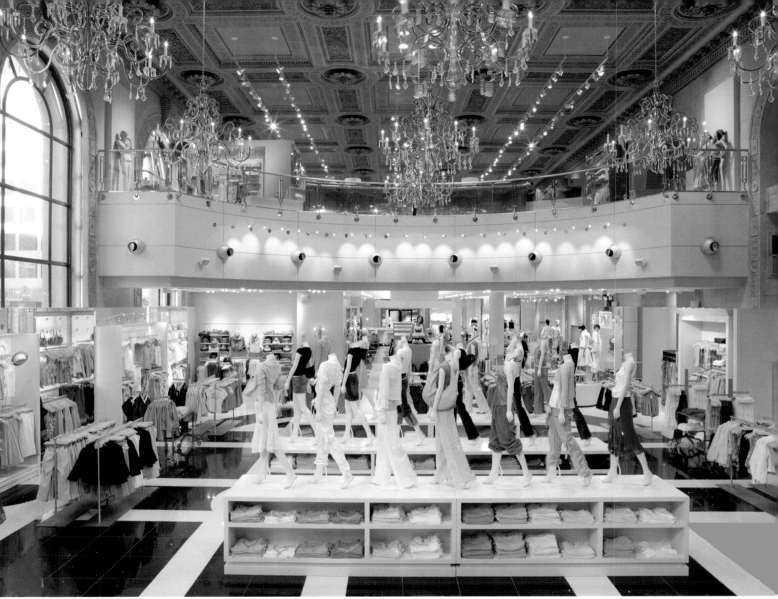

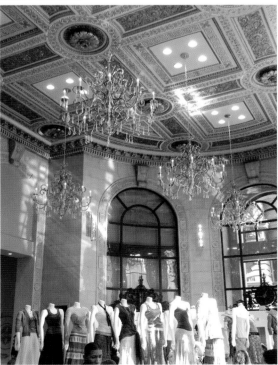

worthy features of the original grand banking hall. Forever 21 takes up 30,000 sq. ft. of ground floor, mezzanine and the third floor and they maintain the building's ornate main entrance. Maureen Boyer, the project Manager for Gensler said, "We found ways to maximize the space, making it practical and usable by today's standards while respecting and enhancing the historic structure. A priority was to leave the stunning original Italianate ceiling, floor and walls fully exposed." The mezzanine was extended to turn it into a functioning second level. Larry Meyer, Sr. VP of Forever 21 said, "Our interior design team together with Gensler created a spectacular look and feel in the new store. We are known for our fast fashion and low prices, but customers also look

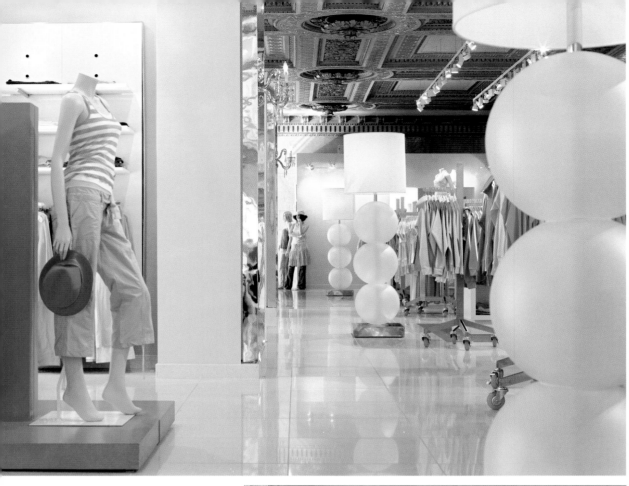

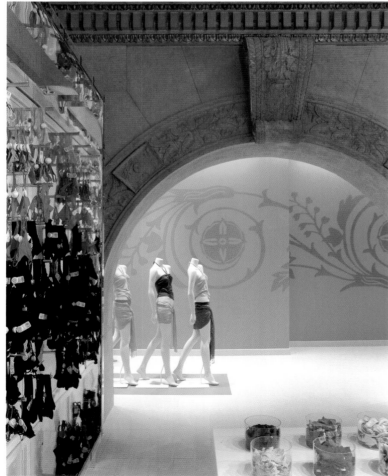

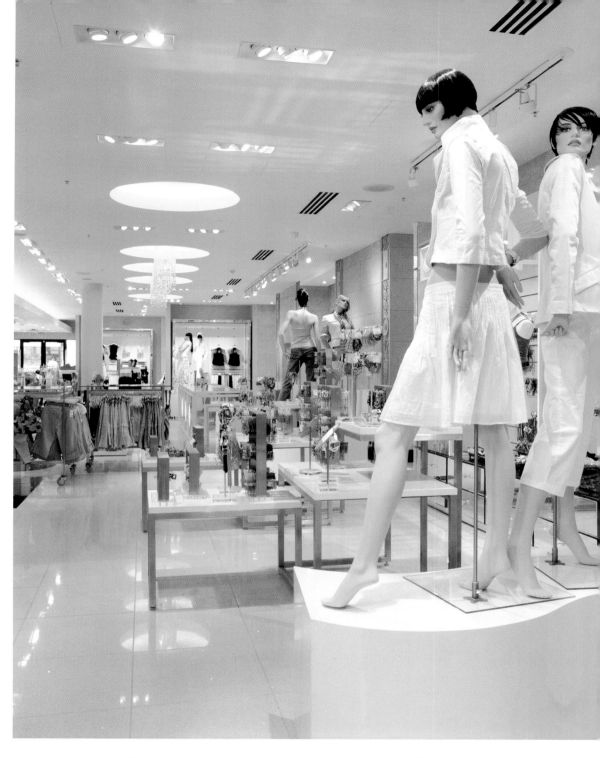

forward to the sophisticated shopping environments we offer as well."

Set into this jewel-box setting is a hip, energetic retail design. Giant custom chandeliers soar over the two story rotunda up front that complements and leads the viewer's eye up to the exquisitely restored ceiling. Arched display cases with reflective finishes follow the form of the building's original window frames—"respectfully reference historic characteristics of the building with modern punch."

"It's a testament to the creativity and ingenuity of the design team that they were able to build a space that mixes a new look with historic. Together we appreciate the 1920's building and worked to showcase it while maintaining Forever 21's well known sleek store design," said Maureen Boyer.

PLAYBOY

The Forum Shops, Caesar's Palace, Las Vegas, NV

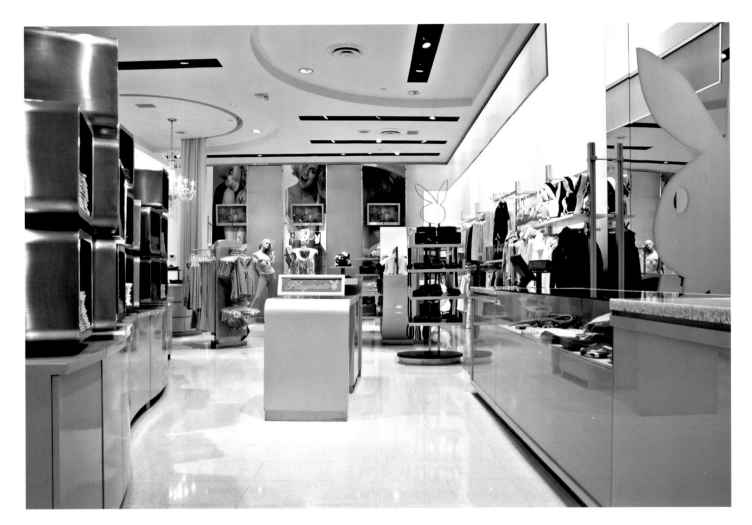

The challenge for the design team at The Walker Group of New York was "to leverage—on a macro scale—the legendary Playboy brand and the company's extraordinarily successful apparel line. As the design concept was conceived, the goal was to simultaneously appeal to a sophisticated and cultured female audience and to affirm and celebrate the internationally iconic brand."

Working closely with Christy Hefner, Jay Valgora of the Walker Group and his design team were able to fully realize her crystalline vision of a setting that "reflects the fun and fashion forward gestalt of the clothes." The design that evolved is "elegant, boldly sensual and utterly modern," and it

DESIGN: **The Walker Group,** New York, NY
DESIGN PRINCIPAL: **Jay Valgora**
STUDIO DIRECTORS: **Miho Koshido, Craig LasRosa**
DESIGNER: **Mohamed Gabr**
ARCHITECTURE: **IDS Architecture, Inc.,** Honolulu, HI
OUTSIDE DESIGN CONSULTANT: **SCA Design,** Henderson, NV

For the Client, **Waikiki Trading Group:**
PRESIDENT: **Jim Geiger**
CEO/CFO: **Al Cottral**
VICE PRESIDENT: **Frank Crowley**

PHOTOGRAPHER: **Eric Laignel,** New York, NY

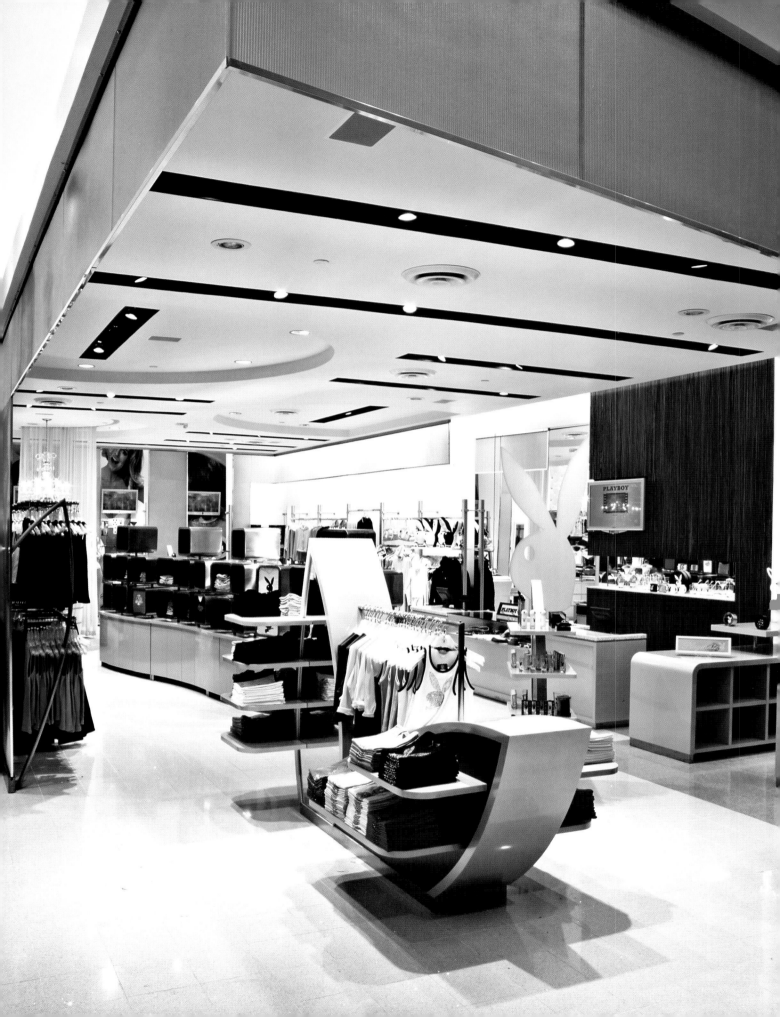

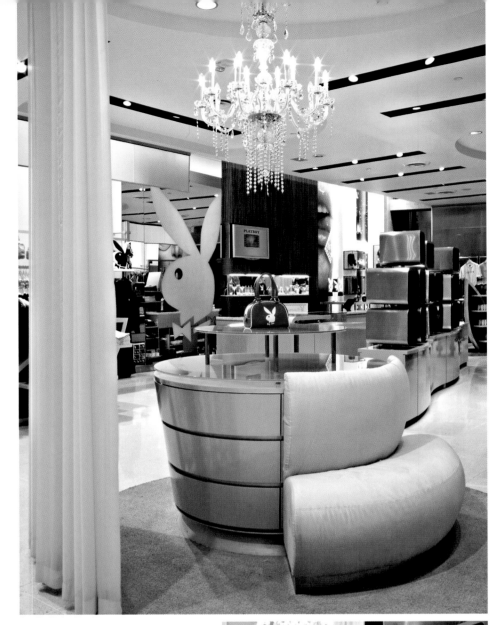

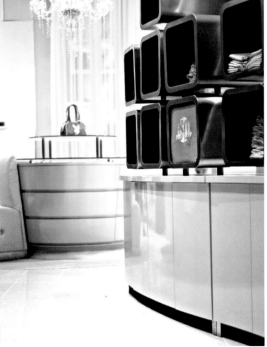

speaks to "a contemporary ethos of sexiness/sensuality that breathlessly invites and captivates both male and female audiences." This store's design will serve, in the future, as a prototype for freestanding and in-store shops with the lingerie targeted at trendy 18 to 25 year olds.

Since Playboy is a lifestyle brand, the designers felt that they needed to bring the Hugh Hefner/Playboy mansion and magazine culture into the design. "Environments offer one of the greatest ways to represent a brand, especially one like the Playboy that has such prominence and is so recognizable," said Valgora. The Playboy logo bunny is everywhere in the shop; appearing in various sizes, in various materials and often in unexpected places. From the Playboy archives there are graphic reproductions and even one-of-a-kind memorabilia.

The store is basically a composition of white on white contrasted with dark zebrawood that is currently "in" but that also recalls the 1960s and '70s—when the Playboy mansion was in its heyday. Also reminiscent of the mansion is the "window" behind the cash/wrap. It recalls the windows behind the Grotto Bar in the mansion—the pool area—and looking through that "window" one can see clips from Playboy's "After Dark" TV shows. Adding to the sexy/sensual atmosphere are the crystal chandeliers, the soft, see-through draperies, and a padded and quilted wall of white velvet. "The architectural elements that underscore the theme and augment the store's aesthetic include use of layers of frosted glass on the perimeter walls throughout the store; multimedia installations that provide customers with constantly changing images and morphing sounds; and cropped silhouettes and abstractions of the famously recognized Playboy Bunny employed to create an architectural language for the store's fixtures."

"The design incorporates a fresh and of-the-moment approach consistent with the sophisticated vibe of the Playboy retail brand."

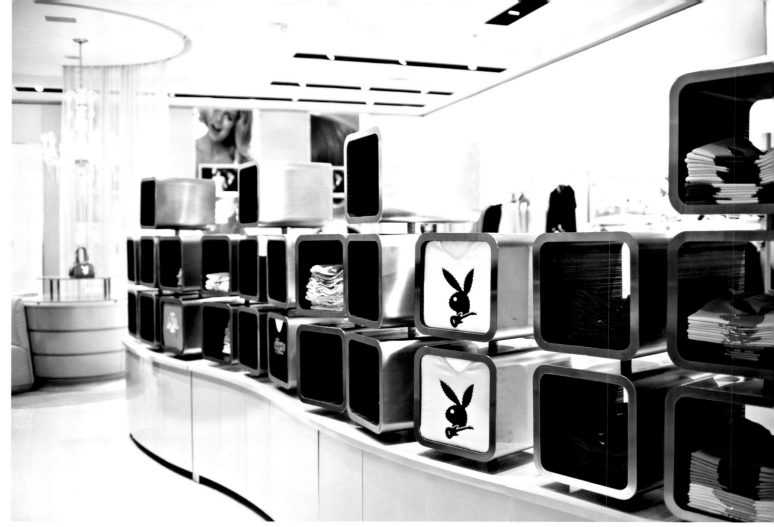

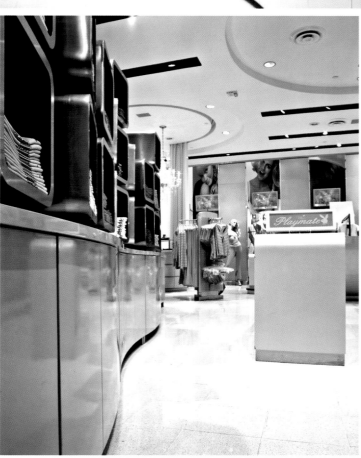

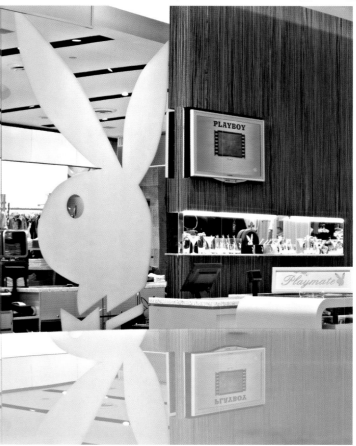

ESPRIT

Covent Garden, London, UK

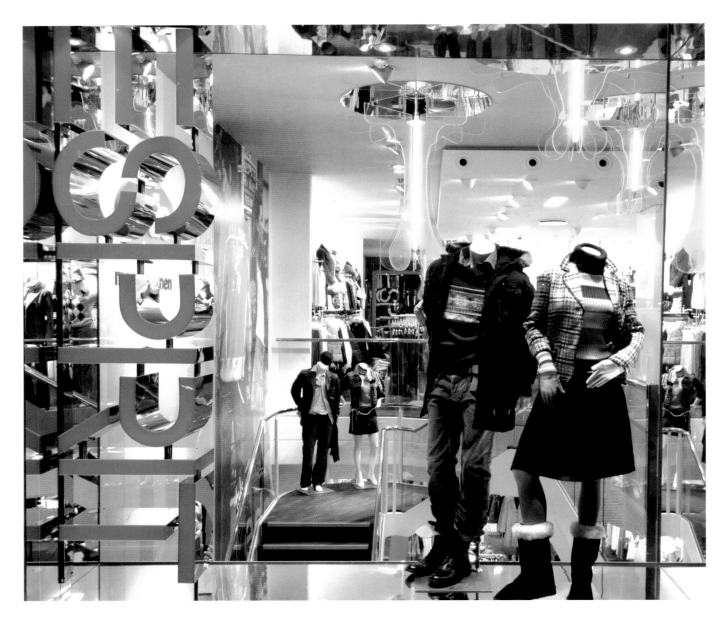

JHP is the design consultancy to Esprit UK and the London based design firm recently completed their fourth store for Esprit in London. This one is in a 380 sq. meter (just over 4000 sq. ft.) space on Longacre St. in the popular Covent Garden area where teens to thirties—tourists and locals—mix, mingle and shop.

According to the designers, "The main challenge was to transform the existing site without interfering too much with the existing fabric of the building." To accomplish the desired results, the designers introduced clean architectural lines to the ceiling and enhanced existing features and elements. These included the stairway that connects the ground level to the lower level as well as the flooring details and finishes.

The excitement—or buzz—starts with the wide open expanse of glass across the old building's façade. It is highlighted by the Esprit name/logo in red running down one side. The new staircase and stairwell are also on view—front and center—and invite shoppers to come in—come down—and explore. Adding to the tingle are the unusual yellow and clear acrylic lighting pendants that float down from overhead. The space within glows with light. There is one long wall of back-lit, red acrylic panels with merchandise over it. This

DESIGN: **JHP,** London, UK

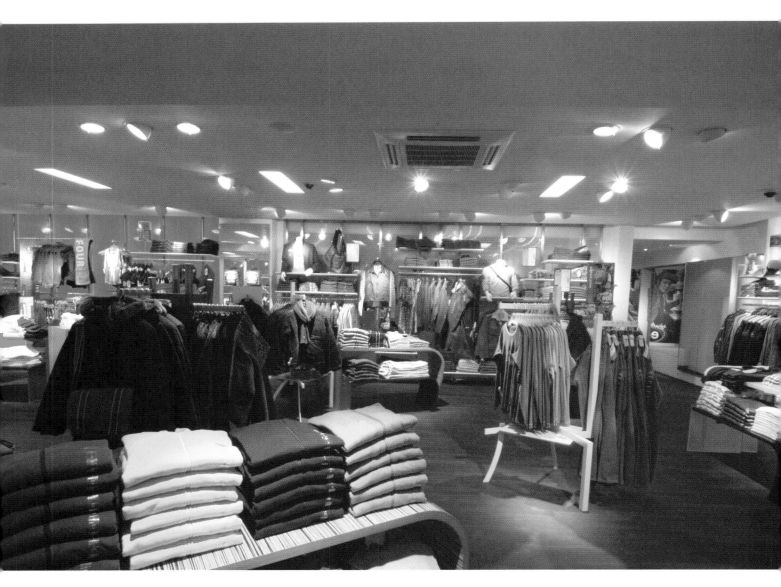

demands instant attention. On the opposite side, in the men's area, folded jeans and denim jackets are revealed against a frost white acrylic wall that also exudes light. Oversized film strips of Kung Fu movies create decorative horizontal bands across the illuminated wall that carries the cantilevered white shelves for the stacked garments. Much of the shop's space is otherwise white—and light and complemented by the dark, rich color of the floor. Giant graphics— many blow-ups of current Esprit ads and promotions— not only add color to the space but further the Esprit lifestyle.

In addition to the back-lit walls, the ceiling carries a combination of recessed fluorescent light fixtures, incandescent down-lights as well as focusable spots to highlight the wall-presented garments.

Steve Collis of JHP said, "Esprit is the chain that never was, because it tries to make every store different. This is becoming increasingly difficult as it opens more of them." Still, with a new one scheduled to open later in the year, JHP is sure to come up with new and novel twists on the Esprit brand image for the stores yet to be built.

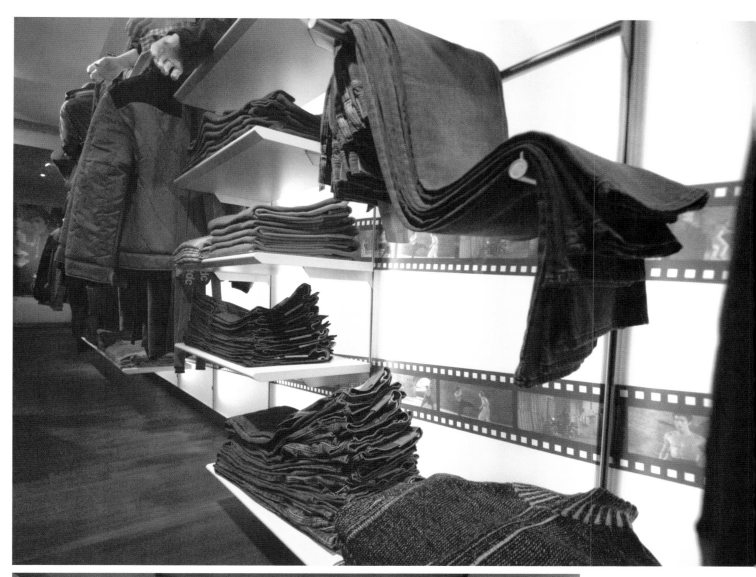

WRANGLER

Trafford Shopping Centre, Manchester, UK

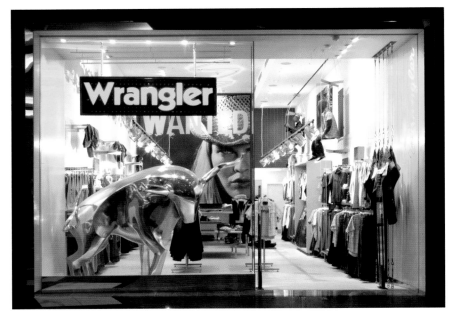

DESIGN: **JHP Design Consultancy**
ASSOCIATE DESIGNER: **David Rock**
BRANDING & COMMUNICATION: **Darren Scott**
STRATEGIC DIRECTOR: **Steve Collis**
PHOTOGRAPHY: **Adrian Wilson**

This Wrangler shop, in the Trafford Shopping Centre in Manchester, UK, is the first stand-alone flagship store for the jean company in the UK. It was designed by the JHP Design Consultancy of London to "build brand equity and show the brand's rich spirit."

Located on the ground level of this large mall that has one of the highest traffic generating locations in the UK, the new 1600 sq. ft. store adds excitement to the brand's perception. Steve Collis, JHP's Strategic Director says, "The brand's thematic platform is the Spirit of the West. We've interpreted this with a European sense of voyeuristic irony." "Highly expressive" mannequins share the open back window with a double height, abstract chrome bull. The Wrangler's signature yellow color forms a bold and welcoming frame around the entire façade. Inside the shop the yellow reappears over and

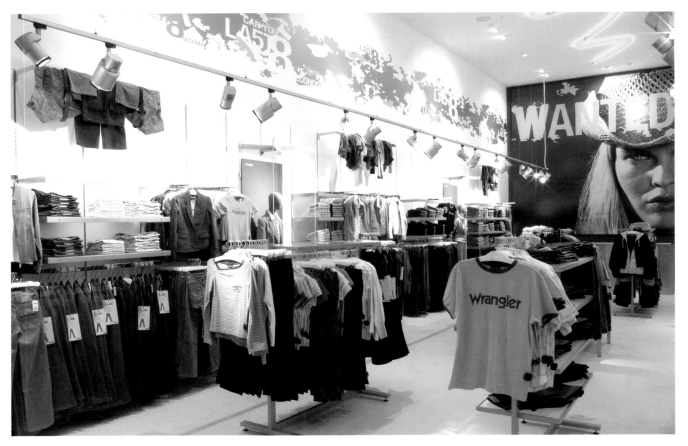

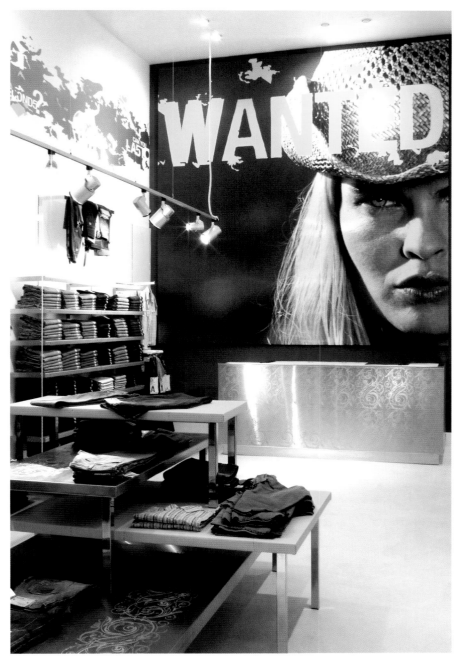

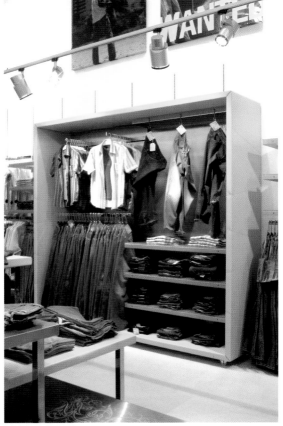

over again: as leather on the furniture stitched in blue (a reverse of the blue jeans stitched in yellow), as the finish for some of the floor fixtures and framing wall cabinets. Otherwise, the space is white and accented with stainless steel. The cash desk and most of the floor fixtures are stainless steel that has been etched to reflect the detail on as cowboy's boot. A giant yellow neon "lasso" snakes its convoluted form across the white ceiling. The "raw" palette includes a desert pebble stone and screed floor.

Adding to the sense of newness and the excitement—as well as further pro-

moting the brand—are the giant vinyl wall murals that are changeable and meant to tie-in with current advertising. "We are working closely with the advertising agency to ensure the message of continuity from events and promotions through to in-store marketing."

Scotte Otte, speaking for Wrangler Europe, said, "Our store will be a true, unique experience, featuring all the brand's values and collections. We want to create a space where the brand is presented in all its aspects. Not a design store—but a Wrangler world to experience the brand fully."

THE SF JEANS CO.

Mumbai, India

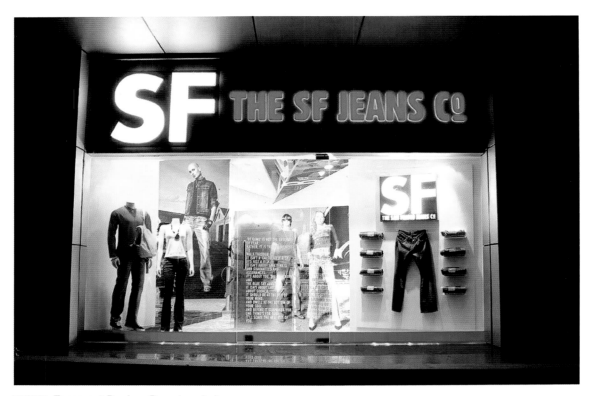

DESIGN: **Tessaract Design,** Bangalore, India
Partha Sarathy s.j., Akbar Bivji, Avani, Nipun Mistry
PHOTOGRAPHY: **Courtesy of Tessaract Design**

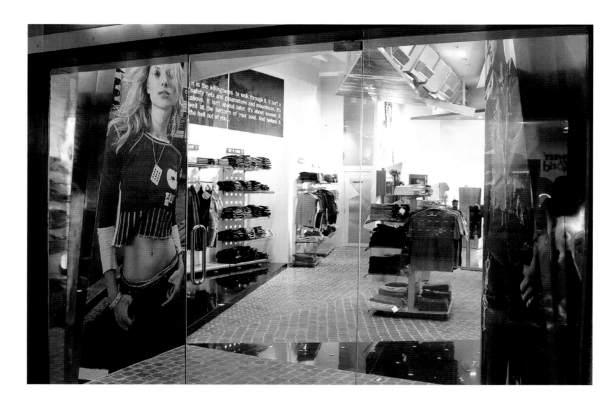

According to the designers at Tessaract Design of Bangalore, India the challenge that they faced in the several stores they designed for The SF Jeans Co.—"a baby in the denim market"—was to create a retail brand image that would introduce the innovative and adventurous range of products and would make the more established brands now flooding the Indian market seem "old" by comparison.

The store's design was conceptualized to "take forward the brand strategy into its retail design image." Taking their cue from SF Jeans' "Be Game" philosophy, they hoped to "break away from the experience of traditional stores in the country." The brand's edginess was literally translated in the design by the introduction of sharp angles, distorted lines, forced perspective, splintered forms and "triangulated geometrics." The materials and finishes used in the execution of the store are "an amalgam of the fine, rugged and edgy urban attitudes."

The cobblestoned main aisle of the Mumbai shop is angled and interrupted by the different patterns in

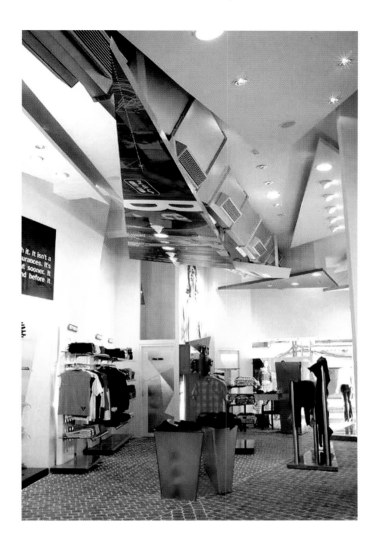

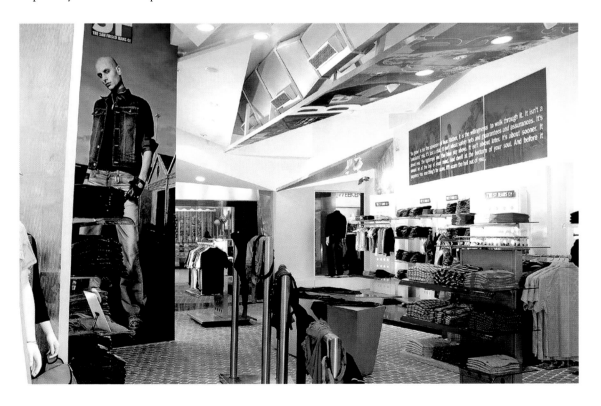

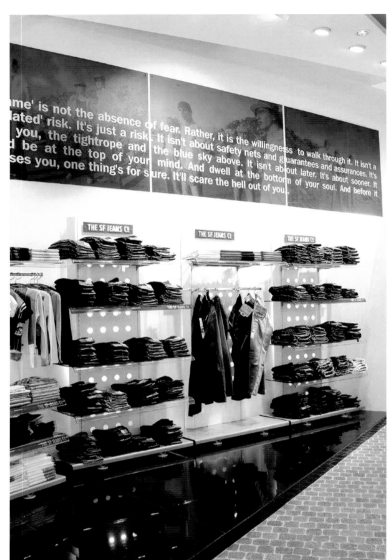

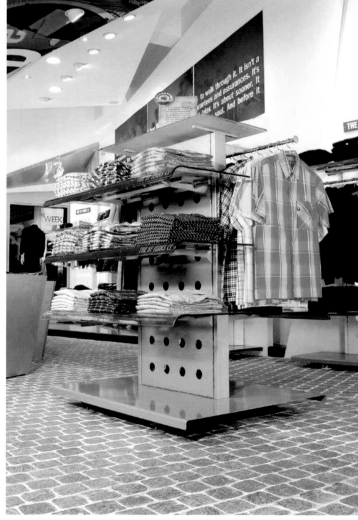

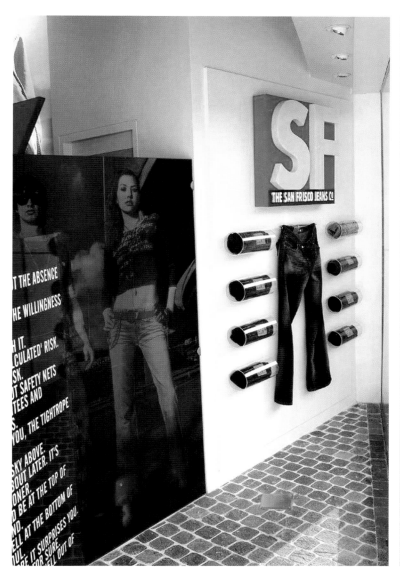
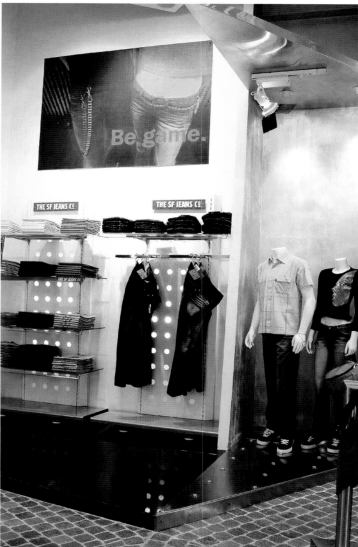

the laying of the cobblestones as well as the intrusion of triangles of industrial metal up near the entrance. The same angular sense of movement is carried through in the triangular forms breaking from the ceiling into odd, irregular segments of varying heights and finishes. The truly dramatic mirrored element dropped from the ceiling that carries the HVAC system as well as the focused lighting visually leads shoppers to the rear of the shop. For guideposts—along the way—there are the lifestyle blow-ups of the target market and lifestyle "quotes" that create a colorful fascia over the wall displayed merchandise. Occasional mannequin stands—pie cut pieces of metal extending into the aisle—carry

through the urban/ industrial look as do the pierced pieces of back-lit, metal panels on the walls that back up and set off the shelf lined garments. All the custom floor fixtures echo that look as well.

The stores are crafted by Tessaract Design to be "site specific" and "carry forward the look and feel of individual stores having custom elements that are not cookie-cut across the chain."

PACIFIC SUNWEAR (PACSUN)

Galleria @ Tyler Mall, Riverside, CA

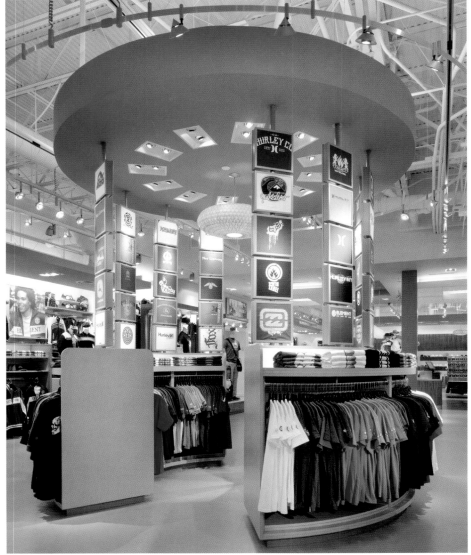

Pacific Sunwear—PacSun—has for many years been a leading retailer of world class surf and skate apparel and accessories and the PacSun stores have been a fixture in many malls across the country. They called upon Gensler of San Francisco to "reinvent their store design" and make their position in the field even more recognizable and secure. In addition, "they wanted to create an immersive retail experience via a flexible, kit-of-parts that could be utilized in ground-up concepts, as well as adaptive to multiple renovations for over 800 existing stores."

The prototype that was developed opened in a 9000 sq. ft. space in the Galleria at Tyler Mall in Riverside, CA. To help PacSun with their goals, the Gensler design team balanced "programmatic functionality and flexibility with a meaningful and unique design aesthetic and customer shopping experience." The PacSun line of merchandise didn't change though a new lifestyle category was added that included luggage and some home products. The services provided by Gensler included the exterior and interior architectural design, product zoning, custom product and lifestyle "story-telling" fixtures as well as finish packaging and marketing materials. Ted Jacobs, the Design Director Principal at Gensler, explains—"The store is not thematic. There aren't surfboards hanging all over the place—there aren't fake waves and things. The design is meant to evoke the cultures and is even theoretically kind of a hybrid of cultures."

One of the most distinctive aspects of the new design is the "eye-catching, iconic storefront." It is an inverted Koa Wood half-pipe entry that invokes the board sport focus of the merchandise presented up front on either side of the opening as well as on displayer/merchandise platforms

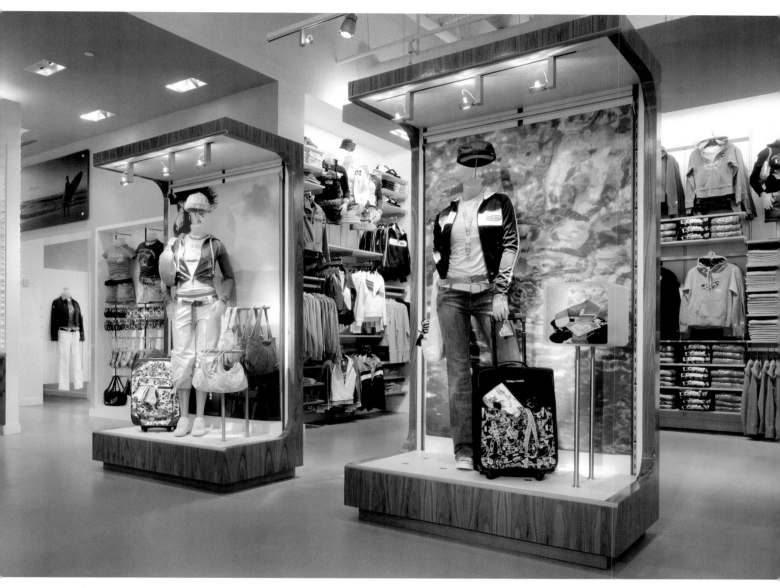

DESIGN: **Gensler,** San Francisco, CA
PRINCIPAL: **Dian Duvall**
DESIGN DIRECTOR PRINCIPAL: **Ted Jacobs**
SENIOR ASSOCIATE: **Brady Titus**
DESIGN LEAD ASSOCIATE: **Eric Mele**
JOB CAPTAIN: **Daniel Gonzalez**
PHOTOGRAPHER: **Benny Chan**

immediately up front and center. This "mannequin-lined lifestyle runway" not only shows off the latest fashions available for men and women, but it leads shoppers into the central focal area of the store—the tee shirt rotunda. Here, in a high-ceilinged enclosure, the newest tee shirt styles and brands are on view and there is also a great capacity for folded garments. Another focal element is the Koa Wood footwear wall located at the rear of the space and this is internally illuminated and shows off a large volume of shoe styles. It serves as a "primary draw" to bring shoppers to the back of the store. In many ways it recalls the store's façade and Ted Jacobs adds,

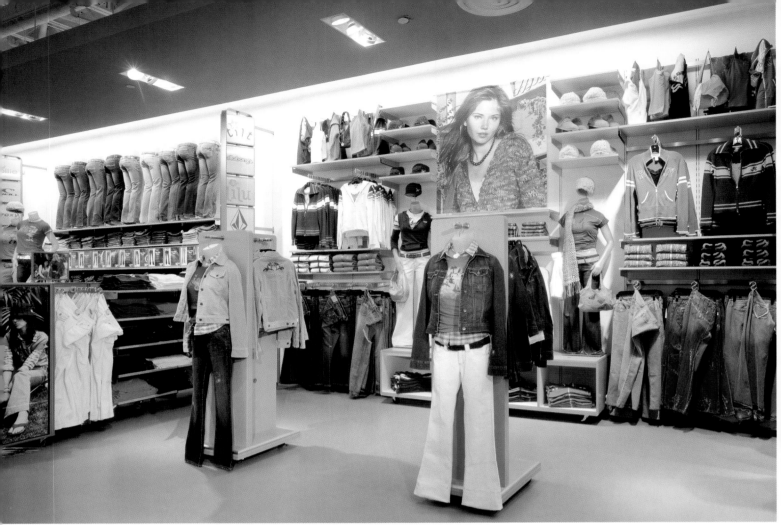

"It serves as a bookend to the whole
PacSun experience. It has similar
material and construction forms, so
the whole store is kind of wrapped
between these two iconic pieces."

The basic fixture concepts were
designed to work as efficiently in
a store half the size of the proto-
type. The iconic elements have been
retained and with the kit-of-parts
design for the fixtures it is possible to
maintain the store's look. In describing
the kit-of-parts elements, On casters,
these fixtures are readily moveable.

"Overall, the new store concept
dimensionalizes the various PacSun
brands by showcasing product catego-
ries and a wide spectrum of product
types in a way that creates a unique
and meaningful story-telling journey
and experience."

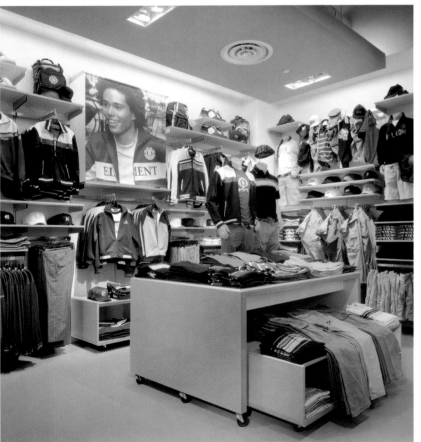

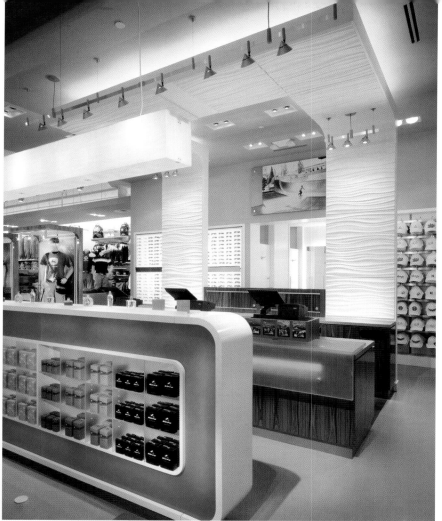

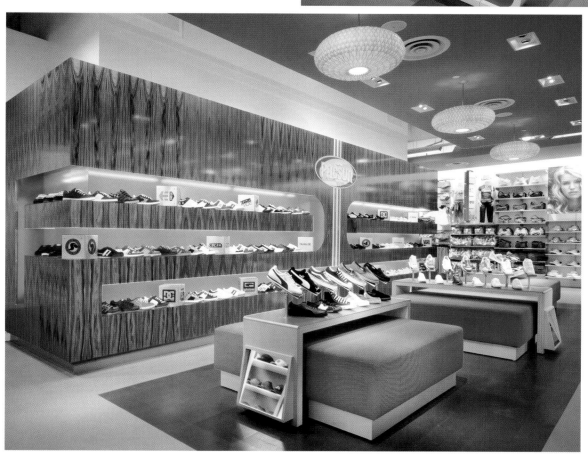

PIMKIE

Berlin Schonhauser, Berlin, Germany

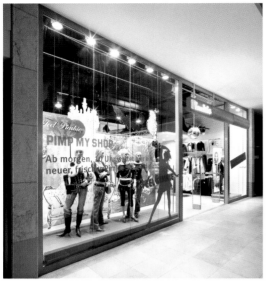

DESIGN: **Dan Pearlman Marketarchitektur gmbh,**
Berlin, Germany
PHOTOGRAPHY: **Diephotodesigner.de**

In 1971 Pimkie was founded in France and by now it is a chain of over 640 stores throughout Europe. The pink and orange logo colors are targeted at young, trendy, fun-loving girls and women but Pimkie also caters to the different target groups and markets in different countries. As an example—Italian women tend to dress more colorfully than women of the same age in Germany or France. That means creating different merchandise for the different "markets." The architectural design firm of Dan Pearlman of Berlin was called upon to create a new store design concept that could be adapted to shops and flagship stores in

Italy, Spain, France and other cities in Germany.

The first of this new concept stores was opened in Berlin and designed to be an "in" place, "supplying relaxed, sensual and precious experiences. We want young women to want this place—to spend their leisure time and money here." To get the right feeling and the pulse of the potential shoppers, the designers interviewed numerous teenagers to find out what they wanted—needed—looked for in a shopping experience. The results: "Pimkie needs some pep. We want a place to sit and have a drink, hear some new songs— not the same old stuff that I don't even

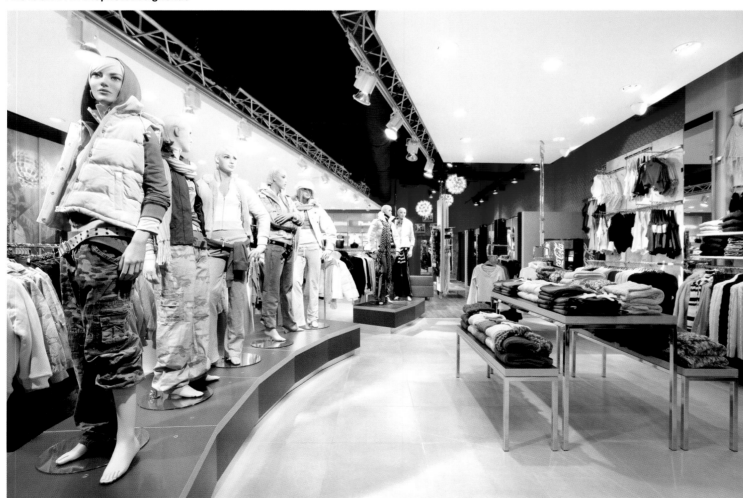

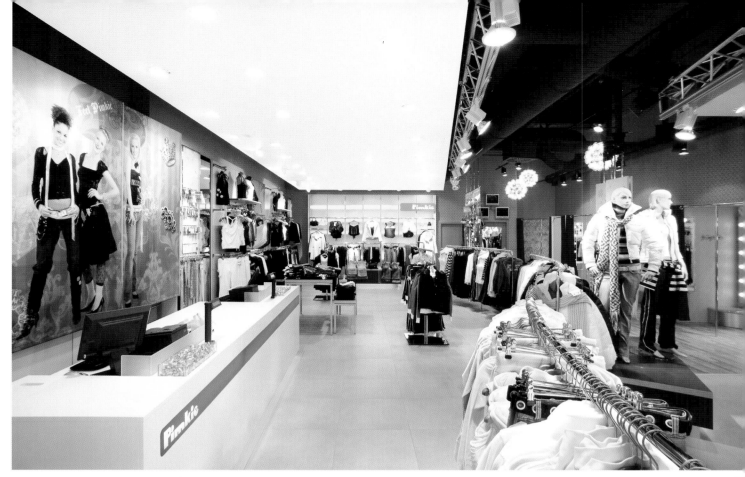

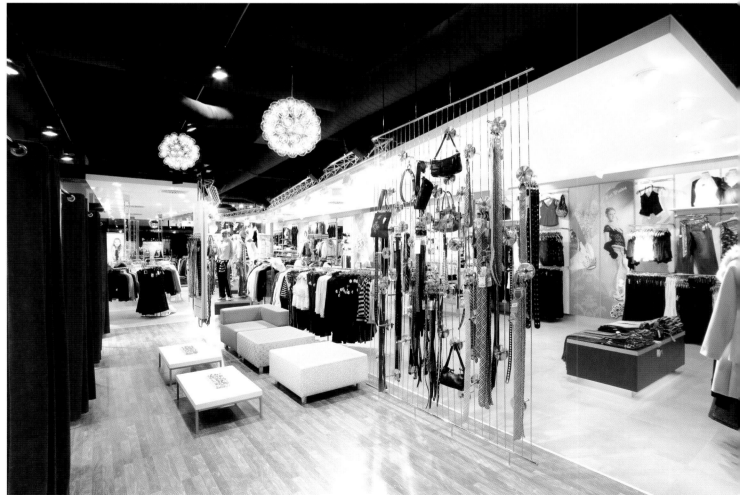

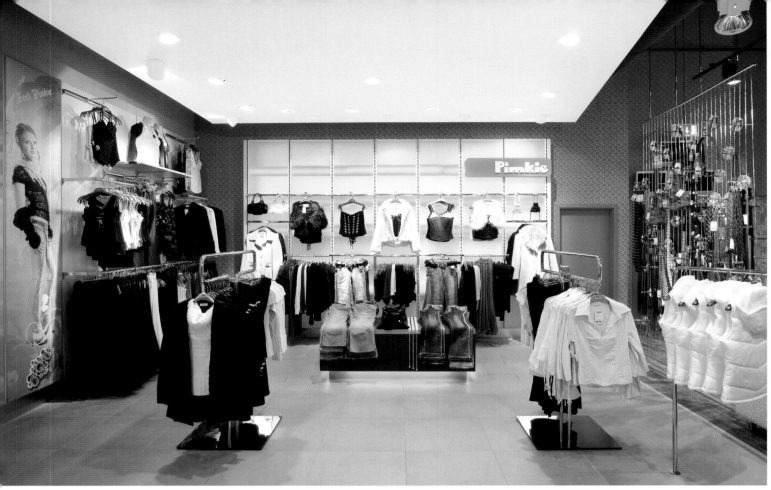

know. A fitting room where you can hang something up." The new store design has sliding wall panels, curved racks in the central zone and a long curved catwalk where mannequins parade in a collection of coordinated Pimkie outfits. There is an accessory zone in the rear of the shop near the lounge and music areas. The fitting rooms have been given special attention. There is a relaxation area with a community feeling where the young women can congregate and communicate with one another and discuss their selections. The fitting rooms are flexible and can be compartmentalized into smaller more private areas by means of fabric curtains.

Wherever one stands in Pimkie, the signature colors are there. The orange and pink colors are everywhere. The designers' challenge was to not only make this "a space made for young women—a female living space and a creative lab," but also "transfer the orange world into

an holistic concept." It is all about "orange": orange is "optimistic, energizing, vibrating, refreshing, young, female—sexy, strong and powerful." According to the designers, "You feel the orange energy" in the music that fills the air in Pimkie. It is the vibes of Pimkie and in keeping with the theme—orange drinks are served in the store.

To carry through the Pimkie brand image as "a store made for the female customer offering fashion, authenticity, assistance and transformation" there are numerous graphics in the store and in the windows of Yvonne Caulfield, a popular German model who also represents Pimkie in their print ads. As their ads say—"Feel Pimkie! It is an emotion—fun and passion. The Pimkie girl tries out a new lifestyle—a new feeling every day. You feel good at Pimkie!" That is a brand statement!!

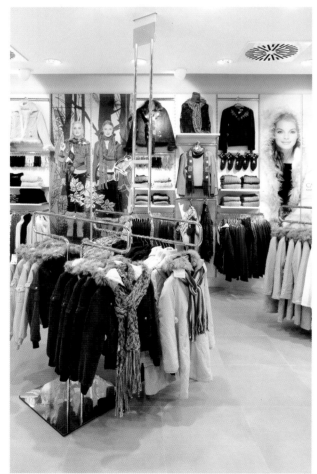

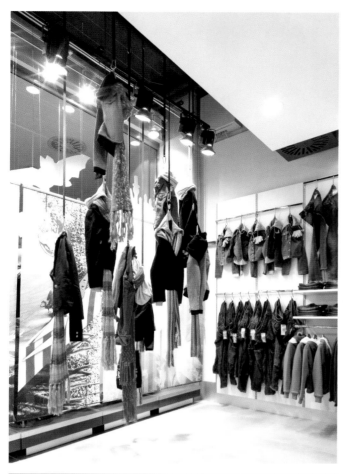
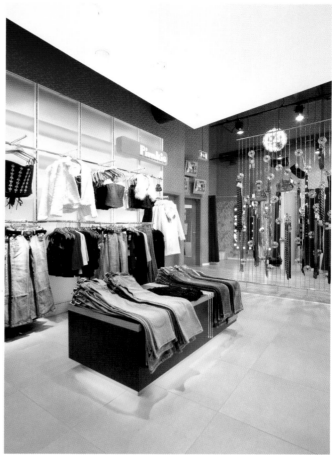
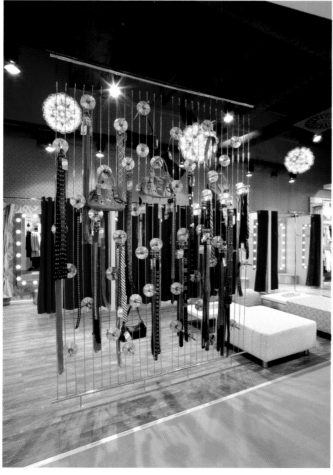
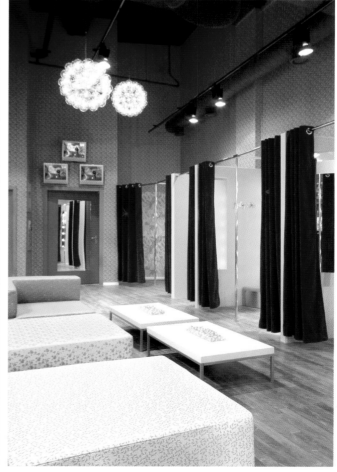

JOCKEY

Kenosha, WI

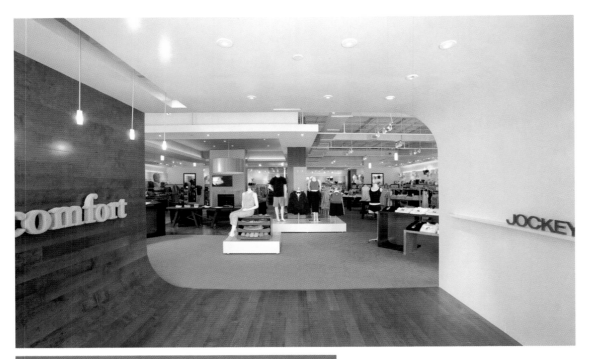

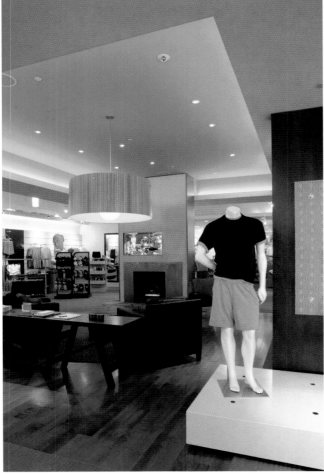

The 130-year-old Jockey company wears a world famous name and is almost synonymous with men's underwear. For their store in the company's home town of Kenosha, WI, they wanted "a store that boasts of all the comforts of home." Jockey also wanted "to motivate customers to take home more Jockey apparel in all categories—from undergarments to activewear." Or, as Gensler's design team put it, "to get consumers to re-evaluate the brand."

The store itself is a "cocoon," a calm interior space within a chaotic outlet mall setting. The cocoon shape suggests two hands cupped together in a comforting gesture. "The symbolism also puts the comfort brand message up front." Wood is juxtaposed against lacquer, acknowledging Jockey's past and present.

The "comfort" element is reinforced by the "living room" in the heart of the store. A persimmon colored ceiling overhead reflects the fireplace below, the leather lounge seating, the oatmeal colored wool rug, the flagstone hearth, and all of these elements are highlighted by a monumentally scaled pendant lighting

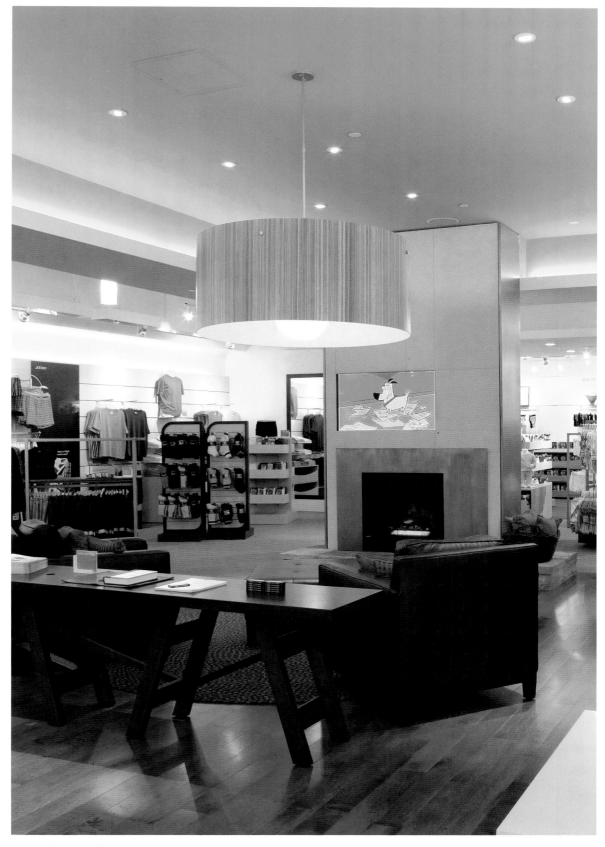

DESIGN: **Gensler,** San Francisco, CA
Jeff Henry, Michael Bodzinger, Janice Natchek, Zsofia Kondor,
Katie Price, Bronwyn Paterson

For Jockey
Jeff Gottleib, Michael Lapidus

PHOTOGRAPHY: **Wayne Cable Photography**

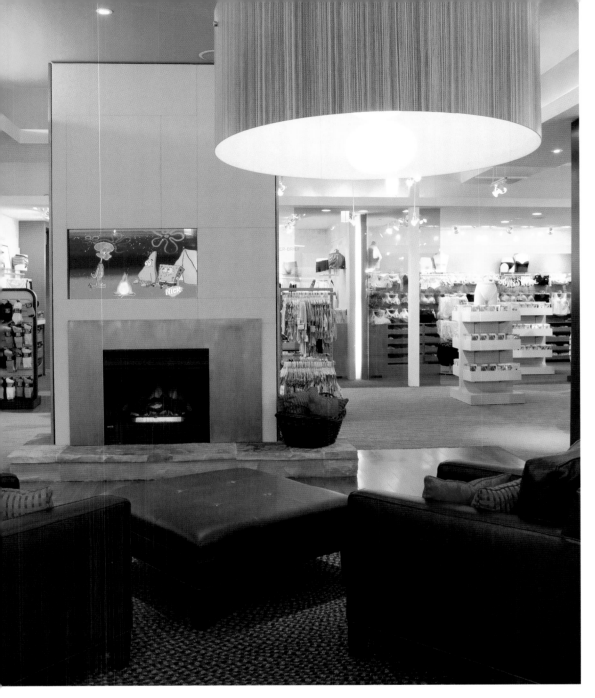

fixture. One wall of the "living room" is a library-inspired wall system. Here, new introductions and personal care products are on display. Scooped, shoppable drawers provide accessible back stock. Modular "lifestyle" platforms surround the "living room" perimeter—bringing activewear forward in the space. Beyond, a persimmon colored glass panel defines the "Perfect Fit" zone that lies behind it.

In the Perfect Fit zone male and female products are segregated but together and provide a graphic overview of Jockey's extensive under-garment assortment. A pattern of small scale boxer briefs appears on the wallpaper in the men's area while it is an all-over design of bras that patterns the custom wallpaper in the women's area.

Since the cash/wrap is up front in the store's layout and close to the window "it becomes a brand messaging opportunity." The reverse side of the graphics provides a backdrop for the theatrical "boxes" that offer merchandise story-telling opportunities to the street traffic.

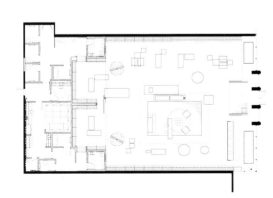

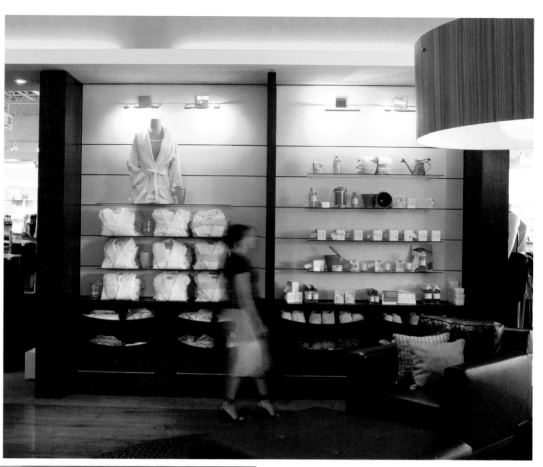

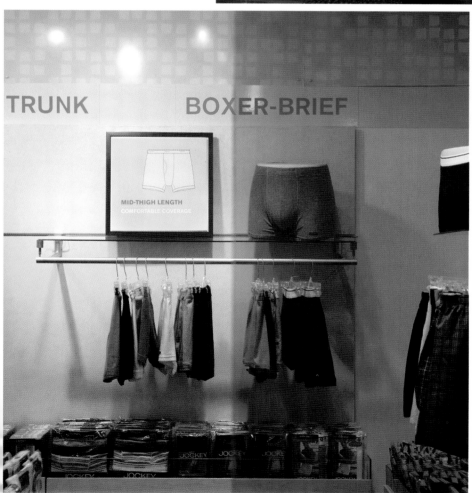

TRUNK BOXER-BRIEF

MID-THIGH LENGTH
COMFORTABLE COVERAGE

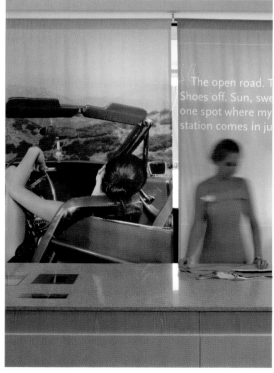

The open road. T
Shoes off. Sun, swe
one spot where my
station comes in ju

SPEEDO

Covent Garden, London, UK

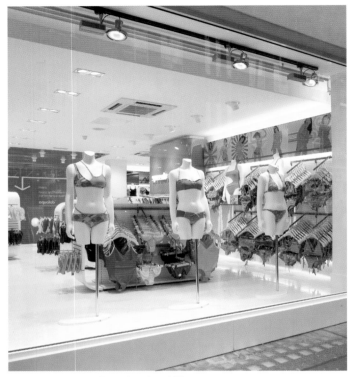

DESIGN: **Dalziel + Pow,** London, UK

A new global retail design for Speedo was unveiled in their flagship store in Covent Garden in London. As designed by Dalziel+Pow, the design will eventually be rolled out across 300 retail outlets worldwide. The new concept has been developed to "reflect the personality of the brand while showcasing the full breadth of product available." Featured in the new design is the new designer collection, Speedo by Rosa Cha, as well as everyday beachwear and the high performance swimwear and equipment used by professional athletes/swimmers.

An illuminated blue ripple wall at the entrance echoes "recollections of water and sky." There are interchangeable display cases here that highlight Speedo's technical products and innovations and they are backed up by a sweeping graphic of a swimmer. The

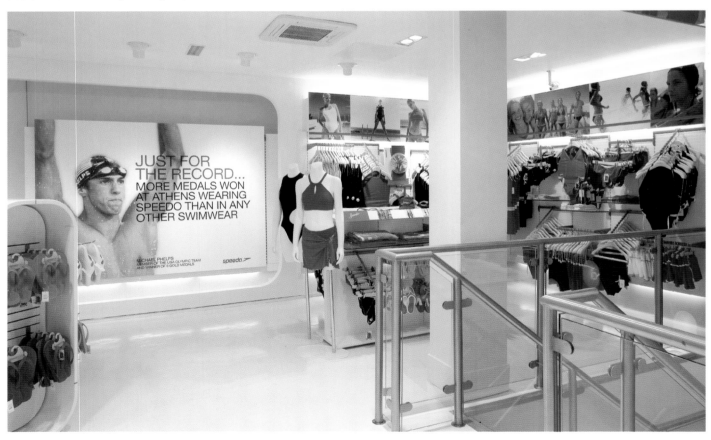

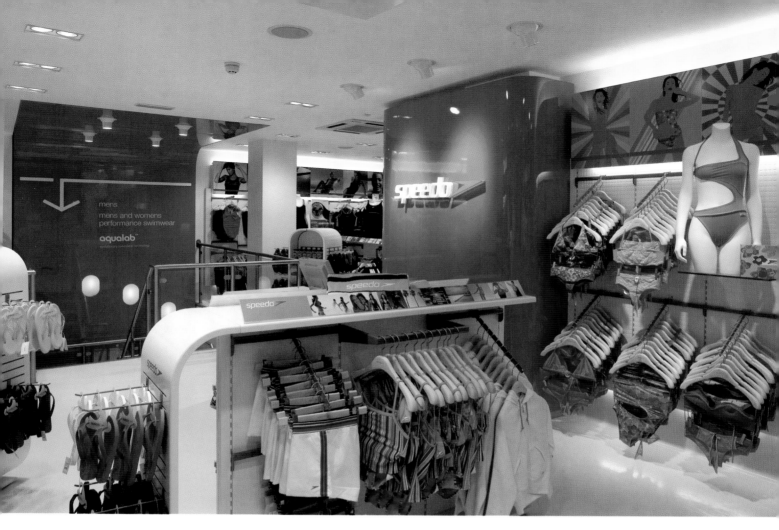

interior design is clean and contemporary with white textured walls and ceiling and white rubber sand resin coated floors. There are bold splashes of Speedo's signature red introduced on some accent walls of this two-level

store as well as graphics that highlight the range of merchandise in the shop. These graphics are constantly being updated—kept seasonally on target and they co-exist with the heritage imagery that "communicates the authenticity of the brand."

Starting on the white ceiling, making a right angle and continuing down the two-level wall that connects the ground level with the floor beneath is a bright red band of color. It serves to direct shoppers to the lower level. This connecting link is a strong focal point and is not likely to be missed. It is an architectural exclamation point. On the lower level, in an almost all-white ambience with the same sort of rounded end floor fixtures and the gentle curves seen on the ground level, is the Aqualab area. Here, on a centrally-located table with bull-nose edges, customers can receive information and expert advice on Speedo's technical and innovative products. There are two touch screens

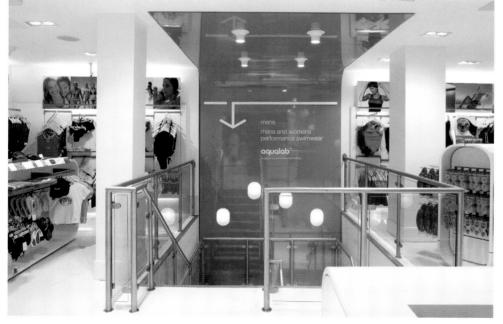

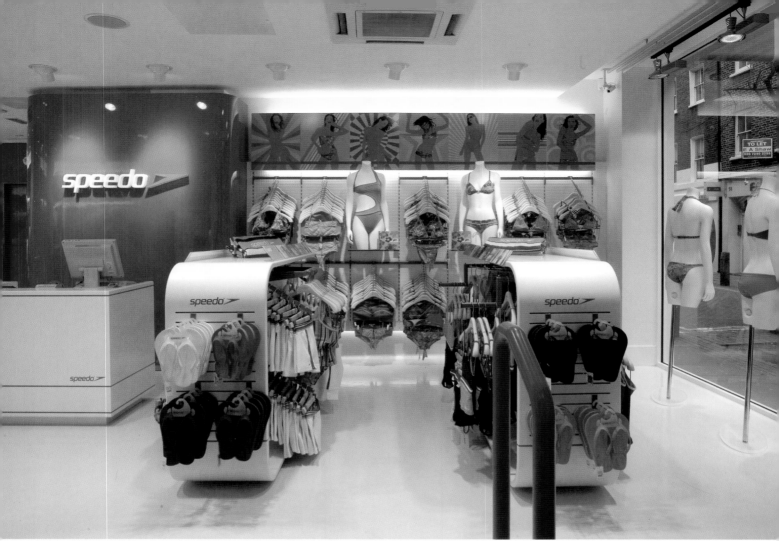

that are a fun way for customers to take a virtual tour around the Aqualab.

Tony Wood, President of Speedo International, said, "The new design concept is engaging to our customers and highlighting our swim heritage. We have chosen a contemporary, innovative design which reinforces Speedo as a source of authority in the swimwear arena." According to David Dalziel, a principal in Dalziel+Pow, "Our concept for Speedo creates a Flagship Boutique, but has a future life far beyond this application. It is designed with five or six memorable details that can be exploited in a roll out. The color and soft line reflect the sports heritage of the brand, and the merchandising and imagery bring out the fashion element."

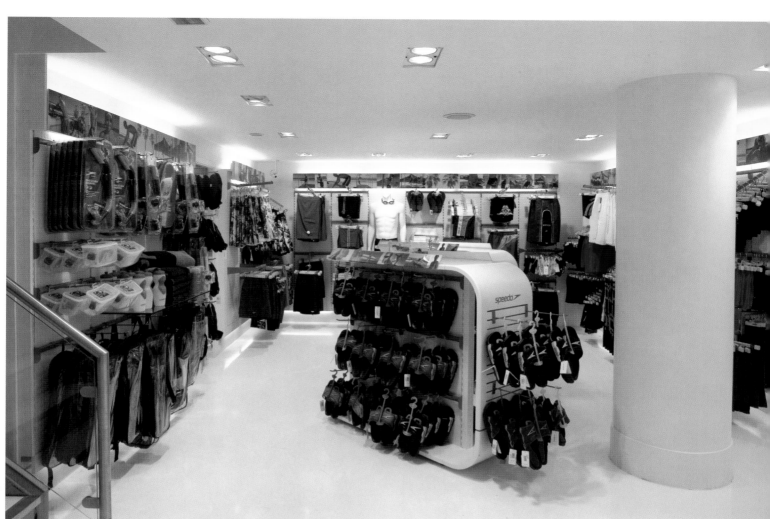

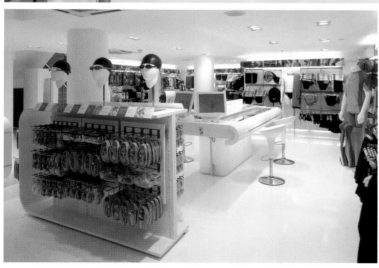

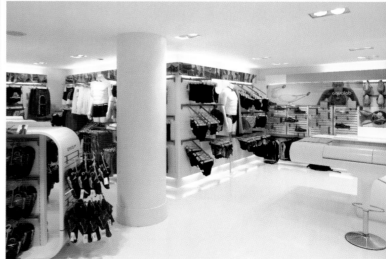

FILA

Madison Ave., New York, NY

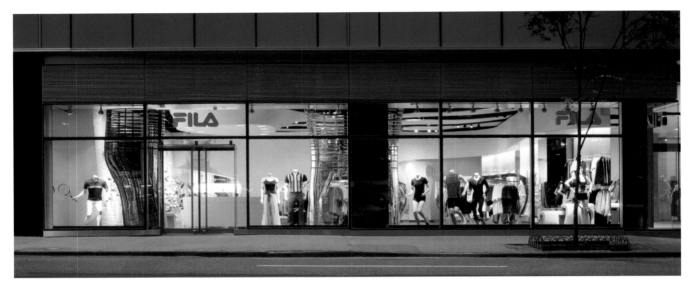

When Fila opened their 4,000 sq. ft. boutique on Madison Avenue several months ago, they did more than stop traffic with a display of red Ferrari and yellow Lamborghini autos out on the street. They introduced a new, upscale, sophisticated and breath-takingly stunning new environment that could easily be seen through the giant windows of the façade. The store viewed behind the live models in their Fila outfits was all white, silver and cool accents of aqua. It was another architectural design triumph for Giorgio Borruso of Marina Del Rey, CA, who has created several award winning retail interiors in the last few years.

According to Giorgio Borruso, "Designing a new concept for a company developing a very high quality product connected with sports, in the Italian tradition of attention and devotion for manufacturing products with the intent to develop unique artifacts, was intriguing. Expressing the need to combine elegance, lightness and grace with the heart of the sport, embodying the ability to stretch and use every muscle—any energy—to obtain performance." Thus, this new design "is a mixture of pleasure for natural materials, sophisticated silhouettes and

unexpected inventions."

The space is filled with a sense of movement –the "movement" that is so much at the heart of the product. "Movement is, in fact, the only meaning or word that we cannot separate from the concept of sport."

The major focal elements in the store's design are the two ellipsoidal metallic tree trunk-like elements that

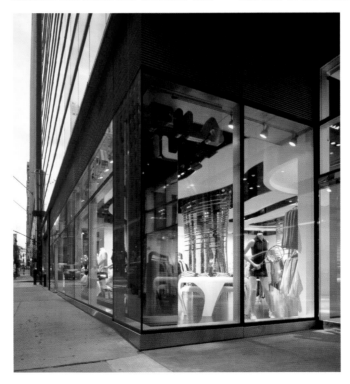

envelop the existing supporting column. They are meant "to reflect the surrounding environment" but these curvilinear, twisting units "move from a centrifugal force, appearing to come down from the ceiling in search of an anchor."

The ceiling, itself, is filled with undulating strips that run from one side of the store to the other—

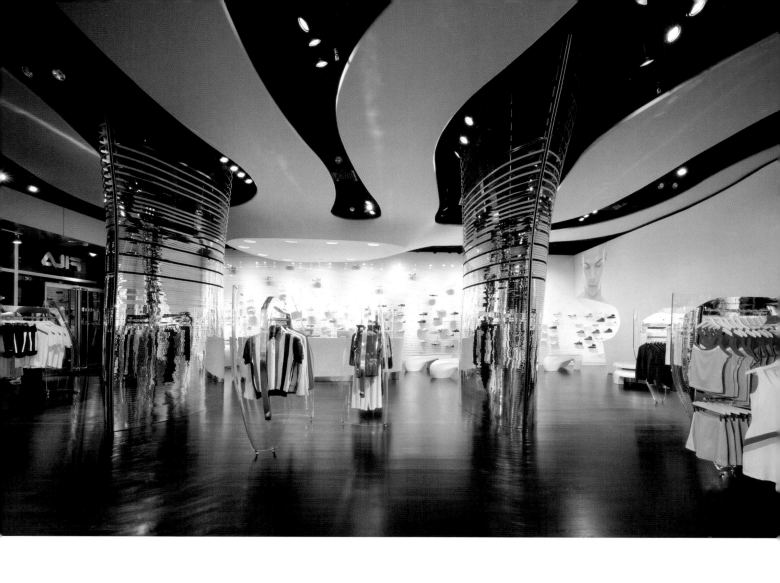

DESIGN: **Borruso Design,** Marina Del Rey, CA
Giorgio Borruso

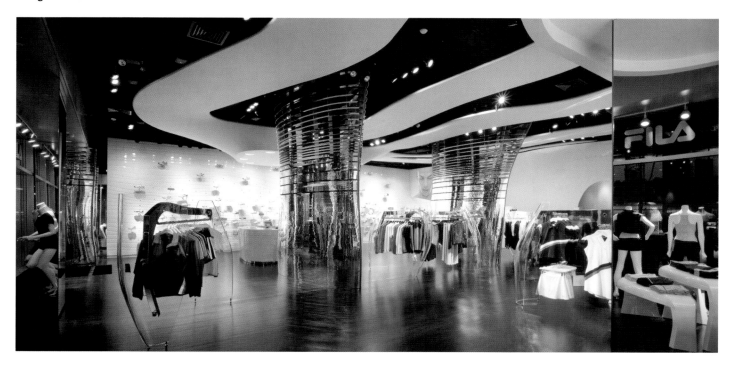

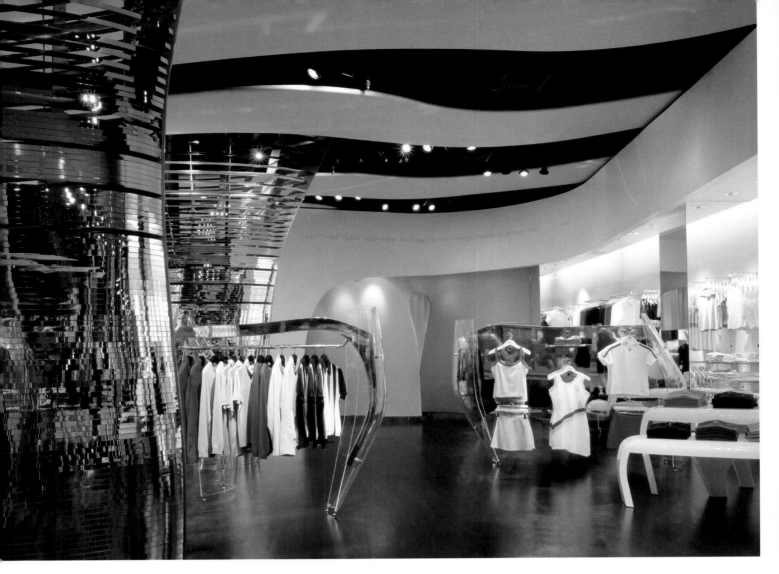

"describing curves, linear tracks, moving, gaining speed again, then slowing. Like a course in the air, it becomes a suggestion of a path—a guide for moving through the fixtures that we can decide to follow or not." It is all about Borruso's "sense of movement."

That same feeling of movement and soft curving, undulating lines fills the left side of the space. Here on a sculptured 50 ft. wall of waves, hundreds of Fila's sport shoes are displayed—"moving in groupings like birds in flight formation." Standing on the dark Wenge wood floors are numerous sculptured floor fixtures made of white fiberglass forms, clear Lucite formed "shields" and chromed metals: soft, fluid and yet "like muscles in tension—resting in extraordinarily beautiful poses, ready at any moment to spring to life danc-

ing, running and jumping." The product display seems to "ride the furniture—enjoying the movement." The clear shields that top some of the fixtures "protect the precious vital organs—the product—that is the body of the fixture."

Soft white draperies and cool aqua accents at the right, rear end of the shop set off the spacious dressing rooms. "A semi-transparent wall filters shadows generated by the movement of the customers." Amoeba shaped benches are set around on the wood floor for the shoppers' comfort and convenience while music and changing images cast on the frieze below the ceiling provide gentle entertainment. This is a space that personifies "movement" as well as grace, elegance and Italian sophistication. It is definitely a new retail star—on upscale Madison Avenue.

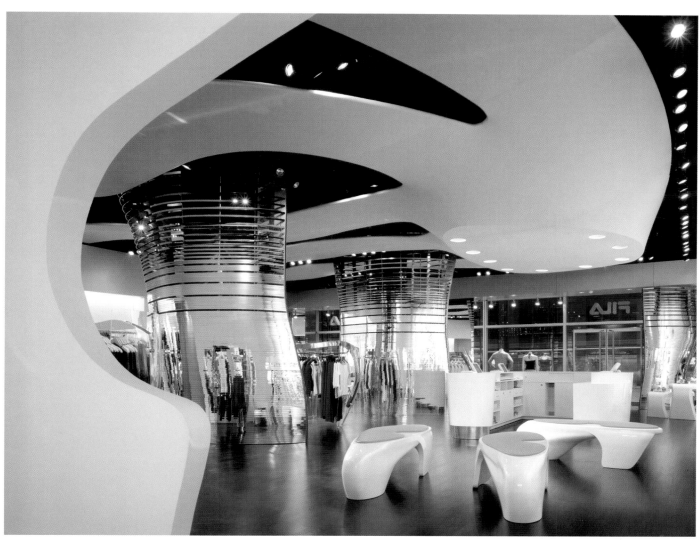

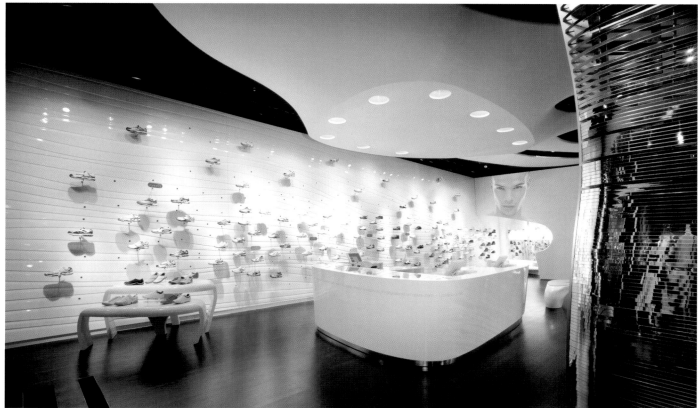

LADYBIRD

Cork, Ireland

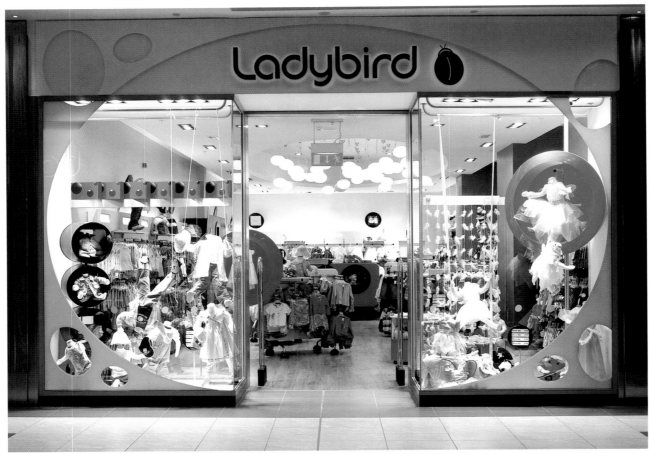

DESIGN: **Checkland Kindleysides,** London, UK

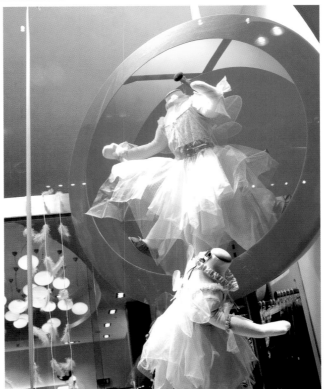

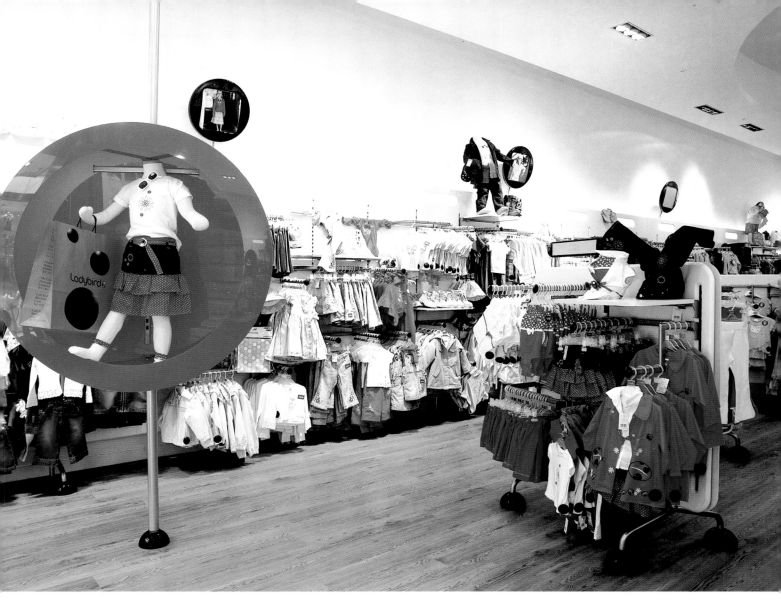

The focus for the design of Ladybird, a children's clothing line, was "to create a retail experience that is true to Ladybird—a brand that is fun, adventurous and alive with ideas." As conceived by Checkland Kindleysides, of London, this store in Cork, Ireland, presents the company's strong heritage and tradition of providing accessible, high quality clothing, and blends these in with the brand personality. In this design concept, the designers created a layout and visual merchandising plan as they would for an adult fashion retailer: one that is modern, friendly and uplifting. "A shopping experience that is stimulating and engaging for both parents and children alike." The traditional red ladybird bug is used to communicate the brand with a distinctive tone—"creating an environment which is the essence of the brand."

A three-dimensional ladybird bug appears on the shop facade—over the doorway. Inside, the store's fixtures and fittings are "full of character with an animated look emanating from the fixtures' legs and sucker-like feet." They look as though they could walk out of the shop. The Ladybird store signature is created with the play wall, the changing rooms and the feature pods in red and black. There are fun distractions for the children at their eye level such as games and measuring charts. The Kids' Zone provides an oasis in the store where the children can relax, watch TV, play games and generally be kept amused and safe. The changing rooms have a fun, spacious yet cocoon-like feel. The cash desk and back wall, in red and black, are engaging, and within the recesses product stories can be told and/or they can provide display and storage space for gift wrapping materials that reinforce the store's signature colors.

The store is easy to navigate. "We achieved this through both high level signage and imagery and the use of subtle lighting to provide distinction between the three main product areas: blue for boys, pink for girls and cream for babies." There is also localized lighting that "gives an uplifting feel with ball pendant lights which look like bubbles—subtly introducing gender navigation through color." Graphics play an important part in presenting Ladybird as a fashionable

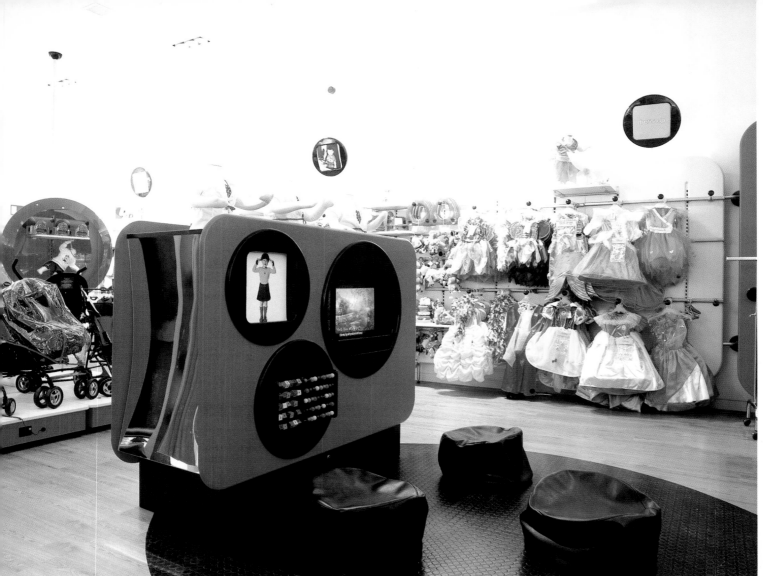

and contemporary children's clothing brand. They show a brand with more attitude by using fun and funky kids. All sharp edges have been rounded off in the design and the fixtures to "generate a feeling of safety, which also make elements of the store feel almost toy-like in appearance whilst giving the fixtures a uniqueness and an attitude that is relevant to the Ladybird brand."

Simon Brown, Marketing Manager for Ladybird said, "We are delighted that Ladybird now has a consistent store identity delivering a fun environment with maximum choice for our customers. It is flexible and can be rolled out across all global territories delivering a constant message that can adapt to the broad demands of international retailing."

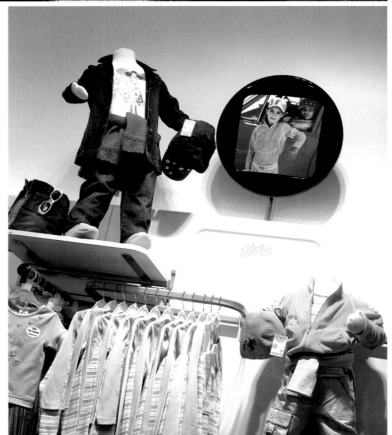

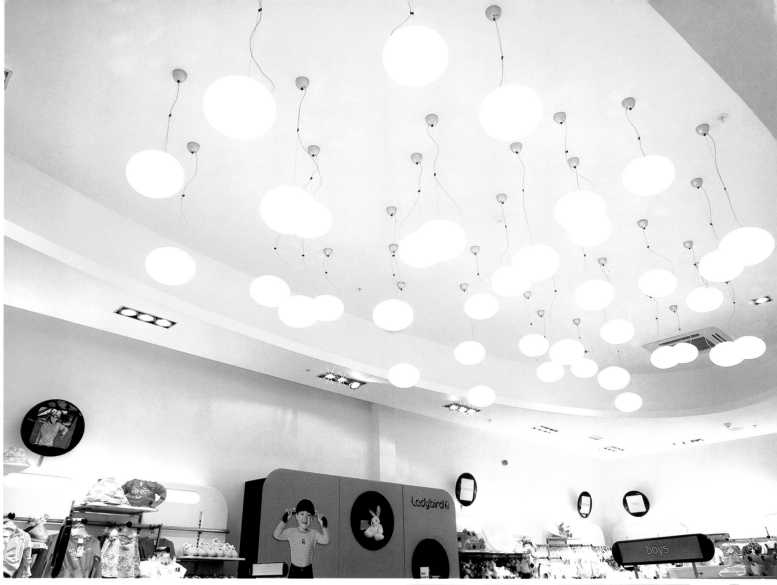

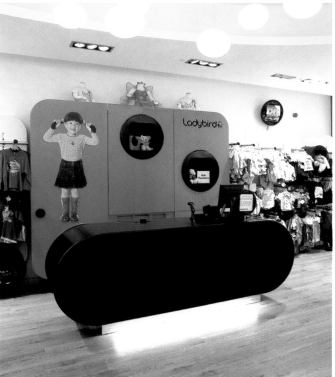

HANNA ANDERSSON

Fashion Island, Newport Beach, CA

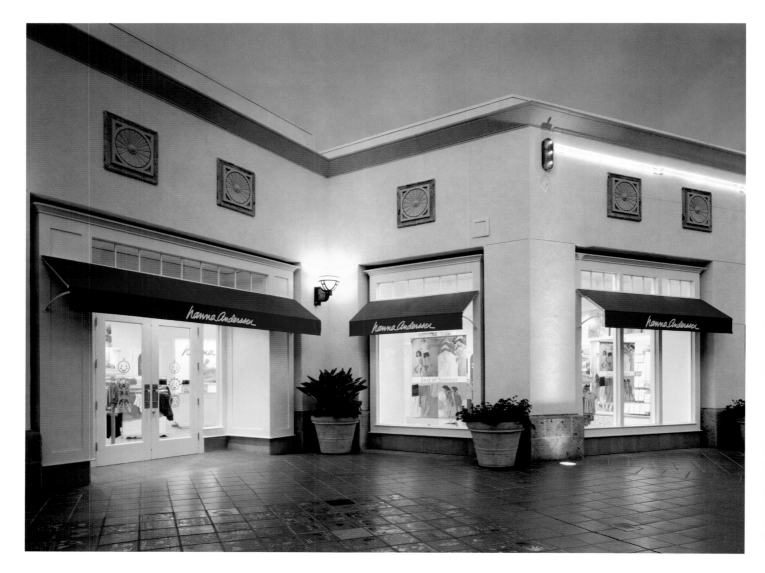

With this new prototype store in Fashion Island, Newport Beach, CA, Hanna Andersson affects a new look for her line of children's clothing. In her store, Hanna Andersson tried to show that she understands mothers and how they want to find the best quality apparel for their children. The design firm, Bergmeyer & Associates of Boston, was presented with the following mission:
• Highlight the values of the brand.
• Create a place where mothers and children will want to come and stay awhile.

• Celebrate the joys of motherhood.
• Add "dimension" to the values and messages in the store's catalogue.
• Bring Hanna to life in the store.

To accomplish this, the Bergmeyer design team used traditional Scandinavian/Swedish design as the inspiration. They updated it with a level of simplicity in the architectural detailing thus "framing and showcasing the product." To suggest the "level of craft" that goes into all the Hanna Andersson products, fine details were integrated into the floor fixtures, the cash/wrap and the fitting

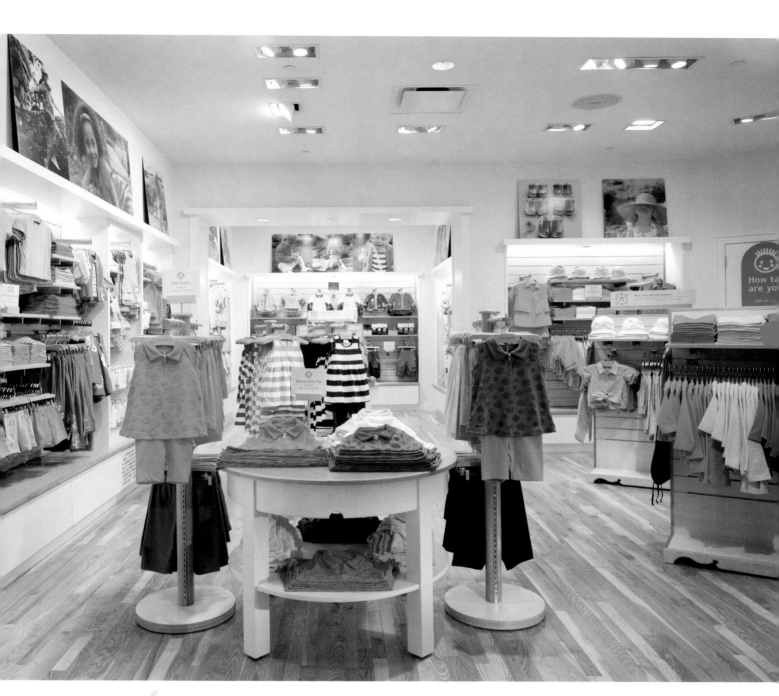

DESIGN: **Bergmeyer Associates,** Boston, MA
PRINCIPAL: **Joseph P. Nevin, Jr.**
ASSOCIATE: **Claudette Lavoie L'Huillier**
PROJECT DESIGN MANAGER: **Mare Armstrong**
JOB CAPTAIN: **Benjamin Heyd**
DESIGN TEAM: **Maria Panagopoulou & Brian Houghton**

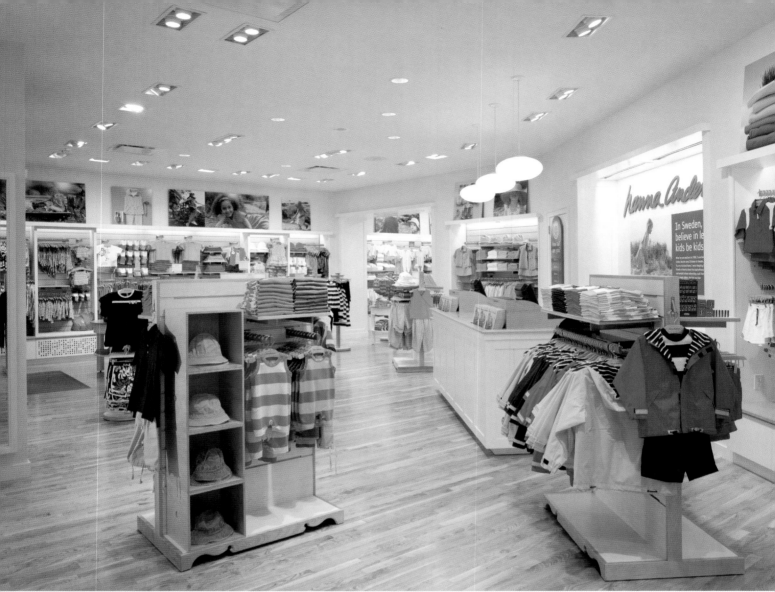

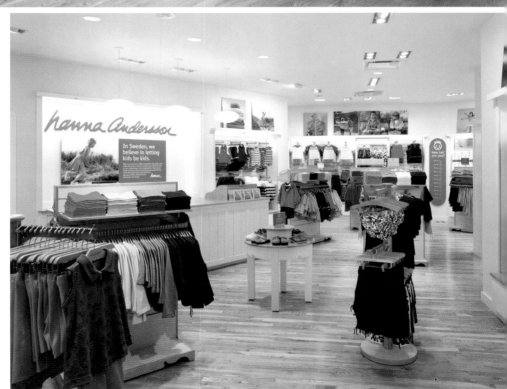

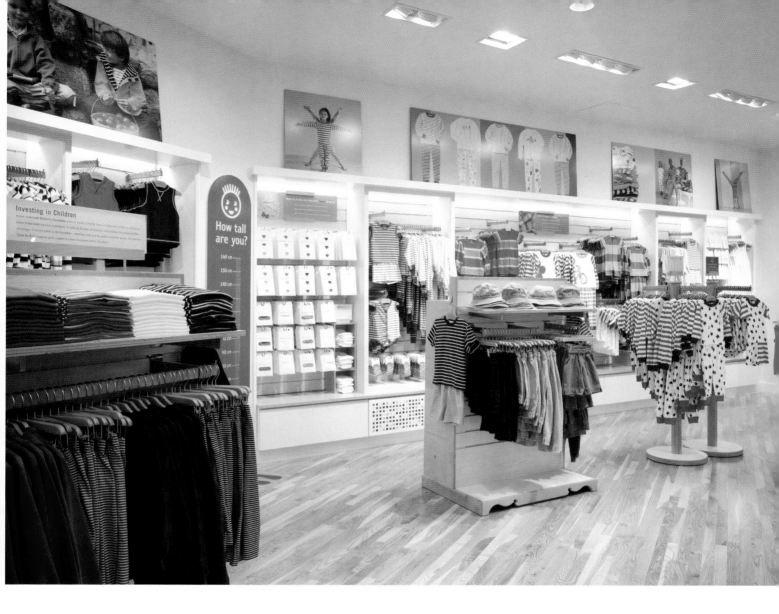

rooms. Special graphics were developed for the in-store signage and photography that "brought the core brand message and values to life in the store." The merchandise is simply and clearly organized, coordinated and displayed in the pastel yellow environment accented with white millwork, shelving and fixtures. A light natural oak wood in used on the fixtures and for the flooring.

Children are made welcome and are entertained as well. Below each feature bay of merchandise is an interactive, back-lit marble game feature: "Its glow invites the child to roll the marbles and change the look of the panel." In a safe and protected area there is a Brio train set-up and a box of toys can be found in each

dressing room.

The focal point of the design is the cash/wrap—"much like a kitchen in a home, it is a meeting point in the store." While the perimeter fixturing creates a more boutique-like setting, flexibility of merchandising is provided by the custom-designed slatwall system. The floor fixtures are residential in scale sand design.

The storefront integrates graphic elements and brand icons representing children and family with a simple, sophisticated traditional Scandinavian design while, on the interior, the integrated graphics showcase unique product attributes and the Hanna personality.

GUYS & DOLLS

Walton St., London, UK

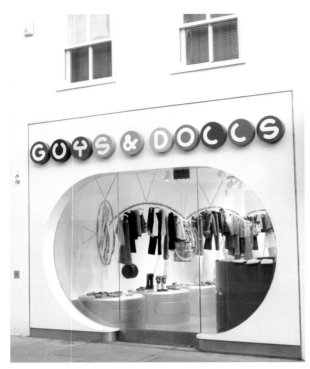

DESIGN: **Sybarite,** London, UK
**Simon Mitchell, Torquil McIntosh, Iain Mackay,
Eliana Voutsadakis**
PHOTOGRAPHY: **Adrian Myers,** London, UK

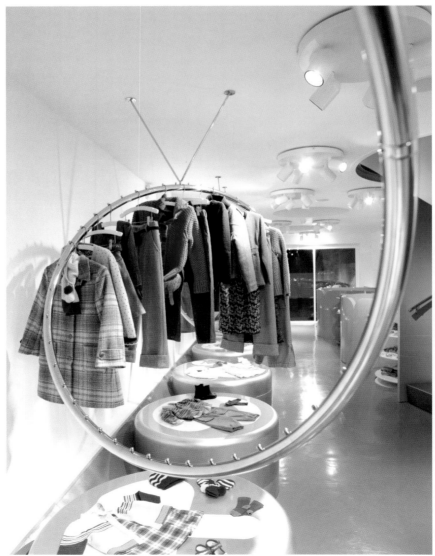

The creative design team of the Marni boutique on Sloane St. in London not only impressed the Marni group who then asked them to do several more of their shops around the world, but it had a great effect on the Marni store's neighbors. Joseph, the owner of a well known chain of fashion shops in London, recommended Sybarite, the design firm, to Sarah and Sabrina who were about to venture into the children's clothing business. Sybarite's design team came up with the name and the store concept that was readily accepted and the images shown here are of the Guys & Dolls two story shop on Walton St., in London.

"Children see the world as a much bigger place and are naturally curious—always looking for fun and play which means there has to be a hierarchy of scale progression that they can interpret instantly. At the same time a child's attention is more easily grabbed by bright colors and bold simple design." With this in mind, the design team used curved flooring with all the

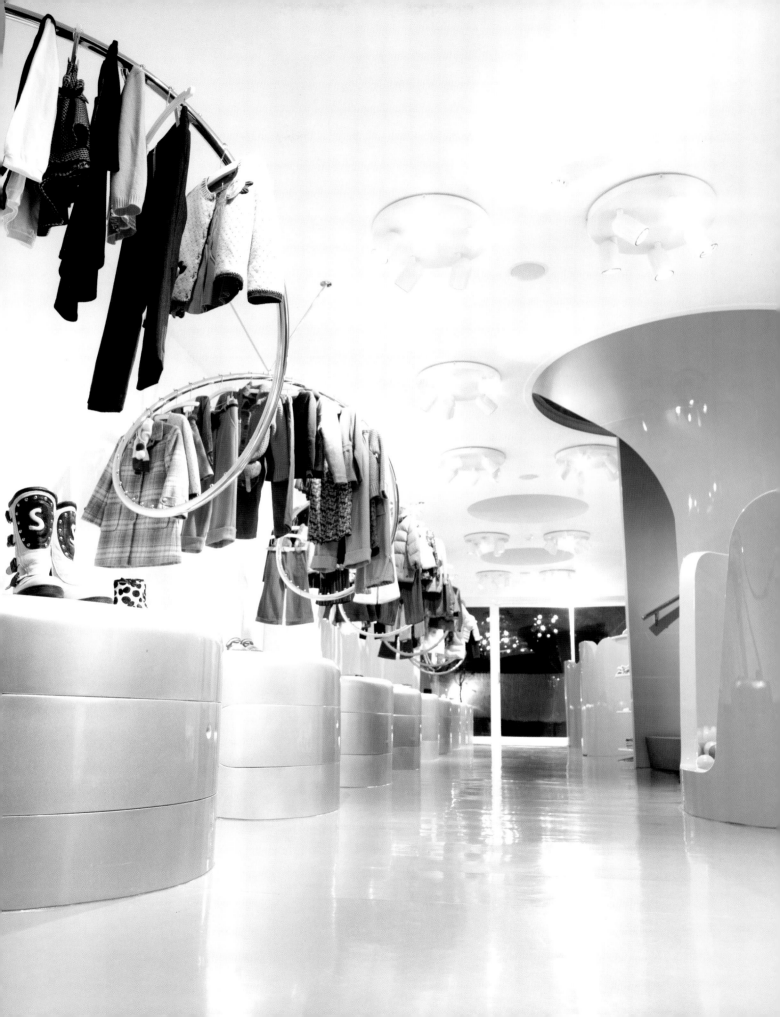

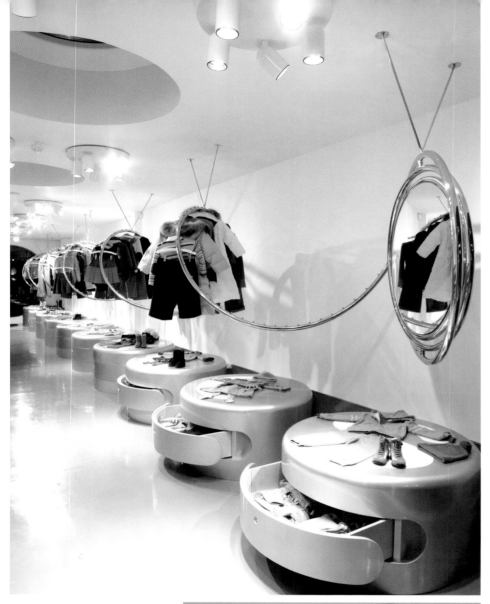

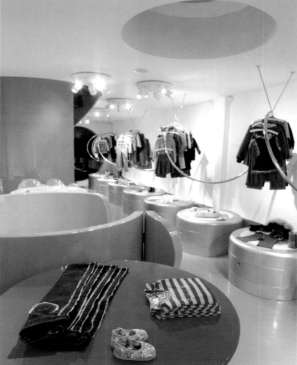

colored furniture pieces inserted like "Lego" building blocks. The circular, rounded feeling continues in the spiral staircase, the spiral clothes racks or rails that suggest a "slinky" toy descending stairs, cylindrical fitting room pods, play pods with rubber balls, circular drawer units and rotating circular shelves. Even the lighting fixtures are circular! As Simon Mitchell, design director of this project said—the concept extended to the logo design. "The logo is actually a lengthy exercise in circular geometry." The logo is printed in large, individual letters on the surface of the drawer units at the child's viewing height.

The cut out glass facade frames the entrance into "the multi-colored den." The low level drawer units have soft edges and the garments are displayed at the children's eye level, The curved rubber flooring—like a skateboard ramp— "increases the perspective within the shop making it appear much larger in scale." The spiral rail continues the circular theme and not only allows for a very flexible display of clothes at varying heights, but also can achieve up to three times the capacity of the straight rail. The dressing room pods are high enough for the child to undress and dress in and the mirror is adjusted to the child's height. However, the parent can still look in—over the open top of the pod—and check things out. The designers also planned spaces where baby carriages can be parked and there are hooks upon which bags—or babies in carriers can be hung. The play pod is a great place to leave the playful child while the parent checks out what is available. There is even a small kitchen area where bottles and milk can be heated.

"The material selection is also intentional as safety is a primary concern. Sybarite have adopted rubber flooring in the shop, all the pods have rounded edges and banked grass rolls down to safety flooring in the outside area at the back which is fully secure."

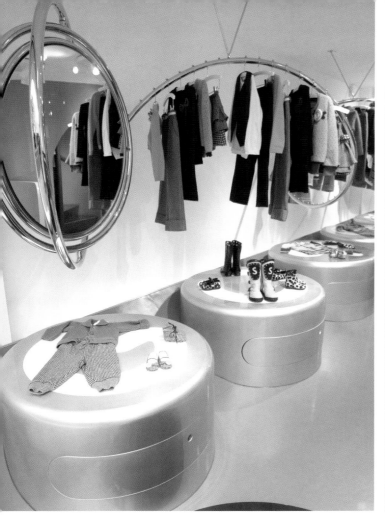
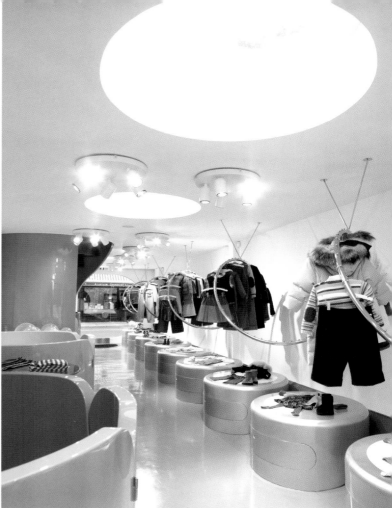
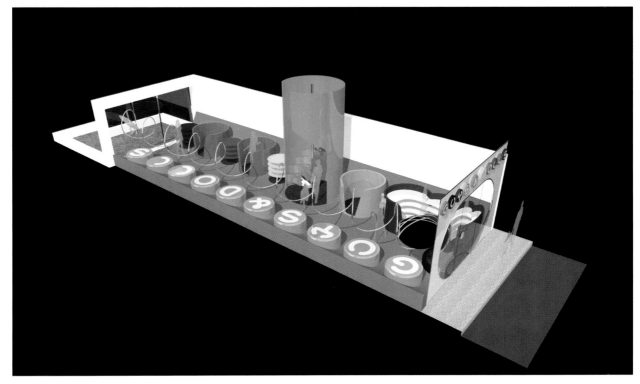

123

GYMBOREE

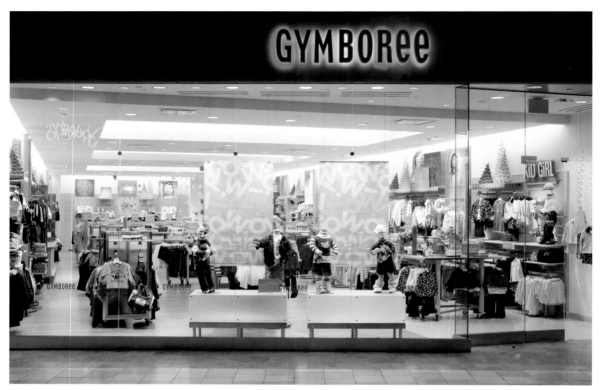

B&N Industries of Burlingame, CA is known for its many attractive and versatile wall and floor systems and fixture designs. Gymboree's In-house design team worked closely with the talent at B&N to come up with a new store look based on adaptations of some of their effective systems. "A completely fresh look was created for Gymboree stores without sacrificing their brand identity and not losing the loyalty of the customers. With the addition of new and fresh materials and a simplifying of the space, the store reinvented itself with a clean new ambiance."

Gymboree sells lots of children's apparel and the merchandise is changed frequently and there are also several different age ranges that have to be served. In addition, the garments are usually colorful and full of patterns. While slatwall works well, and does allow for the display

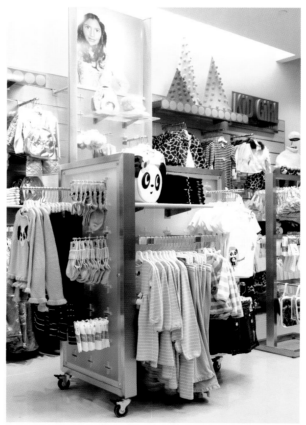

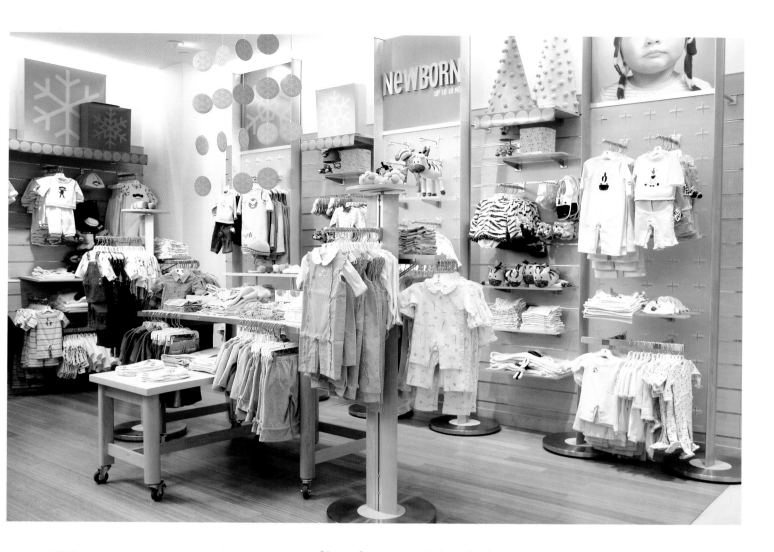

DESIGN: **B&N Industries,** Burlingame, CA and
Gymboree's In-house Design Team
PHOTOGRAPHY: **Michael Skott Photography,**
East Sound, WA

of lots of garments, it doesn't often look new—or fresh—or interesting and it doesn't easily "divide" into product categories. To maintain the existing slatwall perimeter walls, the new scheme makes the slats 6 in. on center rather than 3 in. and B&N's Sorbetti system was introduced along with some new materials. The slatwall is now done in maple and metal slides are used on the Sorbetti system. These are the pieces that are slid onto either side of the Sorbetti uprights. This system is also used to create focal points along the wall and to break up long runs of the slatwall. "These outward 'bays' are also a vehicle to tell very directional product stories, and to promote the overall color and design themes of the season." The "stories" are reinforced by a special graphic panel that accentuates a color or pattern. The large photographs also help

with visual relief and contrast with the many colors and patterns of the small garments.

Panels of frosted acrylic with plus signs cut out allow the maple-toned walls to "glow through" and they do break up some of the more pronounced areas of the horizontally striped slatwall. "It was also a great way to enable the use of common and existing slatwall hardware and the plus sign is also an allusion to mathematics and learning—used in a fun way." The plus sign also appears on T-units on the floor. They allow the products to be gently backlit with light refracting in the panel." The panels also permit the merchandise on either side of the unit to create soft glows of color—providing pretty interest while still maintaining a clean background that is not too stark." More of these acrylic plus panels were

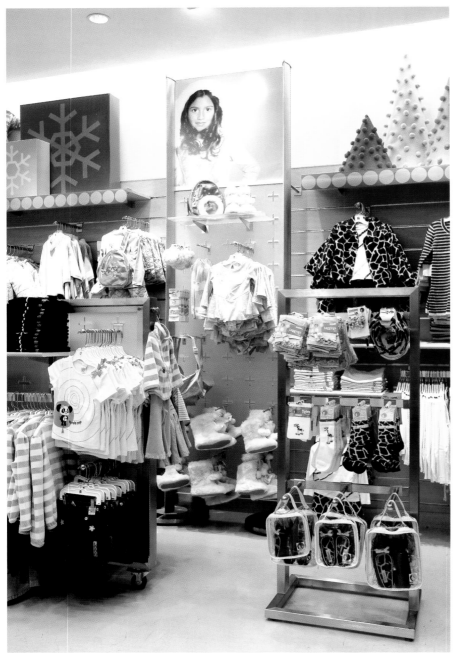

added in the newborn area. They are used here to create bays and give "a stronger rhythm to this area of the shop. The gentle look of the panels lend a light and airy ease to the merchandising."

These new revisions are being used to update the existing Gymboree stores and will be the basis for the new stores being built.

THE CHILDREN'S PLACE

Vaughan Mills, ON, Canada

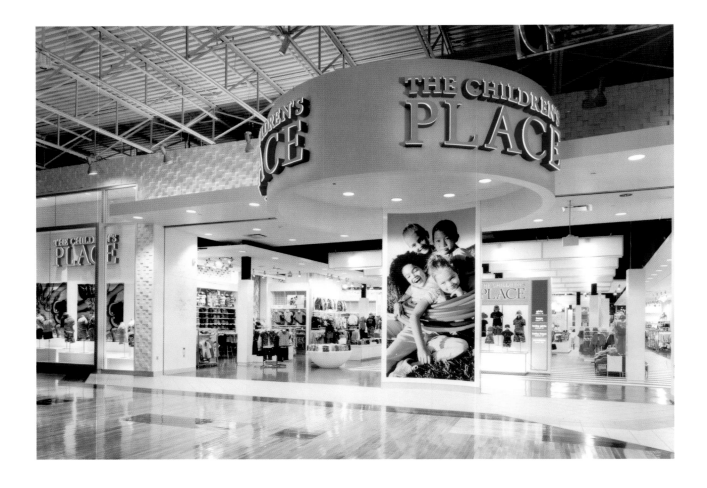

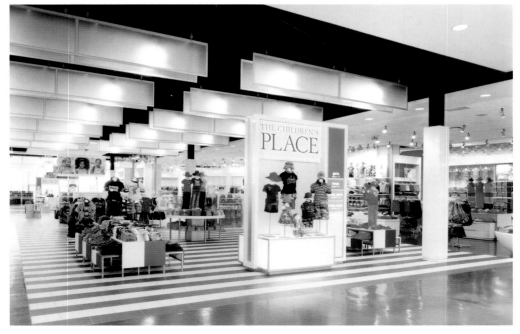

DESIGN: **GHA Shoppingscapes,** Montreal, Q
VP: **Steve Sutton**
SENIOR DESIGNER: **Debbie Kalisky**
DESIGNER: **Marie Francoise Fourcand**
ELECTRIC & MECHANICAL ENGINEER:
Phillipe Dallaire

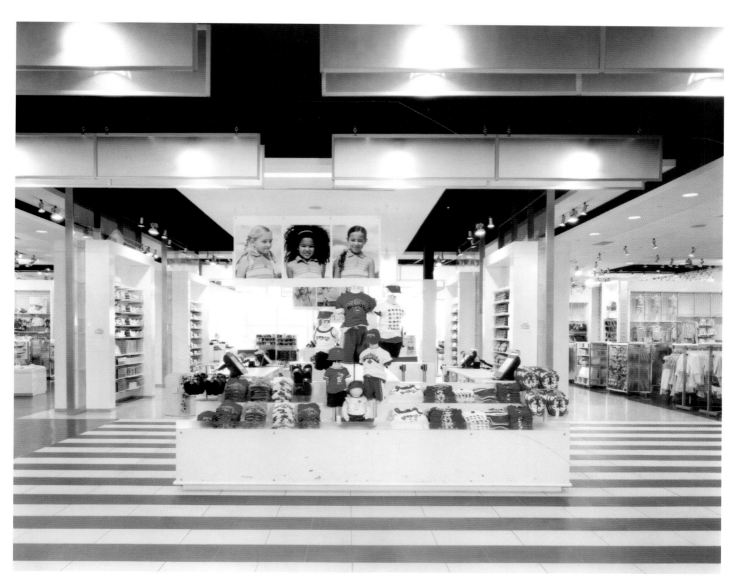

"The Children's Place" is a leading retailer of children's merchandise exclusively produced for them and sold under the brand name. The garments are high quality, popular priced and range from newborn to ten year old. According to Steve Sutton, VP of GHA Shoppingscapes, "The design concept offers an exciting shopping experience within a user-friendly atmosphere for both children and adults. The vibrant, structural environment is divided into clearly identifiable, distinctly separate departments to allow easy browsing through the complete gamut of collections. Product lines are departmentally arranged by gender and age groups to offer a focused buying experience and augment add-on sales"

For this new store of over 10,000 sq. ft. in the Vaughan Shopping Centre in Ontario, Canada, GHA Shoppingscapes created an all new look for this U.S.A. based company. With merchandising as a primary focus, the perimeter wall hanging systems and free-standing fixtures are designed to accommodate the range of fashion collections and "an attentive visual merchandising team creates a unified story within each collection category." There is also a bold new look to this design and a key component of that "look" is "graphic": from the contrasting charcoal and white banding on the floor to the sequence of acrylic lighting blades that repeat the same horizontal striping on the ceiling. The departments are brightly color-coded and visual graphic programs, using over-scaled and strategi-

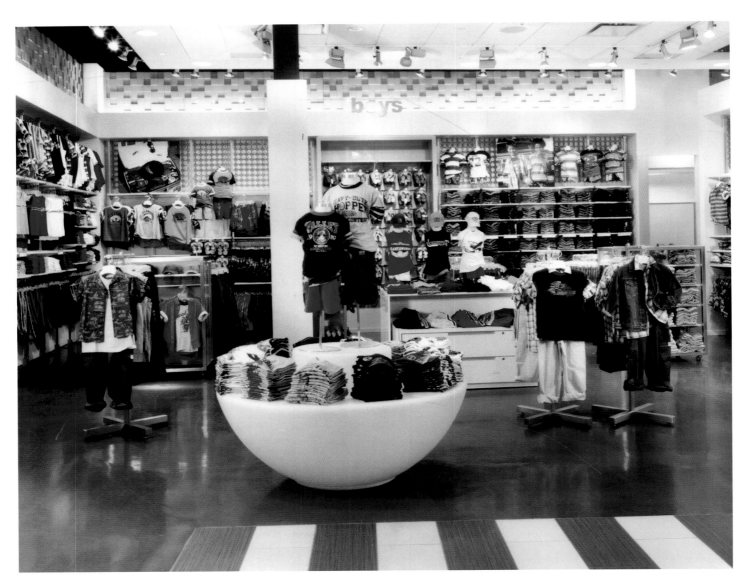

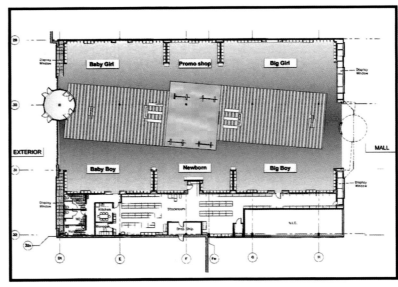

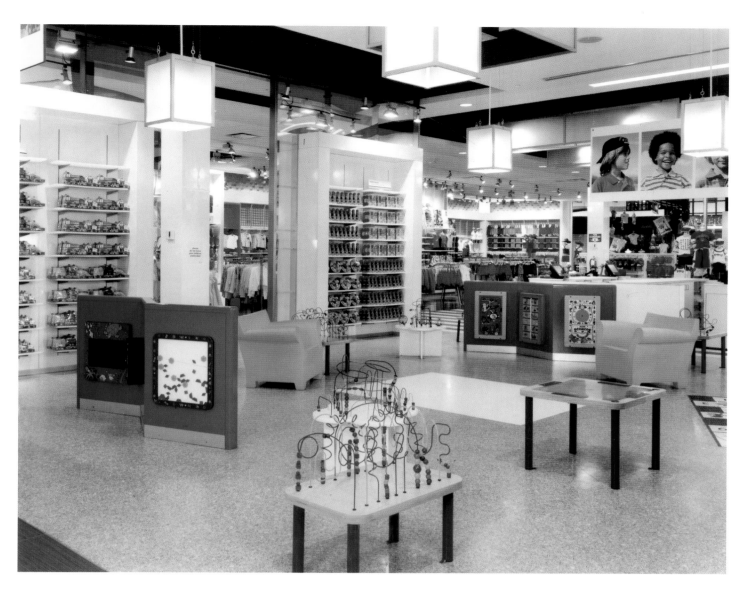

cally placed graphics—"achieve impact and enhance the animation."

The materials that are used throughout are mostly contemporary synthetics: primarily acrylics, resins and epoxies. Frosted acrylics are used on the previously mentioned ceiling blades and also as a backdrop to 12 ft. feature wall displays. In the children's play area there are iridescent acrylic panels that vary from purple to pink to green—depending upon the angle from which they are viewed. Also in this special play area there are conventional toys to keep the children occupied as well as the Reactrix feature: an interactive, secure system that projects images onto the floor that react and change according to the motions and actions of the children below. This space, where parents can safely deposit the children while they shop, has a custom epoxy floor with flakes of

muted turquoise and aqua and it is furnished with molded resin chairs.

The white textured checkerboard MDF panels that appear on the façade are re-integrated to each department except in each area it appears in that department's distinctive color. "The textured MDF panels create continuity throughout the store interior and become the store's signature material."

This store has been "a dazzling success" and currently is surpassing all the American locations.

BAILEY BANKS & BIDDLE

The Galleria, Houston, TX

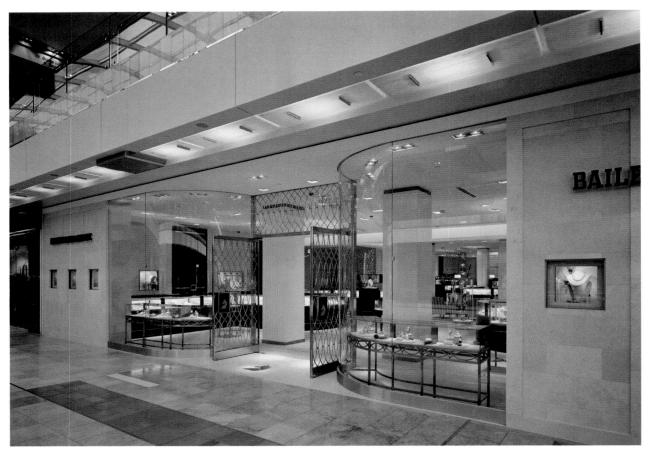

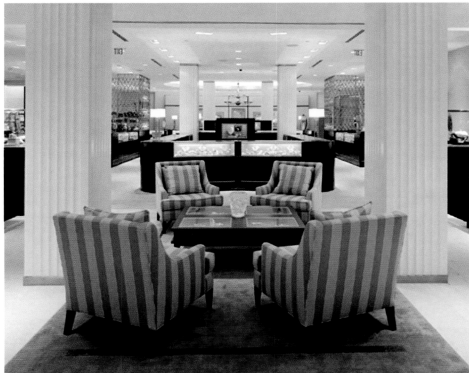

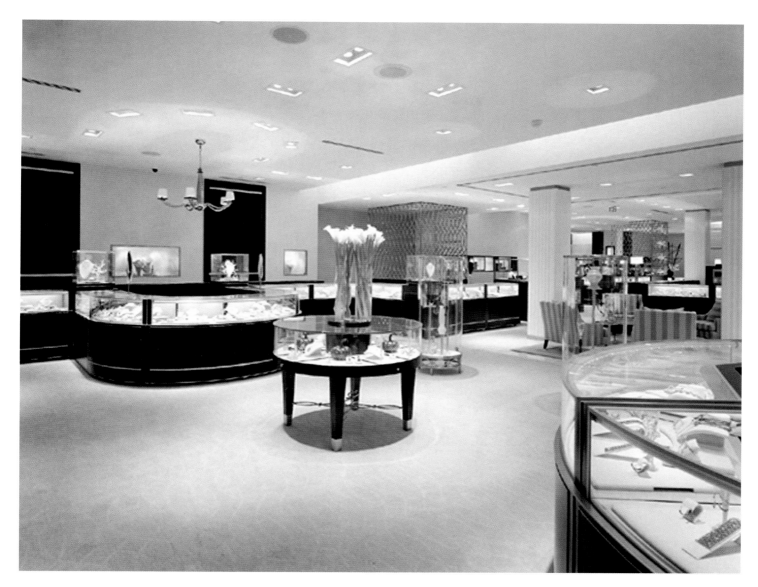

DESIGN: **RYA,** Dallas, TX
CEO/PARTNER: **Tom Herndon**
CREATIVE DIRECTOR/PARTNER: **Mike Wilkins**

Client's Team
PRESIDENT/CEO, ZALE CORP.: **Mary L. Forte**
GVP/COO, ZALE CORP.: **Sue E. Gove**
PRESIDENT OF BAILEY BANKS & BIDDLE: **Charles E. Fieramosa**
DIR. STORE PLANNING, ZALE CORP.: **Parke Wellman**
DIR. OF VM, ZALE CORP.: **Brenda Houston**
VISUAL PROJECT MANAGER, BAILEY BANKS & BIDDLE: **Kurt Johnston**
PHOTOGRAPHY: **Paul Bielenberg Associates,** Los Angeles, CA

Changing its motto from "World Renowned Jewelers since 1832" to "Where Treasures Live," the 172+ year old Bailey Banks & Biddle updated its image to target 35 to 45 year old women whose lifestyle has dramatically changed over the years and because "today's contemporary woman has a need for day-into evening jewelry." Inspired by a need to modernize and with the use of the design talents of RYA of Dallas, the 1800 sq. ft. space in the Houston Galleria is now the flagship store. It has a dramatic environment that is "softly more residential in décor features" and has a seating area with cushioned armchairs and a coffee table with a display of semi-precious jewelry and crystal under its glass top. In this new store there is a larger assortment of fashion styles in colored gems

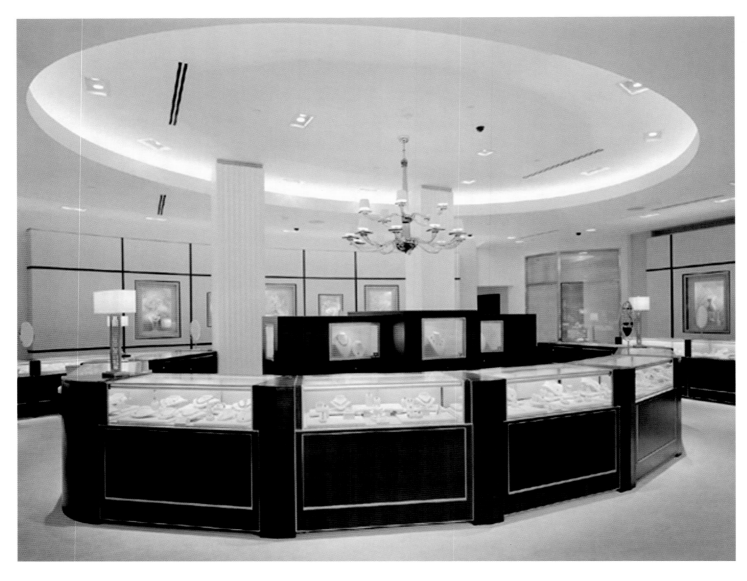

and an expanded home and gift area.

The shopper is invited in through the "sensually curved glass-wall storefront and filigree grilled entrance way" into this new interior rich in cherry wood, fawn suede and brushed nickel. The state-of-the-art fiberoptic lighting combined with lower-profile display cases and the soft colors and luxurious materials, make this a very "high touch environment." The ornamental filigree work from the entrance becomes a signature design element as it is used throughout the store. "It adds a layer of texture to the monolithic space and helps to create rooms within the large space." The grills divide the space and serve as cash/wraps—allowing sales people to remain on the floor. The filigree

wall-like surrounds create individual spaces for fashion, watches, bridal (on the rear focal wall), and gift gallery—on the left. The showcase island is a focal feature that is articulated with a recessed ceiling feature over the island. "With its non-traditional location, customers walk into the store and are pulled to the walls before reaching the showcase feature island."

The gift gallery is all about service and the gift registry allows guests to sit with a sales associate and "experience a custom feel through lighting and case furniture." Built-in vitrines line the wall in the bridal area—"creating visual enhancements to pull the customers to the back of the store." Brides-to-be are encouraged to use the conference area of the bridal

room where they have direct contact with a salesperson.

Mary Forte, CEO of Zales, the parent company, said, "We engaged RYA to help us achieve our vision to transform Bailey Banks & Biddle from a traditional and formal jeweler to one focused on exquisite style and timeless design. Every detail of this dramatic design was considered in a refined, comfortable and elegant manner. Our affluent customer— one of highly discriminating taste— has responded enthusiastically to this design."

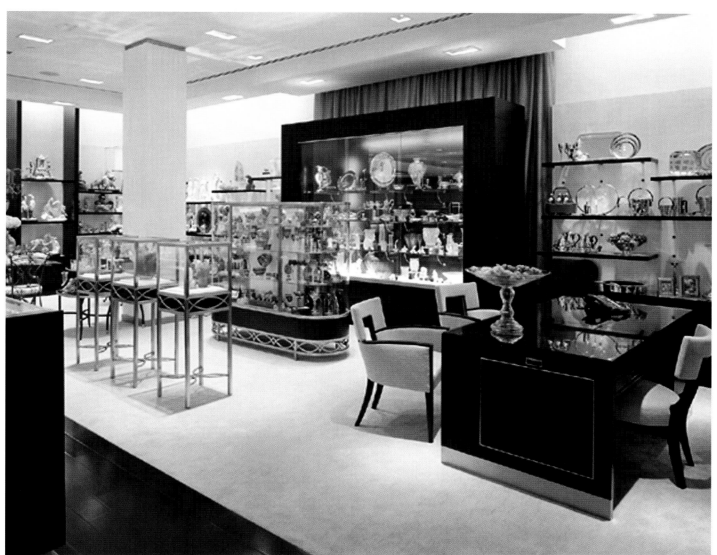

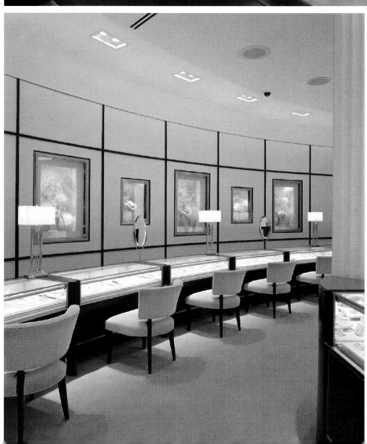

ANTHONY NAK

Austin, TX

DESIGN: **MJ Neal Architects,**
Austin, TX
PHOTOGRAPHY: **Kenny Braun,**
Austin, TX

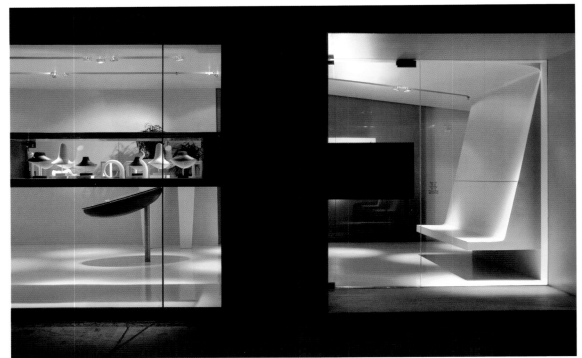

They wanted something different and what they got is different—unique and one-of-a-kind. Anthony Camargo and Nalk Armstrong teamed up to open their first Anthony Nak jewelry store and they approached MJ Neal Architects of Austin, TX with the request for a store design that would as special as the jewelry designs they would be featuring in their shop. They did not want the usual "jewel box" shop. They wanted a space that would invite shoppers to move about easily and feel at home.

The space is white-on-white and interpreted in a variety of textures and materials. There is a Yin/Yang feel to the design with sharp, angular lines of the vertical windows and the piers between them and the long horizontal line of the showcase that makes a continuous band—at eye level—around two sides of the space. These are them complemented by the soft, sinuous oval shaped jewelry display cases that grow up on steel stems from the high-shine white floor. These pop-up pods are the unique jew-

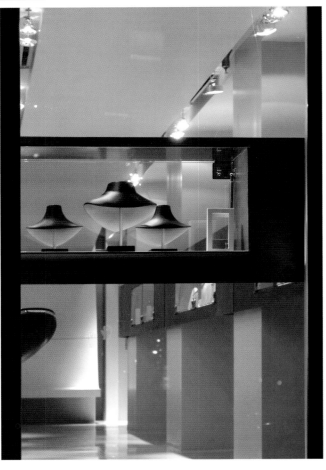

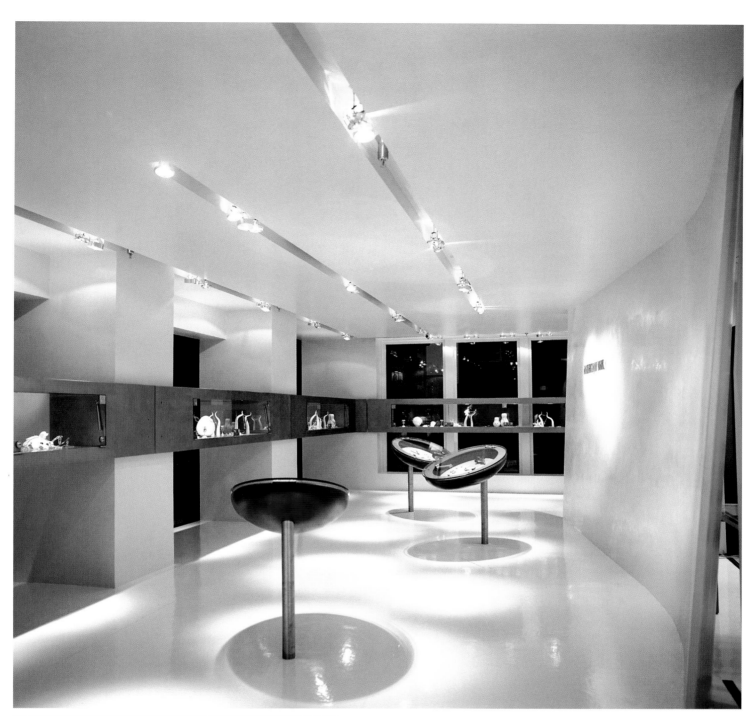

elry display cases in the middle of the shop. The cherry wood bowls are angled and tipped for easy viewing of the encased pieces of jewelry. The jewelry is protected by a glass cover. The cover lifts up and can be set—parallel to the floor and thus serve as a counter upon which the jewelry can be set out upon for the shoppers' perusal. "A pod looks like it's just an aesthetic showcase, but it is actually extremely functional at the same time," says MJ Neal.

The elegant, softly illuminated space

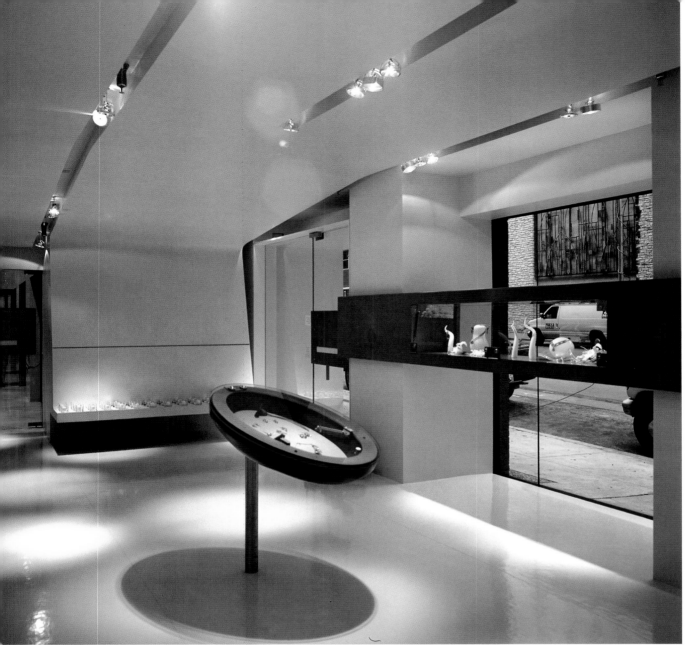

has a quiet, restful quality. The low-voltage lamps are set in recessed slots in the ceiling, but—through use of a filter—at night, after the shop is closed, the lighting takes on a bluish cast. The shop, seen through the floor-to-ceiling windows, seems to blend in with the surrounding "night life" of the street. Also visible through the windows are the video clips that play night and day. They are rear projected onto a sand-blasted glass wall and show celebrities and notables wearing Anthony Nak jewelry.

The shop recently was awarded first place in the Couture International Jeweler Retail Design competition.

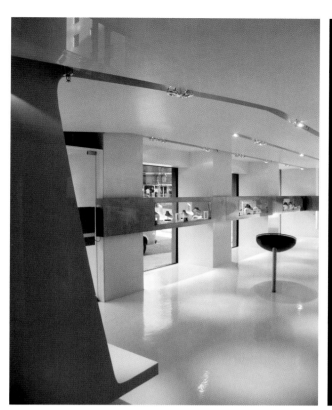

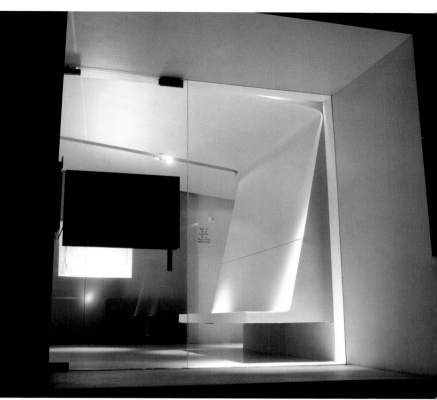

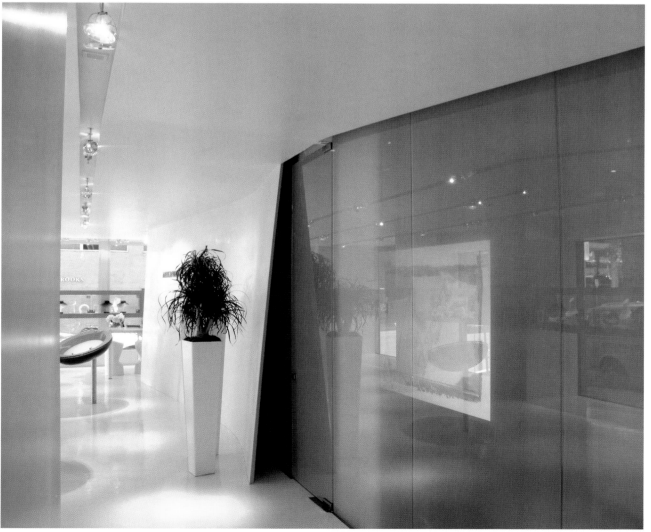

JACOB & CO.

E. 57th St., New York, NY

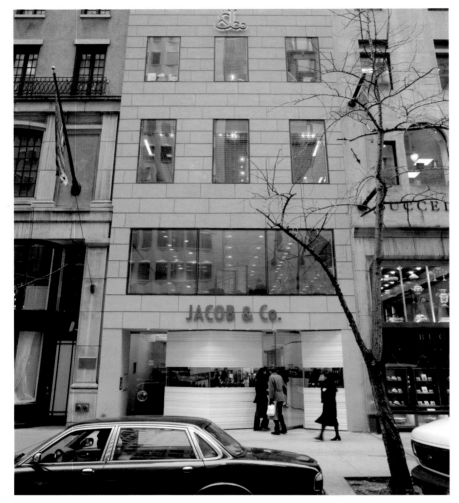

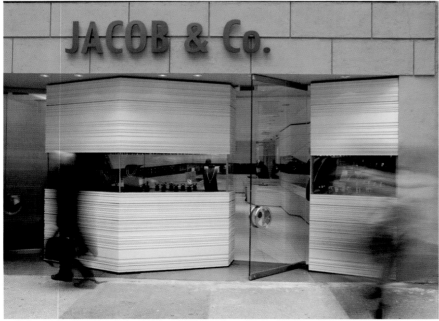

This is NOT your traditional diamond and fine watch store. Jacob the Jeweler has for over two decades had an enviable reputation as The Jeweler to the Stars: mainly the leading new music stars such as Ashanti, Lenny Kravitz, 50 Cent and Sean Coombs who even included a small Jacob area in his own boutique on Fifth Ave. According to James Haag, the business manager for Jacob & Co., "Jacob's business grew to a point where to broaden his clientele and draw a bigger customer base, he needed to open a retail store in the luxury district of New York City. He wants to keep his core business, but then also enhance and broaden it to continue growing."

The inspiration for this unique design—and the unique design actually starts with the façade on E. 57th St.—is the diamond and diamond mining. The designers at the Arnell Group of New York say, "The diamond is the ultimate symbol of success. It represents beauty, strength and achievement. To represent Jacob's story, we will use the metaphor of the diamond." Since diamonds are found in a layer of compressed ore, the design team, under the direction of Peter Arnell, felt that they could turn the mining concept into a retail experience. They took the concept further by emphasizing "strata": the layering of forms. They organized these layers into three levels: the display strata, the storage strata and the lighting strata.

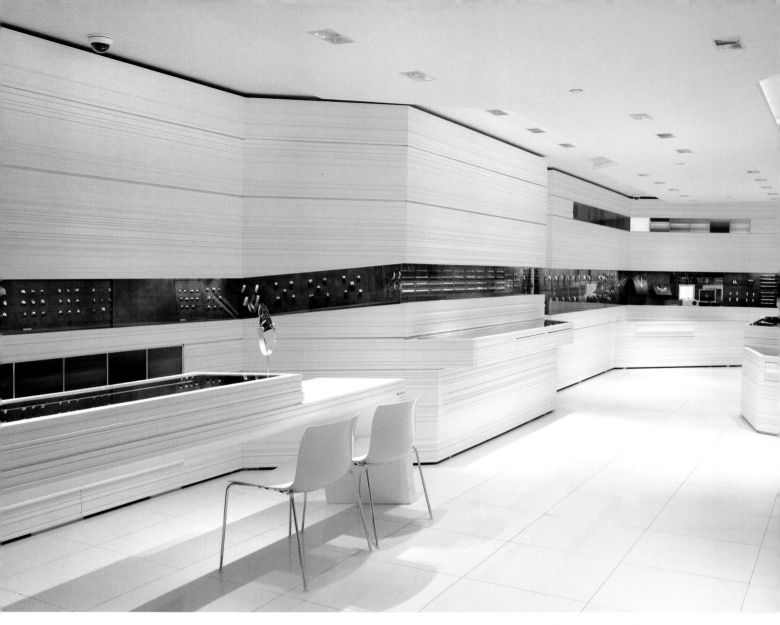

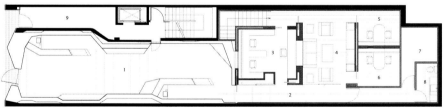

DESIGN: **Arnell Group Innovation Lab,** New York, NY
CHAIRMAN & CEE, IN CHARGE OF PROJECT: **Peter Arnell**
PRESIDENT OF INNOVATION LAB: **Jung-ah Suh**
ARCHITECT: **Philip Von Dalwig**
PHOTOGRAPHY: **Svend Lindbaek**

The interior walls, counters and ceilings run in assorted horizontal bands—striated and multi-layered. Corian is the material that was used and it can be bent, cut and shaped as desired. The color selected was Glacier White and it was digitally carved— based on CAD software drawings provided by the Arnell Group. The space has a long, low, mine-like feeling though it is all glistening white. A white quartz agglomerate is used on the floor and white chairs are pulled up in front of the white display cases. The counters appear to be carved out of the walls and the frieze over the wall-displayed merchandise carries through the same long, horizontal lines broken by sharp, quirky angles and changes of direction. The motor-

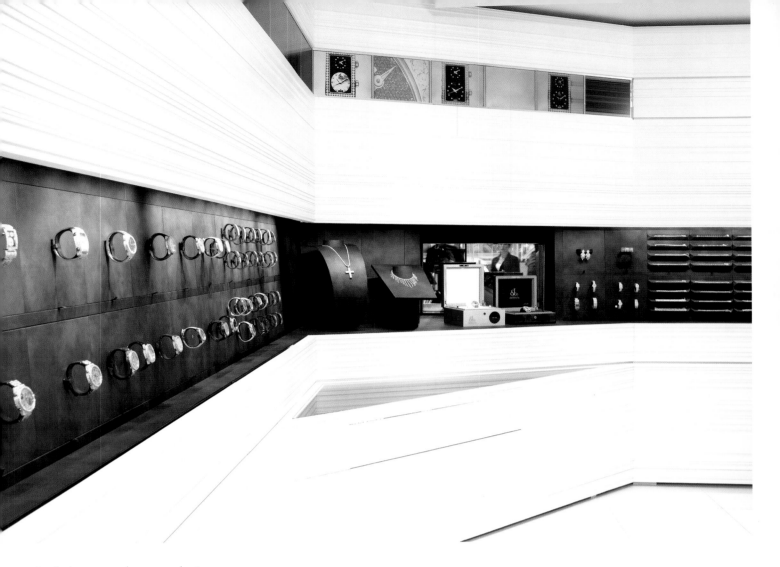

ized glass topped cases make it seem
as though the diamonds displayed
within are still embedded in the "ore."
Instead of handles or knobs to break
the flow and the illusion, the cases are
opened by the swipe of a magnetic
card.

In the rear of the 1200 sq. ft. shop
is a casual lounge for Jacob & Co. cus-
tomers. Haag said, "The lounge adds
to the informality and casual nature
of the store" with its cherry wood
flooring, comfortable black sofas, flat
screens TVs and the unique aquari-
ums. "It almost feels like you're going
to see a neighbor."

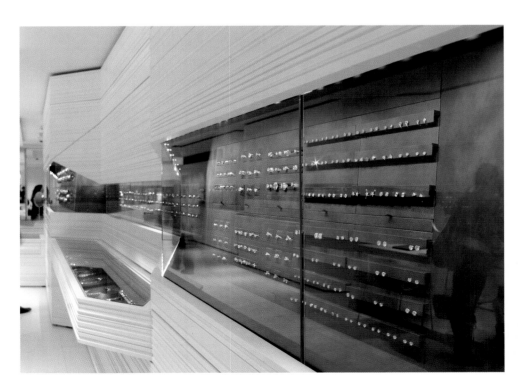

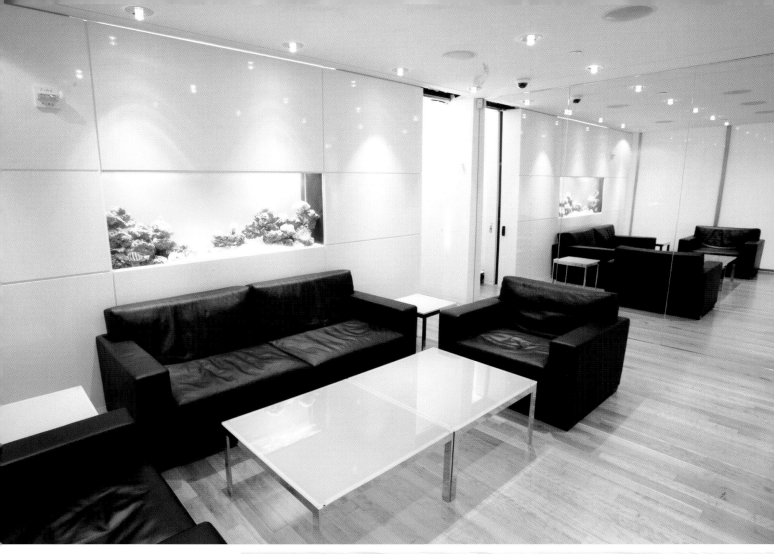

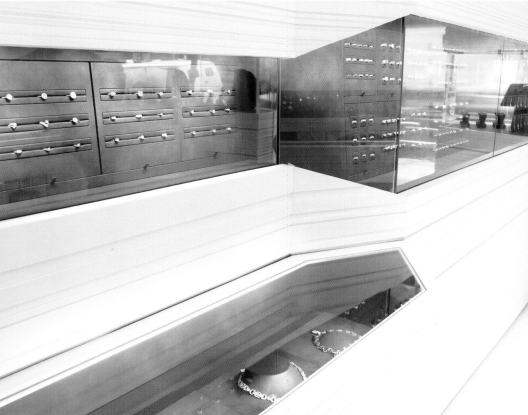

HISTOIRE D'OR

Creteil, France

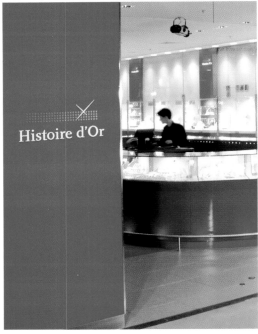

DESIGN: **Dragon Rouge,** Suresnes cedex, France
CREATIVE DIRECTOR: **Georges Olivereau**
PHOTOGRAPHY: **Courtesy of Dragon Rouge**

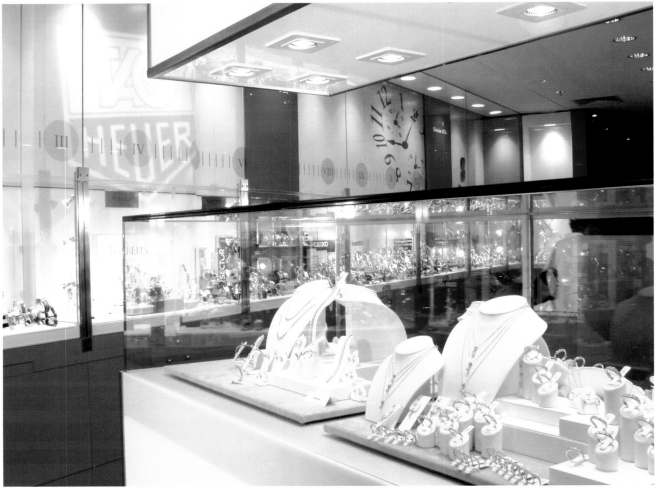

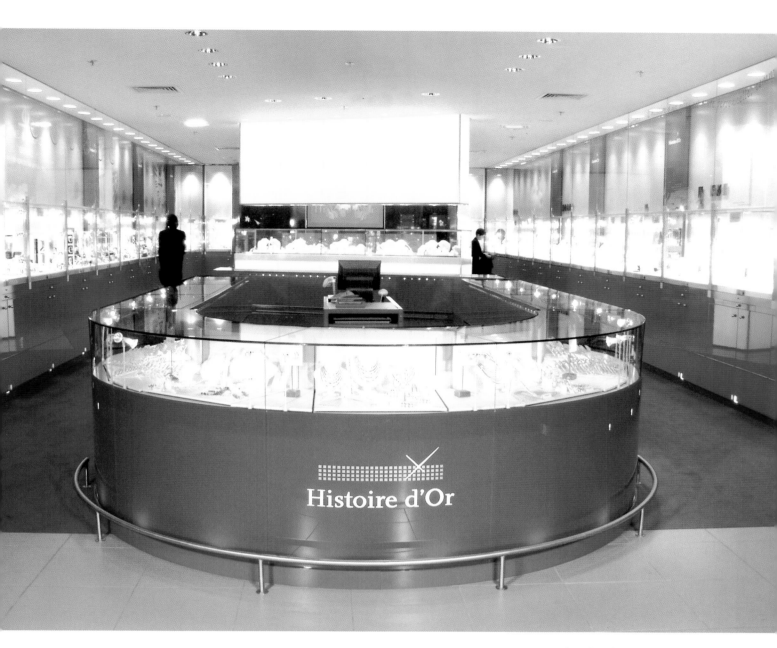

Going hand in hand with the creation of a new brand identity for Histoire d'Or is the new retail space conceived by Dragon Rouge, the Paris based design firm. Histoire d'Or is a chain of over 160 shops usually located in shopping centers that carry jewelry, clocks and watches. The design firm was commissioned to "create a retail outlet concept that is totally innovative in terms of design, promotional activities and communications and breathes fresh energy back into the Histoire d'Or brand."

The new concept focuses on the brand's efficient merchandising activities—the classification and clarification of the product range with showcases tailored to the type of product,

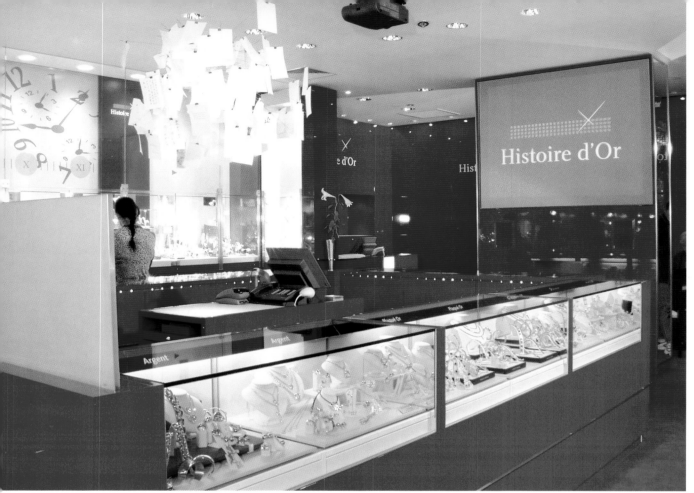

highlighting the brands, and product presentations. Showcases have been designed that include specific presentations: "symbolic and poetic phrases find expression through the interplay of light and shadow while huge visuals are displayed at the back of the showcase. An 'atmospheric' film has been especially designed to conjure up the brand's human and emotional dimension."

All the shops are easily accessible and readily distinguished by the red and gold color scheme. "This choice of color code—evocative of love and professionalism—represents a radical departure from the colors traditionally used in this market segment." The 2000 sq. ft. shops not only carry the jewelry that "accompany each important moment in an individual's life," but they are enhanced by "the use of visuals presenting faces, smiles and appropriate text."

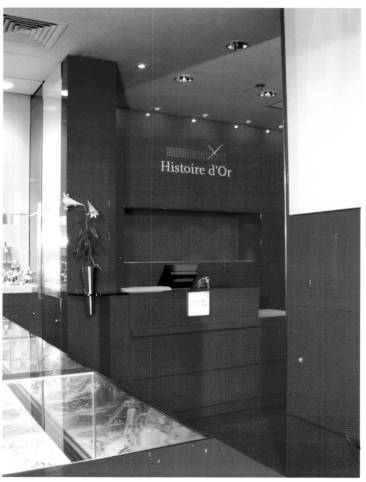

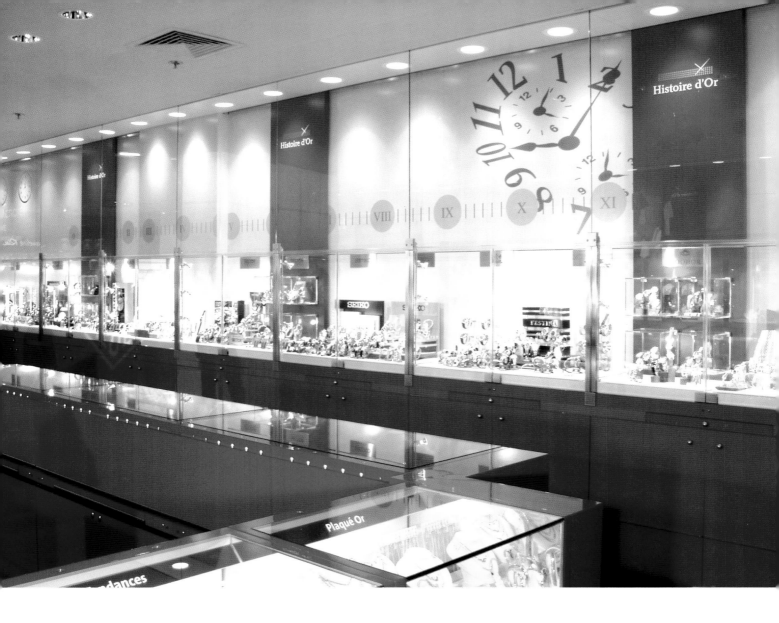

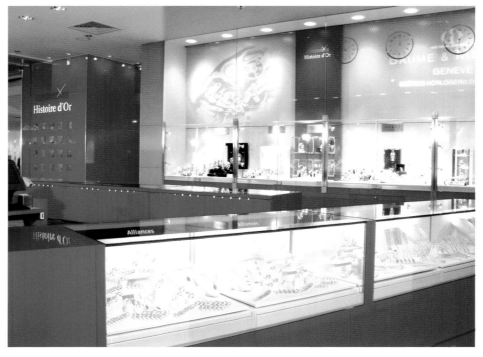

GIUSEPPE ZANOTTI DESIGN

Forum Shops, Caesar's Palace, Las Vegas, NV

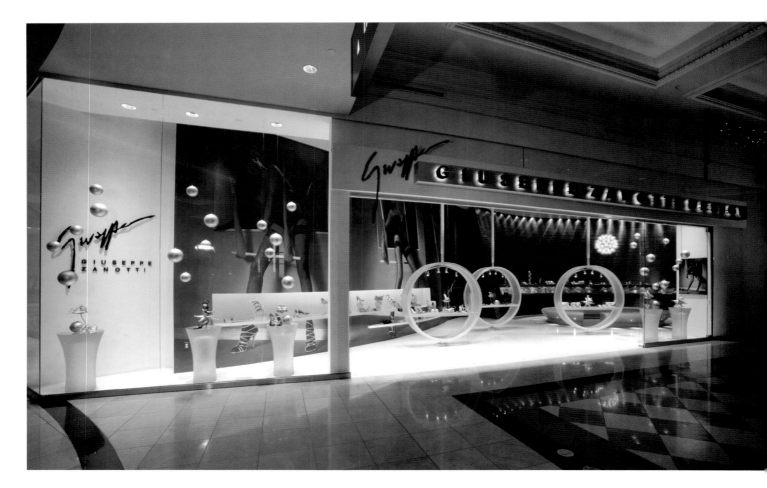

The Giuseppe Zanotti Design shop in the Forum Shops in Caesar's Palace in Las Vegas is the first roll-out for the Italian luxury footwear designer/manufacturer. Zanotti's "sexy and playful" footwear designs inspired Lionel Ohayon and his ICRAVE Design team to take a new and unexpected approach to designing this 1800 sq. ft., wedge shaped space. If the Zanotti designs were not challenge enough, the location and the shape of the space demanded something special and unique. Also, the show designer requested "a fresh and minimalist approach to shoe display and shopping with an emphasis on sleek luxury and a minimalization of displaying cash transactions in the shopping process."

The 21 ft. wide entry was left as open as possible and the angular space

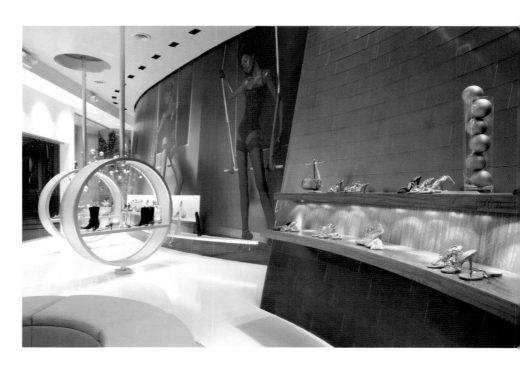

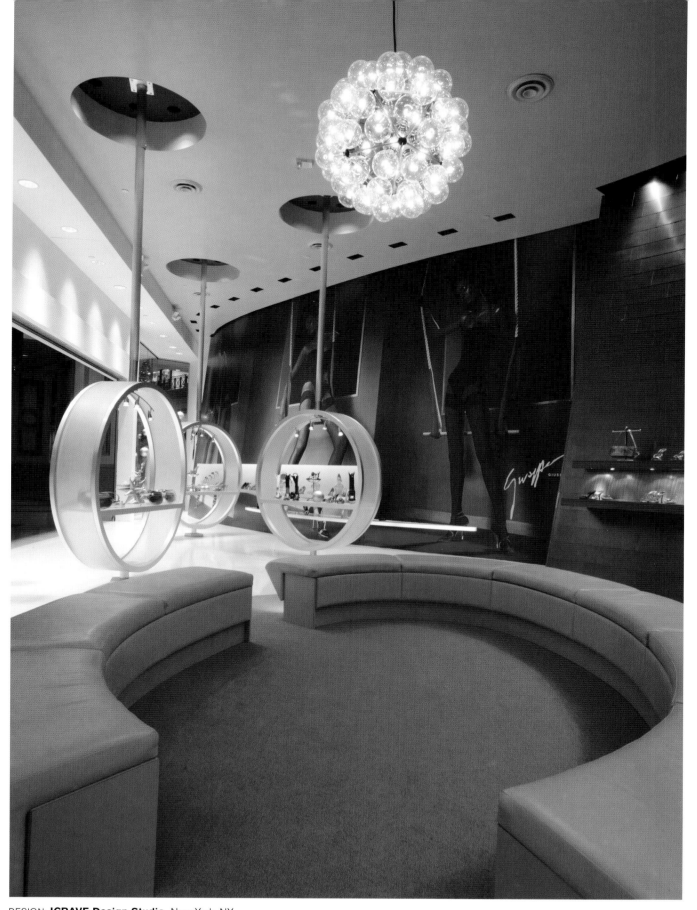

DESIGN: **ICRAVE Design Studio,** New York, NY
PRESIDENT: **Lionel Ohayon**
PROJECT DESIGNER: **David Graziano**
PHOTOGRAPHY: **Jeff Green,** Las Vegas, NV

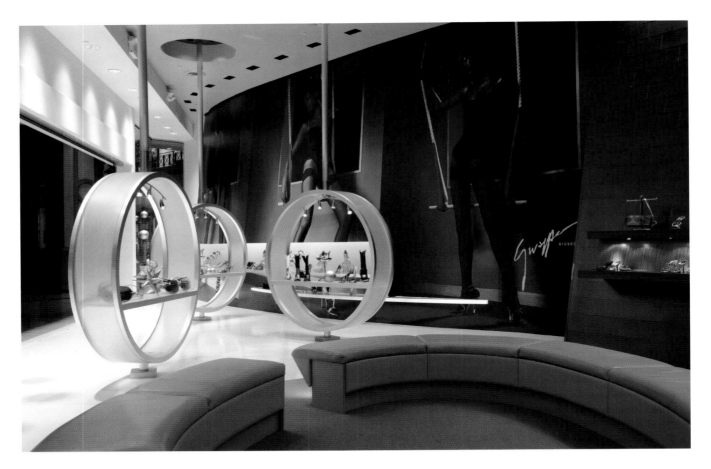

was "rounded out" into a cohesive shop with two sloping and bending walls—"drawing shoppers fluidly in off the mall concourse." Once inside, shoppers "navigate around three large resin rings displaying products—suspended down from the ceiling." These pivot around to serve as window display features when the store is closed. Electricity travels through the shaft from the ceiling to illuminate these unusual display elements. Located up near the floor-to-ceiling glazed panels that enclose the shop are resin formed pedestals upon which featured shoes are displayed as "works of art." "We created the pedestals as if the shoes were mini sculptures."

The left curving wall features an oversized graphic that is changeable and there is a space behind that wall to hide storage and maintain the out-of-sight cash/wrap. Illuminated resin display shelves are cut from the wall that leads shoppers into the center of the retail space. The back wall is layered in ribbons of zinc sheets that are cut to take the curves and angles of its form. This wide sweeping curved wall is also

positioned on axis from the front entry—"creating a strong organizing principle by which the circulation flows." Inside its curve are a pair of large, suede covered banquettes. The two arced forms create an inner oval with openings between them. Fiber-optic lights are embedded in these seats so that the shoes—when viewed—are illuminated.

Shoppers can sit either facing inside the oval—for privacy—or on the outer rim so as not to miss any of the activity in the shop. For the shopper's convenience there is a large mirror that "visually continues the curving line of the back wall. Hanging over the central void is a bubble chandelier. David Graziano, the project designer, said, "We wanted to create a centerpiece over the seating area, and we wanted a chandelier that would tie into the rest of the architecture and lighting." This centerpiece area is further highlighted with a foot-warming carpet while the rest of the shop has an epoxy coated floor.

This is a design that more than holds its own in the world of Las Vegas. It makes a definitive statement!

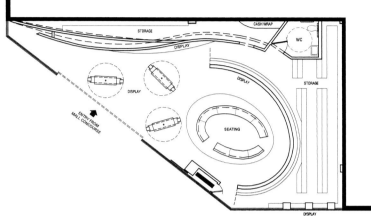

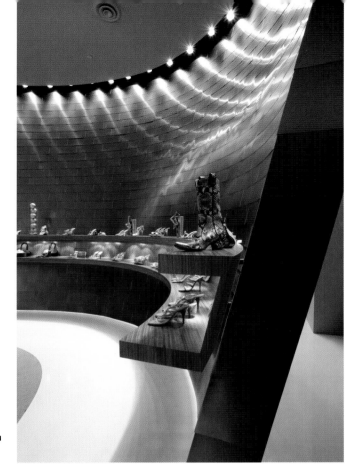

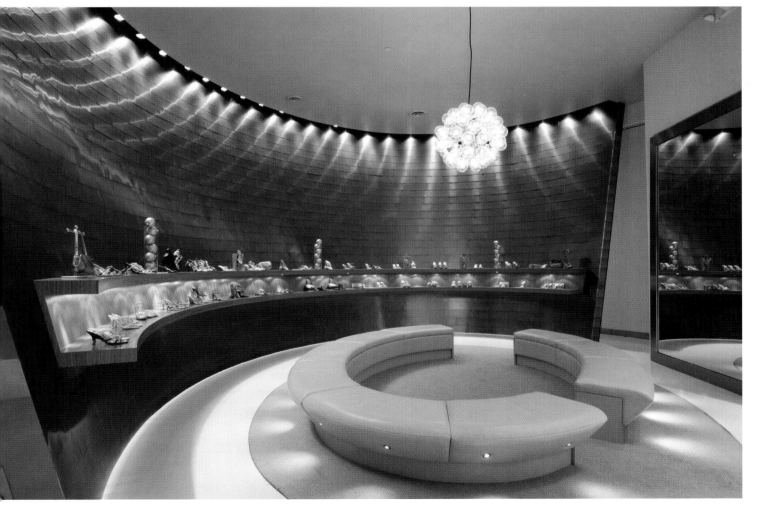

HUMANIC

Schildergasse, Cologne, Germany

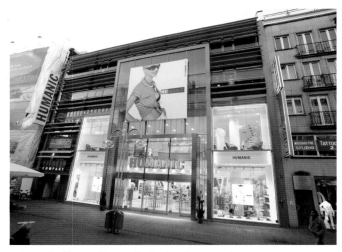

DESIGN: **In-House Humanic design team and Umdasch Shop Concepts**
SHOPFITTING: **Umdasch,** Amstetten, Austria
PHOTOGRAPHY: **Courtesy of Umdasch**

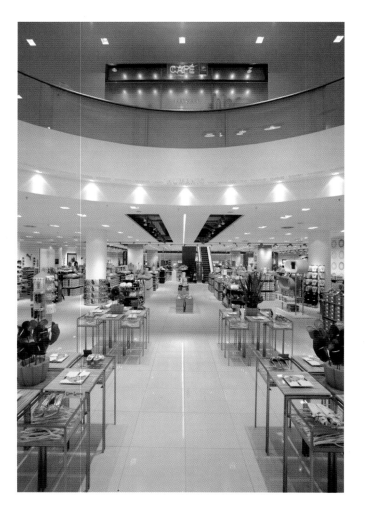

Reinhard Peneder, a writer on things retail in Germany, wrote, "The Graz-based Leder & Schuh AG has set new standards in the shoe trade within Europe with the opening of two Humanic Shoe World stores, each approximately 3000 sq. meters (31,600 sq. ft.) in size, at top addresses in Cologne and Vienna. One of the secrets of the success of the long established company is its avant-garde shop design, which arouses the senses with its uncompromisingly well-ordered shoe presentation."

A shoe store of this size is unique and allows shoppers the opportunity to see many different designs. "In order to become the market leader in any given field, it is essential to have a certain number of designs on display. The number of designs on display multiplied by the presentation philosophy gives the sales area required," said Dr. Thomas P. Kidder, Chairman of the Board of Humanic. It took the combined talents of the Umdasch Shop Concept team working closely with the Humanic in-house designers to create the exciting phenomenon that appears on the Schildergasse in Cologne.

The ground level of the three story shop is devoted to women's shoes with the young, trendy fashions to the right of the entrance and that area is bright, fun and exciting. Sports brands are on the left. Children's shoes are located in the basement where youngsters will also find entertainment designed just for them; a playground with a basketball court and a PlayStation island. Men's shoes are on the first level up with exclusive designs displayed on the far wall and sports shoes on the right. "Special Offers" are available on this level as well as in the basement in the "Bestseller Area."

Throughout, the colors are sharp, clear and bright with red predominating. There are bold swaths of red patterning the off-white floors and the bands continue up the walls and cross over-

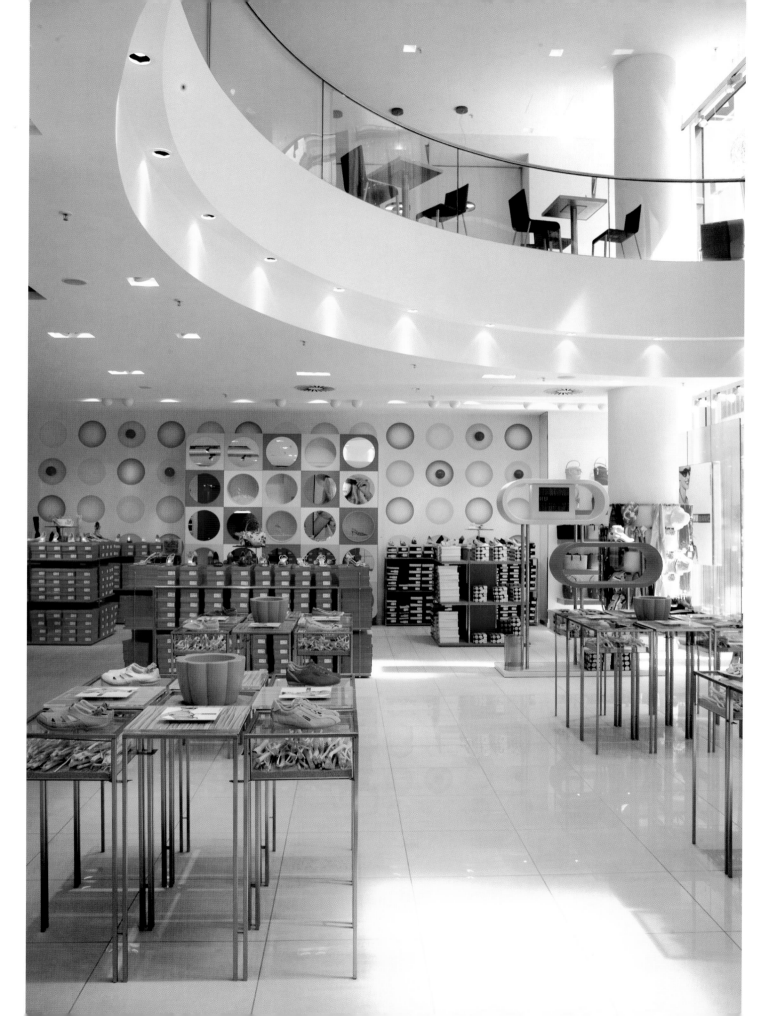

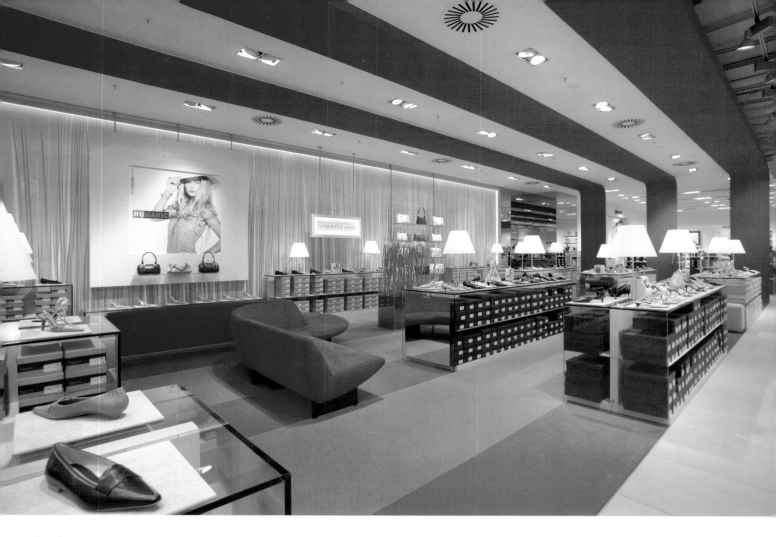

head—sandwiching the light looking acrylic fixtures in between. Giant colored graphics of attractive young people serve as departmental signage and pinpoint the areas with their lifestyle imagery. In addition to the overhead spots that reflect off the clean, white walls and floors there are small residential-style lamps set atop the mass merchandise fixtures to highlight the styles shown at the shopper's eye level. "The expert use of colors is as important as the communication via pictures and the skillful emotional appeal. Humanic arouses the senses. Consistency is important when it comes to the installation of a particular range; the rules to follow are clear."

A café on the upper level not only offers an attraction for coming into Humanic but it is also a reason for staying longer and shopping more. Though the space is very large, the individual areas and departments are all human size and the color banded ceilings tend to lower them and create a sense of intimacy.

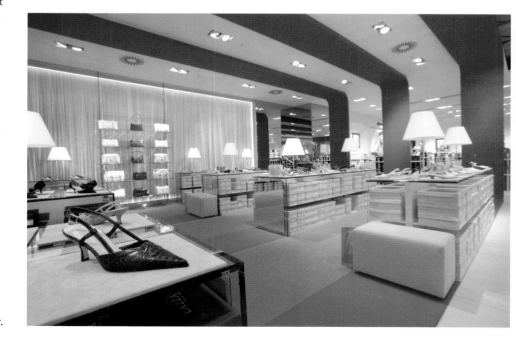

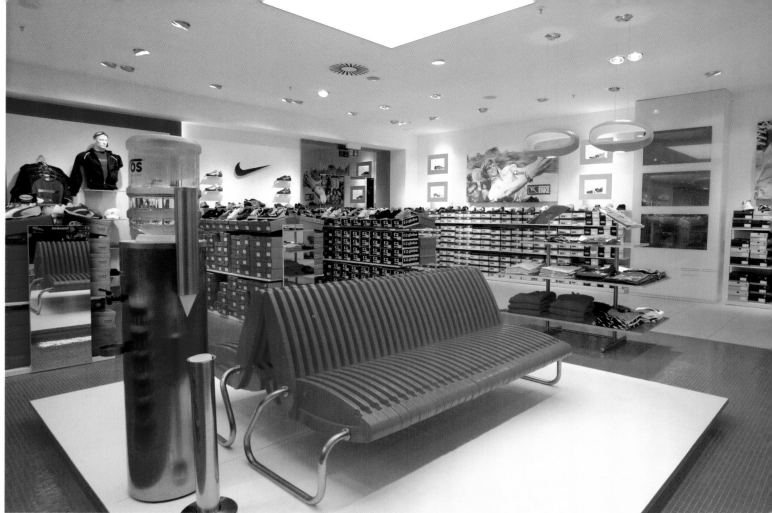

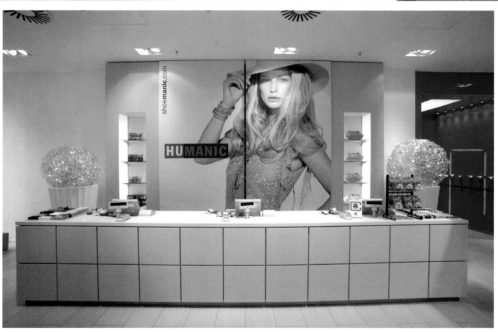

TOWN SHOES

Toronto, ON, Canada

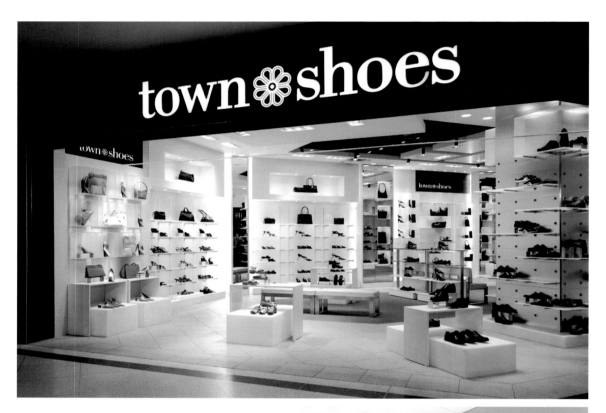

DESIGN: **Watt International,** Toronto, ON, Canada
Andrew Gallici, Brian Bettencourt, Merrill Fung
PHOTOGRAPHY: **Richard Johnson, Interior Images**

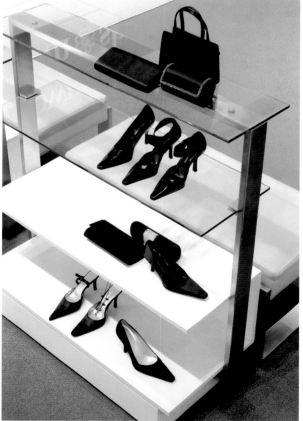

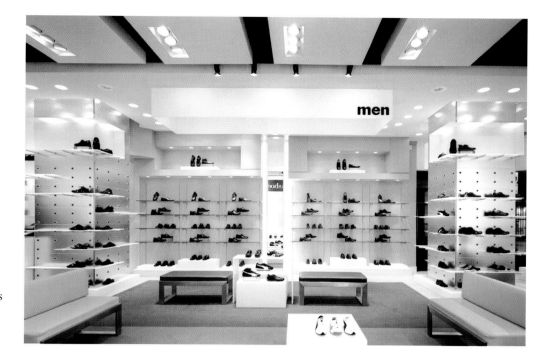

For its first urban, unisex shoe store, Town Shoes selected Watts International of Toronto to design this "fashion forward shoe store" that now appears in malls. It was designed to appeal to a broad spectrum of clientele—from men and women in their 20s to a mature age group.

The space is wide open—completely exposed to the shoppers in the mall. The black, proscenium-like façade is distinguished by the white backlit store name and logo. It also contrasts sharply with the all white-on-white shop that is accented with Plexiglas and stainless steel. The white tile floor is laid on a diagonal to increase the sense of space and the floor fixtures and seating are all white and chrome. Diagonally placed partition walls carry a display of shoes and handbags and also create a sense of movement in the space while dividing it up into definite areas. The partition walls carry their own illumination so that all the displayed products are on view.

The design is totally modular in concept from the wall fixtures to the re-arrangeable wall partitions so this design concept can easily be adapted to various size and shape spaces. "The inviting and sleek concept, through the manipulation and juxtaposing of architectural and fixture elements provides an appealing environment for the broad target market of fashion savvy consumers." This design has received awards from the Association of Registered Interior Designers of Ontario and the International Council of Shopping Centers.

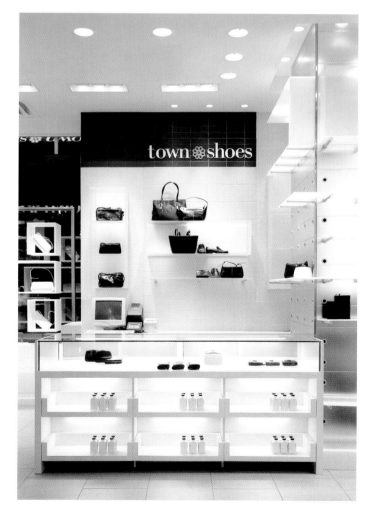

DAVIDS

Yorkdale Mall, Toronto, ON, Canada

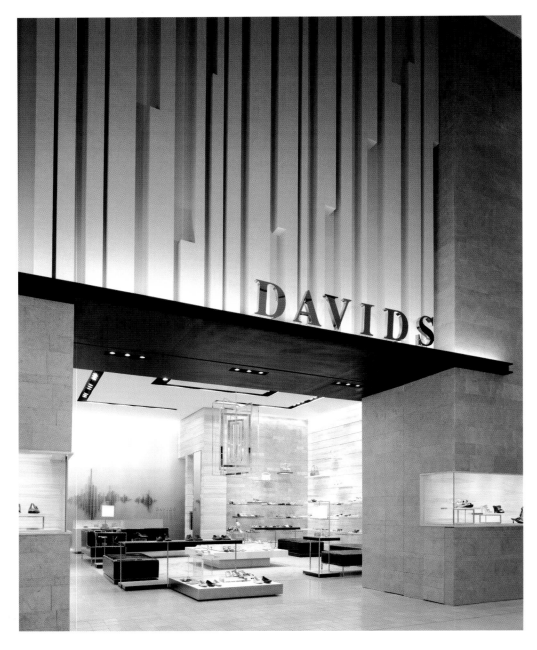

DESIGN: **Burdifilek,** Toronto
DESIGN DIRECTOR: **Diego Burdi**
MANAGING PARTNER: **Paul Filek**
ARCHITECTS/CADD: **Michelle Tang,
Georgia Ydreos**
SENIOR DESIGNER: **Tom Yip**
JUNIOR DESIGNER: **Michael Steele**
PHOTOGRAPHY: **Ben Rahn**

For more than 50 years the "well-heeled" and "well shod" shoppers of Toronto got their shoes at Davids. In moving to a larger space in one of the city's major, up-scale malls, Davids called upon the designers at Burdifilek to create a space that would "reflect its refined fashion sensibility." The designers' new retail concept not only reflects the elegance and history

of the Davids' brand but it also provides a sophisticated background with an international aesthetic for the boutique's footwear collection.

"The 'modern classic' space makes a refined statement that creates a distinctive voice in the shopping mall environment." It starts with the startling, yet stunning, façade composed of "complex materials and refined

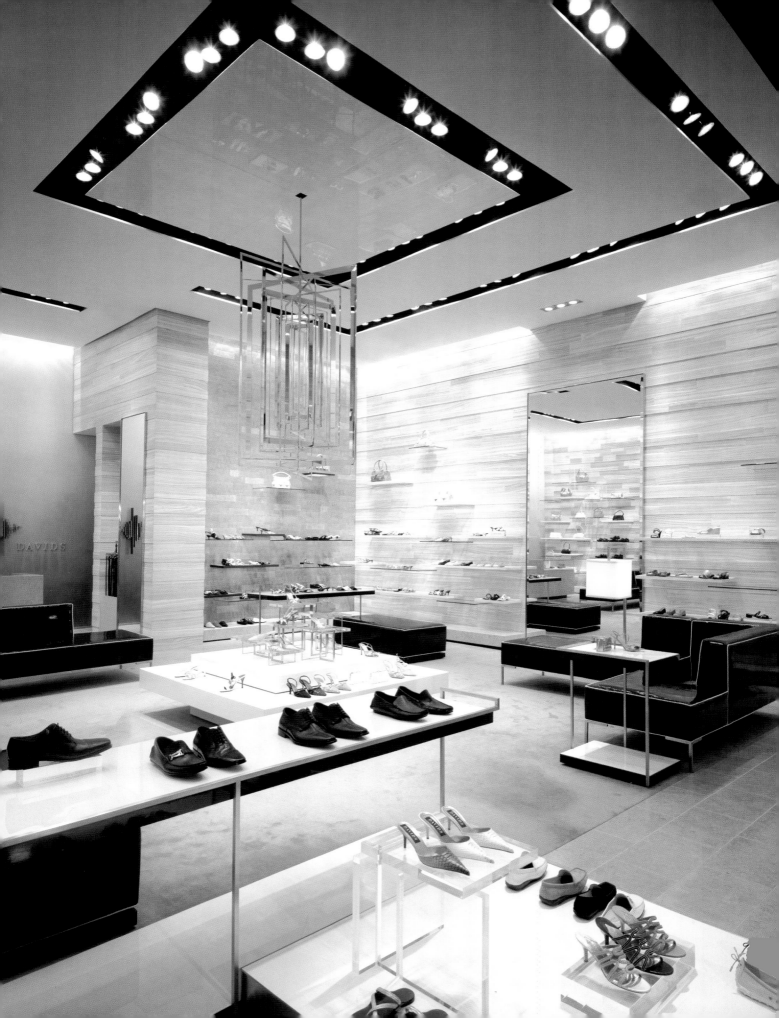

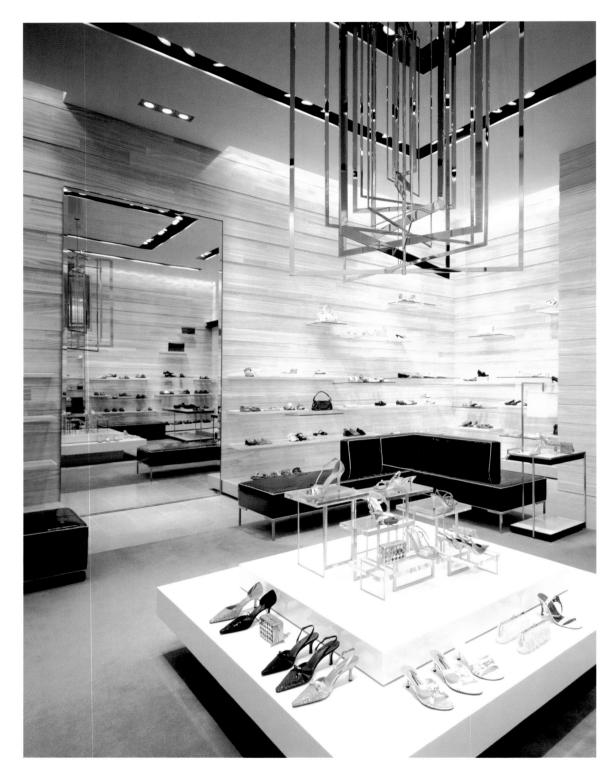

forms." "The prominent rectilinear wall sculpture is contrasted by the smooth limestone façade and a display window creates a dramatic horizontal break in its strong vertical presence."

The interior is soft, subtle, subdued. The blackened zebrawood paneled walls graduate from a soft ecru to a pale, smoky gray. "The horizontally laid wood finish undulates and creates a beautiful textured background for the sculptures and fixturing." Rich chocolate brown sectional furniture—simple geometric slabs of color—break up the space into intimate, seating/try-on clusters and the shoe displays seem to float on air amidst the seats. A silky, steel gray/blue carpet rests on the textured

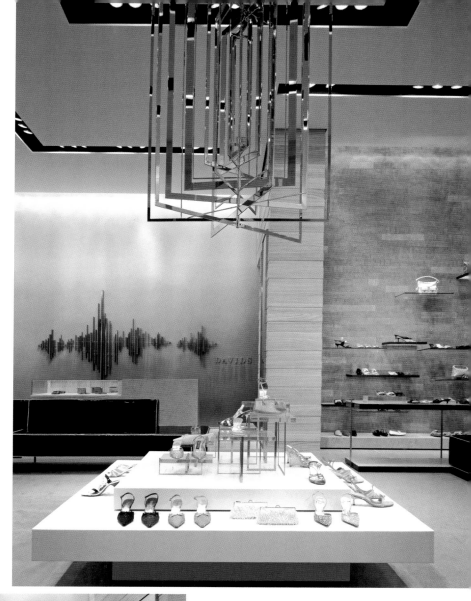

honed limestone floor.

There is a Donald Pliner boutique-within-the-boutique and it is distinguished by end-cut, sandblasted and white-washed walnut. The signature piece in the Davids shop is the Calder-like sculpture constructed of polished and mirrored chrome that hangs "in suspended animation" in the center of the store. The cash desk, at the rear of the shop, is highlighted by a custom, hand-made feature wall installation.

"The new space embodies a true 'urban luxe' environment and uses a subtle and complex materials palette that sets Davids apart."

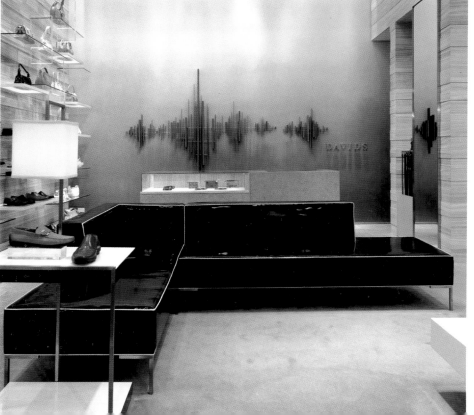

SHOEBUZZ

Millbury, MA

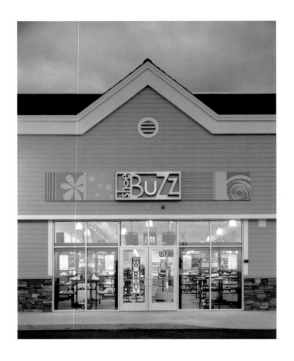

shoeBUZZ is a new retail store concept conceived by Monastero & Associates of Cambridge, MA for the Stride Rite Children's Group. The designers created "a brand environment that offers busy parents, who demand selection and convenience, the most popular footwear brands and styles for infants and children to age ten in a single shopping destination." "It's hip, it's fast, and it has 'zillions' of shoes."

The "shoeper market" is located in Millbury, MA and though it is a "big box" operation, it is filled with fun and friendly graphics and bright colors. Boys shoes are on one side of the main aisle and girls are on the other. Each area is delineated with its own color palette and easy to recognize signage. The walls and ceiling are lime green and the gray floor is gaily patterned in bright colors that appear throughout

the space and they held to define areas. Try-on seating is provided in the central aisle with a circular FIT ZONE up front. Here a member of the store's "Buzz Patrol" can check out the fit of a child's shoe. There is also a play area, displays that are keyed to the young consumer and away in the rear of the long space is the BABY BUZZ area with a display look all its own. Also, in the rear, are the family-friendly restrooms.

The cash/wrap area is located up front, near the main entry, and next to the FIT ZONE. Herrre the bright colored graphics make a big splash on the rear wall and the coral red-colored counter replays the upholstery color of the circular pouf in the FIT ZONE.

All the merchandise is displayed in an "open sell" fashion and the off-the-shelf fixtures were customized to the

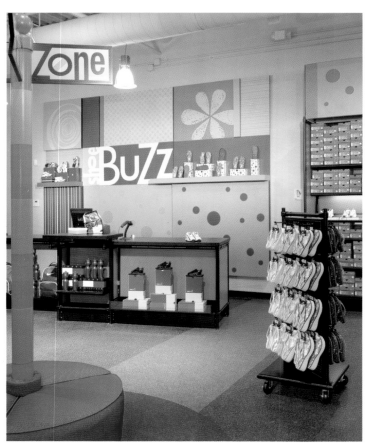

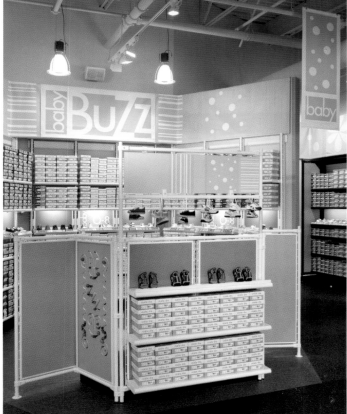

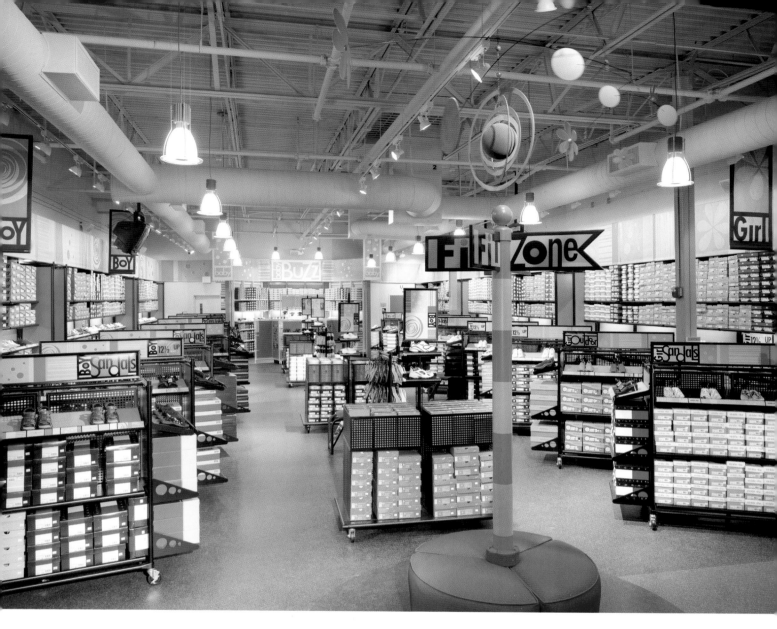

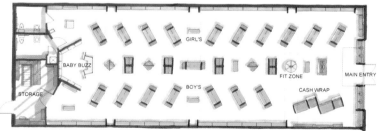

DESIGN: **Monastero & Associates,** Cambridge, MA
PRINCIPAL IN CHARGE: **Nina Monastero, AIA**
DESIGNER: **Edith Twining**
JOB CAPTAIN: **Jonathan Merin**

For Stride Rite Children's Group
PRESIDENT: **Pam Salkowitz**
SR. VP OF RETAIL OPERATIONS: **Jay Nannicelli**
DIR. OF RETAIL & CONSTRUCTION: **James Harte**
PHOTOGRAPHER: **Lucy Chen,** Somerville, MA

designer's specifications to accommodate the custom shelf edge and POP signage, end cap display and other elements that have been added for child play and amusement. In addition to the perimeter wall washers and the concealed fluorescent lights, metal halide lamps provide the main ambient lighting for the store.

The entire shoeBUZZ brand experience was conceived simultaneously. The design team created the name, the brand identity, the shopping environment, fixtures, graphics, shopping bags, etc. "The result is a fresh, new, consistent store concept that customers are 'buzzin' about."

MAISON D'OPTIQUE

Thousand Oaks, CA

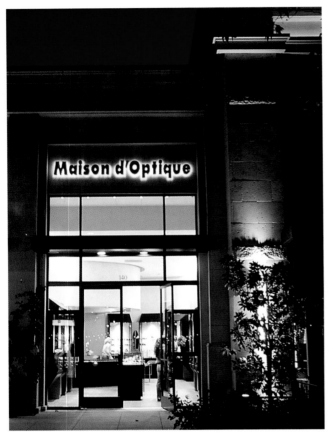

DESIGN: **Atlaschi Associates Architects (A3LA),** Marina del Rey, CA
Principal: **Amin Atlaschi**
Project Designer: **Min Sung**
Photographer: **Sasan Amini,** La Jolla, CA, **Amin Artlaschi**

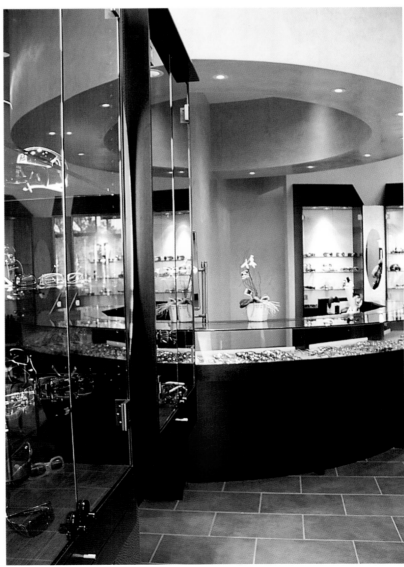

Eyeglasses are more than to help one see. They are also to be seen—seen as a fashion statement. They are part of a wardrobe and a reflection on the users lifestyle. "It's not like a handbag or shoes or apparel—not yet!," said Valerio Giacobbi, Exec. VP of the North American division of Luxotrica. For eyeglasses to sell today they need to be in a fashionable setting.

Amin Atlaschi of A3LA, of Marina Del Rey was invited to design the 875 sq. ft. Maison d'Optique—a new concept for a privately owned chain of fashion optical. The concept focuses on the skilled workmanship of the merchandise that is artfully presented in wall cases, on floating shelves and in museum cases out on the stone laid floor.

The custom designed fixtures are made of a warm dark brown wood

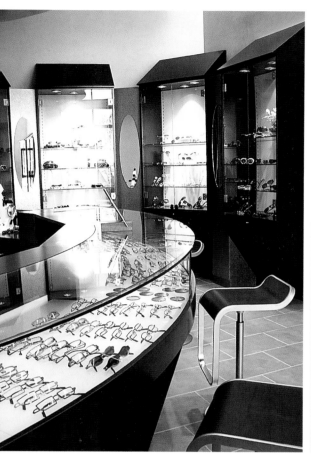

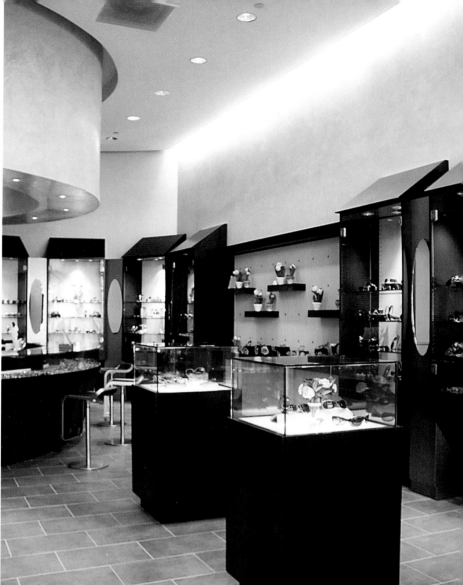

that is highlighted with brushed stainless steel hardware. The walls are finished in light beige and pale turquoise hand applied Venetian plaster. A sweeping half circular crown drops from the ceiling to accentuate the location of the semi-circular cash wrap/service bar where custom fittings and business transactions take place.

Throughout, the lighting is warm and focused. Wall washers along the side wall sweep down to illuminate the wall units that also carry their own internal illumination. Spots are set into the dropped ceiling as well as into the lip of the curved soffit over the bar.

The overall feeling is of a jewel-box boutique.

COOKS OF CROCUS HILL

Edina, MN

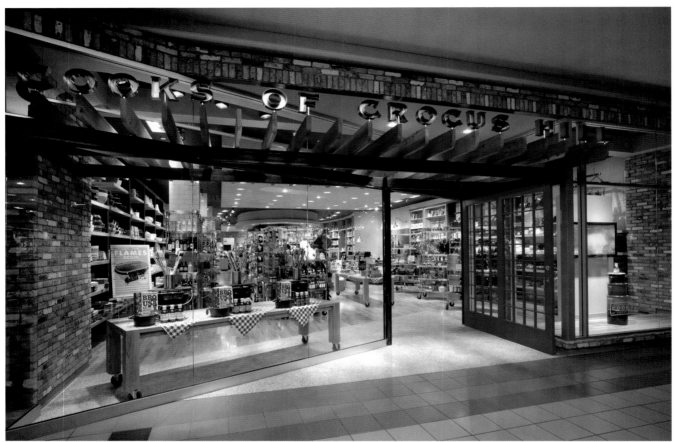

Cooks of Crocus Hill's strongest advantage is that it not only sells cooking equipment but it also teaches customers how to use it. This 25 year old company has long been an established fixture—and destination for—"cooks" in St. Paul and this shop, as designed by Jeffery Agnes of Architects of Minneapolis, MN is the company's first, in-line mall store. Located in the Southdale Mall, in upscale Edina, the store is targeted at "middle to upper class wage earners, 28-45 years of age—and predominantly women."

According to Jeffery Agnes, "Cooks of Crocus Hill believes that 'life happens in the kitchen.' Cooks is about a passion for life where food and food experiences are essential lifestyle elements. It is educational, energetic, experimental, soulful, styl-

ish and legitimate." He felt that in his design he had to express all that and with his design create a 3D brand image.

The storefront is dominated by an overhead trellis made of rough sawn timber that extends through the glass and masks the glazing line. A large logo on a semi-transparent etched glass panel is pinned off the trellis. The terrazzo floor extends inside and outside of the storefront line that is skewed out of line with the adjacent shops. The overhead grill and the bright red doors echo elements found in the flagship store on Grand Ave. in St. Paul.

Inside, a centrally located "Information" core anchors the store's layout. The edge of the core is defined by the "library" with curved white walls of stacked cook books and glossy

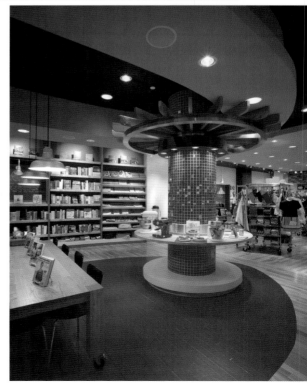

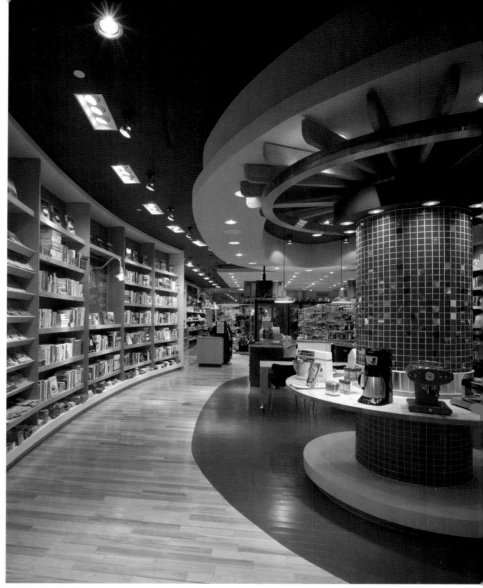

white kitchen tile bookends. At the back of the Information kiosk is a "European-like" community kiosk that is made of rock-candy cherry and it holds public announcements applied with custom-designed metal magnets. An overhead wood trellis canopy serves to highlight the demo products area below it. This kiosk acts as a backdrop to the parabolic display kitchen—located at the bow of the core. The theatrical food presentations here "beckon to the customers while subtle aromas and fresh handouts make the invitation irresistible." The table beyond the "kitchen" can be used to host special events when not serving as a display set-up for products.

A plasma screen is mounted on a wall that changes color with the seasons. It is connected to the display kitchen activities. The monitor is also "looped" to show cooking class videos. The rear wall of the store is fitted with custom metal pegboards that hold a vast variety of kitchen gadgets. A backlit store logo on the curved brick wall ties back to the sign out front and "wraps up the brand experience."

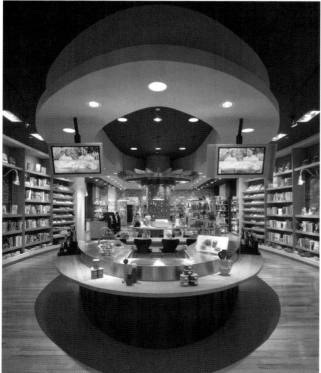

DESIGN: **Architects, LLC,** Minneapolis, MN
ARCHITECT/ DESIGNER/ PRINCIPAL: **Jeffery P,. Agnes, AUIA**
INTERIOR DESIGNER: **Marie Dwyer**
BRAND ADVOCATE: **Karl Benson**
LIGHTING: **Michael DiBlasi, Schulker & Shook, Inc.**
GRAPHICS: **Andy Weaverling, Roto**
PHOTOGRAPHY: **Joel Koyama, Joel Koyama Photography**

HANNspree

San Francisco, CA

DESIGN: **Rich Honour International,** Taipei, Taiwan
ARCHITECT: **Mulvanney G2,** Portland, OR
PHOTOGRAPHER: **Windsong Imagery,** Arvada, CO

The award winning HANNspree store, located in a 9500 sq. ft. space on Sutter St.—near Union Square—in San Francisco is the company's flagship store in the U.S. HANNspree California Inc. is the creator of a brand new category of design-driven, lifestyle inspired home entertainment products.

The elegantly designed store provides Bay area residents with "a fun and inspiring way" to experience HANNspree's revolutionary array of television sets. There are over one hundred models with a variety of concepts, unique shapes, and high quality materials. Designs range from sleek and elegant wood units for sophisticates to cuddly, fur covered sets for youngsters. "HANNspree draws upon contemporary interior design trends and individual passion to create televisions that uniquely accent any room and give expression to any taste or lifestyle."

The two-level store is open, bright and spacious with spare clean white fixtures sitting on bleached white natural wood floors surrounded by mostly off-white walls and white ceilings generously filled with incandescent lamps. A sweeping curved Lucite railed staircase sweeps shoppers up to the mezzanine level that partially extends over the ground floor. The net result is a high, open and airy main entrance level with intimate "shops" located beneath the upper level. A focal wall carries the HANNspree logo accented with squares of sharp green, peach and black. Some of the structural columns are encased in frosted acrylic panels and backlit so that they glow as focal elements on the floor while other columns are finished in the signature green color.

Throughout there are open sightlines and vistas that allow shoppers to find specific areas that are delineated by unique fixturing and/or wall treatments. Graphics and wall treatments help to set the themes or lifestyles for the area

whether it is with cartoon characters from Disney and Warner Bros, overlooking the whimsical children's products, or the exciting, energizing sports area filled with NBA, NFL, soccer and sailing imagery and props. Inset patterns or rugs laid on the wood floors also help to identify areas. A black rug with a soccer ball pattern scattered on it highlights the wall filled with backlit, hexagonal shapes that reaffirm the soccer source of the TV design. A giant half basketball graphic backs up the cash/wrap on the second level while the floor in front of the counter is market off to look like a basketball court. A black checkerboard patterned circle accentuates the children's area on ground level along with the almost life-size toy horse and deer.

In each area the fixtures incorporate internal lighting, a power source and technology wiring. It is the variety and styling of these fixtures that turned this space into the NASFM's top award winner in the Hard Line Specialty store category.

ORANGE

Lille, France

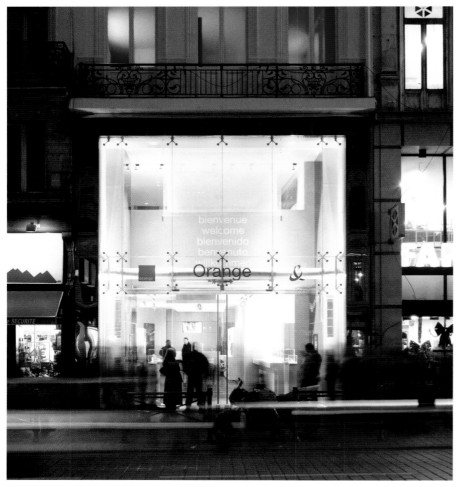

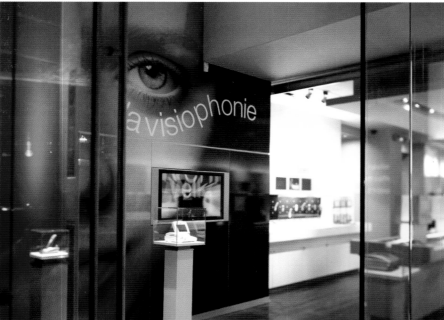

DESIGN: **PrinzDesign,** Paris, France
Jean Claude Prinz
PHOTOGRAPHY: **Courtesy of Prinzdesign**

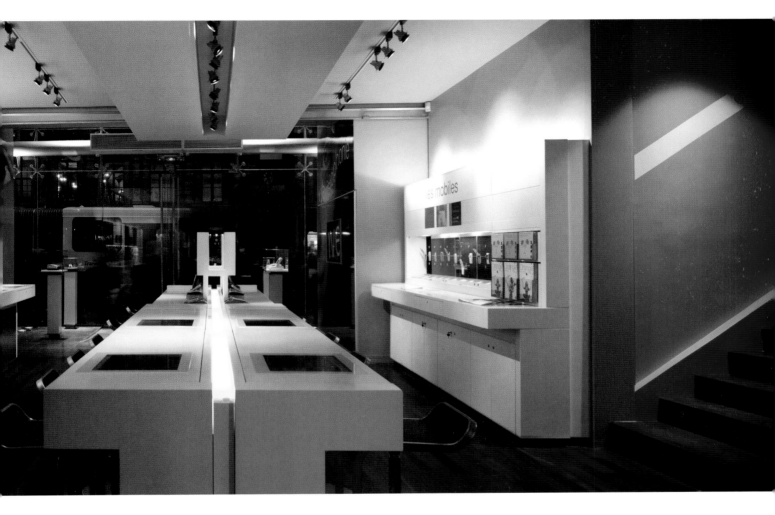

This new and stimulating space, Orange, was designed by Jean Claude Prinz of PrinzDesign of Paris. The design for this telecommunications store in Lille was commissioned because Orange recognized the need for a space that would not only show off their newest products and services but also be a destination: a comfortable and inviting space where consumers could gather and get involved with the product offering. Since Orange considers itself first and foremost in telecommunications in France, they felt the necessity for a setting suited to that claim.

Much of the space is neutral in color: mainly white, gray and some black. In some areas a dark timber is used on the floors while in the lounge area there is a muted gray carpet. In keeping with the company's name, the signature color of orange makes strong accent appearances throughout the space: a feature wall behind the reception desk, couches and seating and in the connecting stairwell to the offices upstairs.

The first contact with the consumer is up front—near the entrance— and here in the gallery some of Orange's newest technology is displayed. Within the store, France Telecom (Orange) offers its many products and services set out on tables or on the walls within reach of the consumers. It is all about "touch, try and buy." It is all about interaction with the new items. Here the client can experiment with new technologies discover new uses and discuss their needs or problems with trained professionals—or with other clients. At the large central table there are four touch screens where shoppers can further test the new innovations.

"Vous etes bienvenus chez Orange!" That's what it is all about.

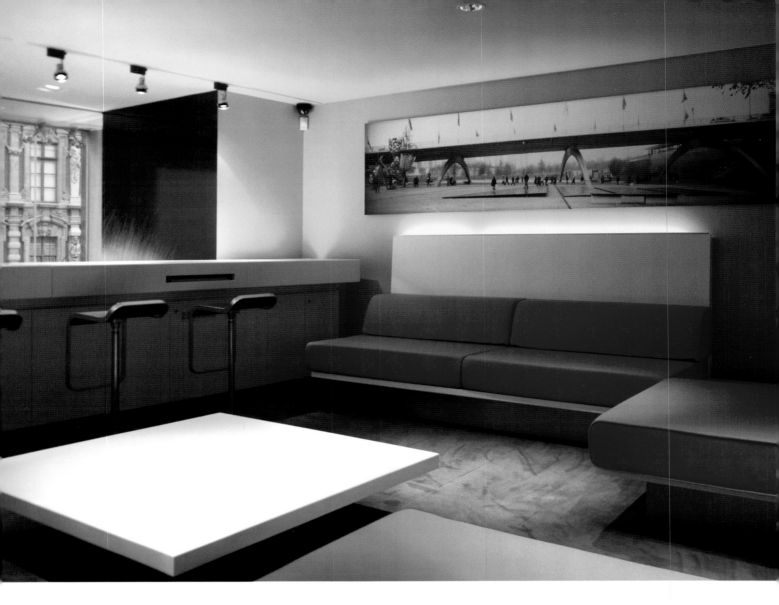

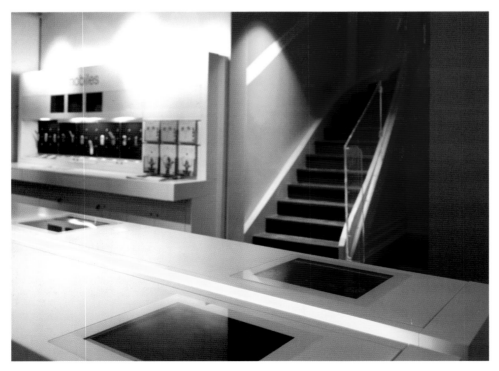

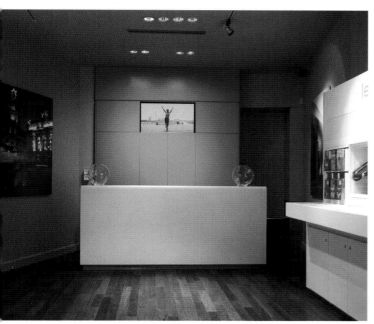

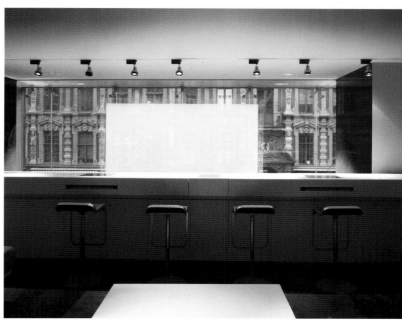

Attend the world's

LARGEST
annual **retail design** and
in-store marketing trade show
as we return to **Chicago in 2008**.

GlobalShop – where retail design and technology converge.

globalshop.org